Themes in Issues, F
A Multi-Di

Burcu Peksevgen

# Themes in Issues, Risk and Crisis Communication:
# A Multi-Dimensional Perspective

Edited by Burcu Peksevgen in collaboration with
Kristian Fuglseth, Erling Sivertsen, Jan Arne Halvorsen

**Bibliographic Information published by the Deutsche Nationalbibliothek**
The Deutsche Nationalbibliothek lists this publication in the Deutsche Nationalbibliografie; detailed bibliographic data is available online at http://dnb.d-nb.de.

**Library of Congress Cataloging-in-Publication Data**
A CIP catalog record for this book has been applied for at the Library of Congress.

The views expressed are purely those of writers and may not in any circumstances be regarded as stating an official position of Volda University College, nor the Editors of the book.

This book was published with the support of Volda University College.

ISBN 978-3-631-81651-6 (Print)
E-ISBN 978-3-631-84423-6 (E-PDF)
E-ISBN 978-3-631-84424-3 (EPUB)
E-ISBN 978-3-631-84425-0 (MOBI)
DOI 10.3726/b17931

© Peter Lang GmbH
Internationaler Verlag der Wissenschaften
Berlin 2020
All rights reserved.

Peter Lang – Berlin · Bern · Bruxelles · New York · Oxford · Warszawa · Wien

All parts of this publication are protected by copyright. Any utilisation outside the strict limits of the copyright law, without the permission of the publisher, is forbidden and liable to prosecution. This applies in particular to reproductions, translations, microfilming, and storage and processing in electronic retrieval systems.

This publication has been peer reviewed.

www.peterlang.com

# Contents

Contributors .................................................................................... 7

Introduction ..................................................................................... 9

*Audra Diers-Lawson*
Applying the Stakeholder Relationship Model as an Issue
Management and Risk Communication Tool ..................................... 13

*Camelia Cmeciu*
Risk Communication and Message Convergence in Product
Recalls. Case Study: The Brădet Dairy Products and an *E.Coli*
Outbreak ......................................................................................... 53

*Hans Petter Fagerli and Laura Asunta*
The Paradoxes, Pitfalls and Potential of Public Terrorism Threat
Assessments in Sweden, Denmark and Norway in 2018 .................. 79

*Şefik Peksevgen*
Remembrance of the Things Past: Crisis Management When a
Sultan Dies ...................................................................................... 95

*Kristian Fuglseth*
Issues Management in Local Government: A Case Study of Risk
Assessment and Issue Management in National Contingency
Plans for Local Governments ......................................................... 115

*Svein Brurås*
Crisis Reporting and the Ethics of News Media .............................. 141

*Idar Flo*
Framing of the Child Welfare Service in the «Naustdal-Case» ....... 159

*Burcu Peksevgen, Erling Sivertsen, Jan Arne Halvorsen*
A New Habitats for Universities in Norway: Crisis in Democracy .... 181

*Endre Eidsaa Larsen*
Abounaddara and the Concept of Dignified Images ....................... 195

# Contributors

**Audra Diers-Lawson**
Leeds Beckett University, United Kingdom

**Camelia Cmeciu**
University of Bucharest, Romania

**Hans Petter Fagerli**
Researcher, Norway

**Laura Asunta**
University of Jyväskylä, Finland

**Şefik Peksevgen**
Volda University College, Norway

**Kristian Fuglseth**
Volda University College, Norway

**Svein Brurås**
Volda University College, Norway

**Idar Flo**
Volda University College, Norway

**Burcu Peksevgen**
Volda University College, Norway

**Erling Sivertsen**
Volda University College, Norway

**Jan Arne Halvorsen**
Volda University College, Norway

**Endre Eidsaa Larsen**
Volda University College, Norway

# Introduction

This book brings together chapters of both senior and junior scholars from various academic fields. A broad invite to calls for chapters reveals a huge interest in the themes and a realization of the versatility of the communication perspective. The selected chapters serve as an introduction to issue management, risk communication and crisis communication and also comprise a range of case studies that illustrates the applicability of theories in film studies and history as well as media and communication.

Written in the times of Corona, the relevance of any study on issues, risk and crisis management is indubitable. While identifying risks and managing them, a collective understanding and agreement are vital to succeed. The current COVID-19 pandemic challenges our understanding of how interconnected the priority of issues and our perception of risk and communicative efforts are in dealing with crisis scenarios. It is also important that the lessons learned in practice need to be carried into the academic field.

The anthology aims to give scholars, practitioners and students new insights from recent case studies and applied theory. Also, a vital goal for this anthology is to be a reminder of the importance of human and social perspectives. Several chapters offer critique to the organizational and systematic perspectives that have been dominant, in particular in the management literature addressing public relations and communication. Therefore, a major concern we would like to highlight is the interdisciplinary approach that can be found in most of the chapters. During times of trouble, addressing possible issues and assessing and communicating risks can be challenging. We believe the best way to address this challenge comes from the multidimensional nature of communication, which we wanted to emphasize also in the title of the book. We hope that this book contributes to the knowledge base of scholars, practitioners and the students of issues, risk and crisis management from every level.

The first chapter, Applying the Stakeholder Relationship Model as an Issue Management and Risk Communication Tool, underpins the importance of a stakeholder-centric model in favor of an organizational-centered

model in crisis management and crisis communication. Audra Diers-Lawson argues that good crisis communication is built on an active and socially responsible approach to stakeholder engagement. Diers-Lawson offers a framework to better understand the opportunities to affect organizational and stakeholder behavior. Based on two assumptions, firstly that the cost of crisis is likely to be reduced with an ethical and active approach to managing risk and secondly by viewing issue management and risk communication as anticipatory strategic management, Diers-Lawson's chapter provides a most appreciated model for issue management and risk communication.

Camelia Cmeciu's study, Risk Communication and Message Convergence in Product Recalls. Case Study: The Brădet Dairy Products and an *E.Coli* Outbreak, is an example of the application of a message-centered approach to the online content generated by the Romanian public authorities, the Lactate Brădet company and the online users throughout the *Escherichia coli (E.coli)* outbreak in Romania in 2016. She analyzes the Brădet company's confidence to regain and participative rebirth after the outbreak and the reactions of the public. She concludes that public assessment was clearly polarized because of transparency and trust issues in Romanian public.

Hans Petter Fagerli and Laura Asunta's contribution in this book is based on valuable insight from representatives from the Security Services and a study of the National Security Assessments in Norway, Sweden and Denmark. The chapter The Paradoxes, Pitfalls and Potential of Public Terrorism Threat Assessments in Sweden, Denmark and Norway in 2018 sets out to find the public perspective of risk communication in the national assessments. Once again, we are pleased to present a chapter that addresses the public perspective in public relations and communication practice. The chapter points out that assessments from all three countries carry little advice for the public on how to respond to risk communication conveyed in various counter-terrorism strategies. It demonstrates the paradoxes, pitfalls and potential of future public terrorism threat assessments within the Scandinavian countries.

In the chapter Remembrance of the Things Past: Crisis Management When a Sultan Dies, Şefik Peksevgen attempts to bringing together modern crisis management studies and early modern history. Although his example

comes from a very different historical context, Peksevgen proposes that 'perception is the reality' premise in risk and crisis management studies and 'political secrets' as a management technique are applicable to both contexts and provide us a relevant framework for analysis. The chapter concludes that despite of all the democratic gains of the last two hundred years of modernity, political crises related to state security and stability still creates opportunities for political secrecy. Peksevgen's contribution as an interdisciplinary analysis is valuable for it and also serves to the book's emphasis on multidimensional nature of communication.

Case studies on risk communication and crisis management are often given from large, international organizations. In Issues Management in Local Government: A Case Study of Risk Assessment and Issue Management in National Contingency Plans for Local Governments, Kristian Fuglseth presents results from small- and medium-sized organizations that have implemented national regulations on crisis management and their contingency plans. Fuglseth finds evidence for issues that are not possible to find or to handle using the current regulatory guidelines for risk assessment. Several cases in this chapter points at skills to handle these issues that still are missing in governmental regulations and guidelines. Fuglseth suggests a new model, 'soft approach' with human perspective to better identify, assess and handle issues.

Following three chapters touch upon some of the trouble spots in Norway. The first one problematizes the transition to open-plan new habitats in Norway and claims that it is a contested issue and creates fault lines in the society. While those who support the transition argue that open offices are more flexible and less costly and facilitate communication in work environment, those who are apprehensive of the transition raise issues related to the democratic culture of Norway. In the chapter, A New Habitats for Universities in Norway: Crisis in Democracy, the authors argue that although the transition is presented as a democratic process by authorities, it will result in managerialism and an increased authoritarianism in leadership. Thus, their contention is that the transition to open-plan habitats in universities in Norway is an example of pseudo-democracy, and it creates risks in Norway's democratic culture. Idar Flo in his chapter, Framing of the Child Welfare Service in the Naustdal-Case, examines the Norwegian Child Welfare Service's (CWS)

management of the crisis during the 'Naustdal-case' by using framing theory. Flo concludes that the crisis that led to fierce criticism and strong reactions against the CWS both in Norway and abroad had a fairly balanced presentation in the media. Svein Brurås's chapter Crisis Reporting and the Ethics of News Media discusses ethical principles and current challenges in crisis journalism. Based on Scandinavian journalism ideology and practice, Brurås argue that the news media have obligations to provide a true and accurate accounts of the crises regardless of the brand and reputation of the businesses.

In the chapter Abounaddara and the Concept of Dignified Images, Endre Eidsaa Larsen uses the demand for 'dignified images' of the Syrian people as an example of how risk is conveyed through imagery. Imagery from the war expresses the horror of war, but very often anonymized the real humans that are depicted. In his study, Larsen points out the risk of dehumanization of the human and concludes that humans in film or pictures are often becoming mere illustrative objects. By connecting the visual imagery in crisis on one hand and the presentation and perceptions on the other Larsen's article represents a human and social perspective on risk communication.

<div style="text-align: right;">
Burcu Peksevgen and<br>
Kristian Fuglseth<br>
Volda, 2020
</div>

Audra Diers-Lawson
# Applying the Stakeholder Relationship Model as an Issue Management and Risk Communication Tool

**Abstract** This chapter argues that organizations can no longer view crisis management and crisis communication as a process that begins when a crisis is triggered. Instead, this chapter argues that good crisis communication is built on an active and socially responsible approach to stakeholder engagement involving issues and risk management as cornerstones of being an ethical organization serving the needs and interests of its stakeholders. In order to accomplish this goal, it argues that researchers and practitioners need to move away from organization-centered models to focus on stakeholder-centric models. Finally, it proposes that by applying the stakeholder relationship management model as an issue management and risk communication tool, organizations will be better positioned to minimize or mitigate risks to stakeholders and develop better overall strategies for responding to situations as they arise or crises as they are triggered.

**Keywords:** issue management, risk, stakeholder relationship management model, social responsibility

From the first study of crises and crisis communication in the mid-20th century to the turn of the century, crises were generally thought of as a, "…low probability, high-impact event that threatens the viability of the organization and is characterized by ambiguity of cause, effect, and means of resolution, as well as by a belief that decisions must be made quickly" (Pearson & Clair, 1998, p. 60). This definition of crisis was supported by a small body of research that had emerged throughout the previous 40 years. However while both practitioners and academics recognized that crises are challenging because they are often ill-structured and complex (Mitroff, Alpaslan, & Green, 2004), they had also witnessed a growing and diverse number of crises like the 1989 Exxon Valdez oil spill in Alaska, the Iran-Contra Affair of the mid-to-late 1980s, the tainted blood scandal from the American Red Cross in the early 1990s, Enron's accounting scandal of 2001, and the terrorist attacks of 2001. As a result

of the risks posed by modern crises in an information-rich world, the research interest in crisis management and crisis communication began to grow substantially.

These new experiences with crisis demonstrated that crises can affect all types of organizations. The causes of the crises can range from circumstances entirely out of an organization's control to careless mistakes of individuals within an organization, to systematic breakdowns or inefficiencies (Argenti, 2002; King, 2002; Pearson & Clair, 1998; Reilly, 1987). With the growth of interest in crises, crisis management, and crisis communication, how we define a crisis has also evolved. Instead of thinking of crises and low-probability and high impact events with ambiguous causes and outcomes, we should be thinking of crises differently. In fact, Heath and Millar (2004) argue that instead of thinking of crises as unpredictable, we should think of them as untimely but largely predictable events. If we accept this definition of crisis, then it also suggests we need to focus our attention on crisis prevention – that is issue management and risk communication – rather than just crisis response.

If we are to begin to shift the narrative and more meaningfully address those factors that most help organizations manage issues and mitigate risk, then we must also shift our theoretical perspectives away from organization-centric theories to stakeholder-centric theories. This shift is also appropriate because the demands of a modern communication environment require organizations to more effectively engage with many different stakeholder groups (Botan, 1997; Xu & Li, 2013). As such, the stakeholder relationship model (SRM) discussed in this chapter builds on Haley's (1996) model for advocacy advertising and provides a heuristic aligned with previous research addressing consumer attitudes (Claeys, Cauberghe, & Vyncke, 2010), public pressure from interested stakeholders in the face of corporate irresponsibility (Piotrowski & Guyette, 2010; Uccello, 2009), and engagement (Hong, Yang, & Rim, 2010). The model argues that it is the relationships between stakeholder perceptions of organizations, issues, and the interrelationships between them that together will help build a deeper understanding of risk, issues, and the communication needs of stakeholders. Previous applications of the model to

analyze post-crisis communication have demonstrated its effectiveness in identifying factors influencing consumer evaluations of the firm, such as an organization's reputation, consumer knowledge of the organization, perceptions of the organization's concern regarding the crisis, and consumers' interest regarding the crisis (see Diers, 2012). Therefore, this represents a new opportunity to apply the model in the context of issue management and risk communication.

## Issues, Risk, and Anticipatory Stakeholder Stewardship

This chapter makes two critical assumptions. First, the core objective of issues management and risk mitigation is to either remove or mitigate crises. No matter whether we prioritize an organization-centric view or a stakeholder-centric view, the first assumption suggests that the costs of crises – ranging from financial to human – are likely to be reduced with an active approach to managing risk. Second, organizations have more options to act before a crisis emerges (Heath & Palenchar, 2009; Meng, 1992), which is why issue management and risk communication should be viewed as anticipatory strategic management (Heath, 2002). Based on these two assumptions, if we can better understand issues management, risk, and stakeholders in complex organizational environments, we can begin to build a framework to better understand opportunities to affect organizational and stakeholder behavior.

### Issues Management as Anticipatory Strategic Management

Heath's (2002) perspective on issues management is stakeholder centered in that he argues that it is stewardship for building, maintaining, and repairing relationships with stakeholders and stake seekers. He argues that successful issues management:

- enhances an organization's ability to plan and manage its activities;
- enhances an organization's ability to behave in ethical and socially responsible ways, as a part of routine business;
- enhances an organization's ability to monitor its environment;
- enhances the organization's ability to develop strategic dialogue to manage relationships more effectively.

However, for issues management to be successful organizations cannot be reactionary – they must view this as an anticipatory process. In his analysis of issues management, Meng (1992) identified a five-stage issue lifecycle (see Figure 1) encompassing the potential, emerging, current, crisis, and dormant stages of an issue. In simple terms, as the issue moves through the first four stages, the issue attracts more attention and becomes less manageable (Heath & Palenchar, 2009; Meng, 1992).

To borrow from a health care analogy – early detection is the best approach to managing issues, which is in both the organization's and stakeholders' interests. If an organization can identify issues before they are triggered by an event, whistleblower, the media, consumers, or any one of the organization's internal or external stakeholders, then the organization has more opportunities to meaningfully address the issue. However, as the issue matures, the number of engaged stakeholders, publics, and other influencers expands and positions on the issue become more entrenched meaning that the choices available to the organization necessarily shrink

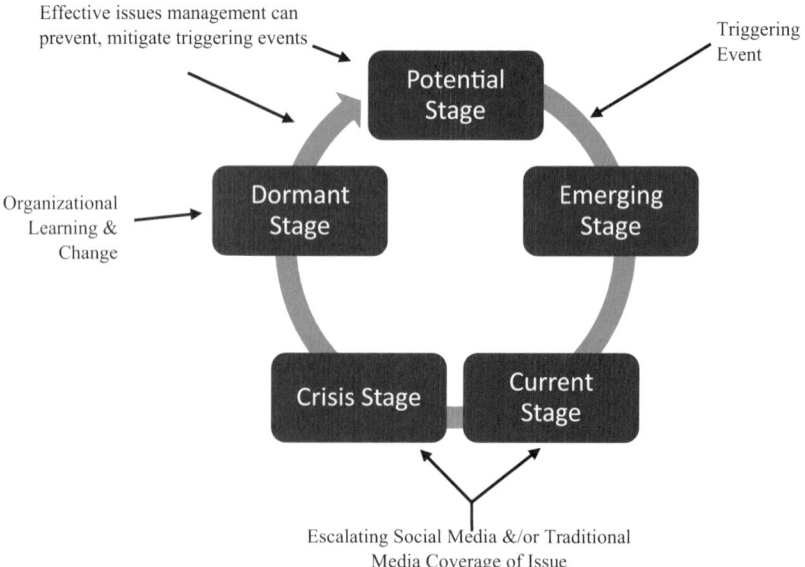

Fig. 1: Adaptation of Meng's (1992) Issues Management Process

(Elsbach, Sutton, & Principe, 1998; Heath & Palenchar, 2009; Kernisky, 1997; Meng, 1992; Pang, Cropp, & Cameron, 2006; Seeger, Heyart, Barton, & Bultnyck, 2001).

## Risk and the Central Role of Communication

In early detection, we are looking for risks that organizations face, wicked social problems like climate change and epidemics to manage, and threats to people's well-being. However, risk is often a difficult concept for social or behavioral scientists to unpack because much of what we must manage is peoples' perception of risk rather than the probability that a crisis will happen (Freundberg, 1988). For example, an engineer can calculate the probability that a bridge will fail, or an infectious disease expert can calculate the spread of disease based on population density and a number of other factors; however, risk management is not about the material risk but about the reduction of the risk and communication of information about the risk.

One of the challenges in this process is that technical information has to be translated and that public decisions about risk are not always rational (Freundberg, 1988). In exploring reactions to the impact of disease, epidemics, and bioterrorism, Covello, Peters, Wojtecki, and Hyde (2001) identified 15 factors that influenced peoples' perception of risk (see Table 1). Though the 15 factors are all very different, what is consistent is that the unknown, uncontrollable, or nebulous make people less willing to accept the credibility of threats; however, at the same time once people judge risks to be "real," those factors that made us resistant to accepting them as credible also mean that they are perceived as greater threats. Put simply, people often bury their heads in the sand, pretend that the risk is not real until it is unavoidable and then they may overestimate the negative effects it could have.

In her review of Hurricane Katrina – an American example of very poor risk and crisis management – Comfort (2007) summarizes a four-step process for risk management that complements much of the relevant research connected to risk and crisis communication (see Figure 2).

Risk detection is a natural starting point in the process; before an organization can plan to minimize the risks that it or its stakeholders could

Tab. 1: Factors Influencing Perceptions of Risk[1]

| Risk Perception Factor | Findings |
|---|---|
| Voluntariness | People are less likely to accept a risk as a credible threat if it is involuntary; view involuntary risk as greater once they believe that it could affect them |
| Controllability | When people believe they do not have control in a situation, they are less likely to accept a risk as a credible threat; but once accepted, they believe the risk is greater if they cannot control the situation |
| Familiarity | If people are unfamiliar with a risk, they are less likely to accept it as credible; but once accepted, they believe it is a greater threat than if it was previously known |
| Equity | People are less likely to believe that risks are credible when they are perceived as being unevenly distributed than if everyone is equally at risk |
| Benefits | People are more likely to accept the credibility of risk if the benefits of taking the risk are clear; however, they are also likely to perceive the risk as less severe than if the benefits are unclear or questionable |
| Understanding | If people do not understand the risk, the risk is viewed as less credible but also carries a higher evaluation of threat than those that are perceived as being understood. |
| Uncertainty | People are less likely to accept risks where the outcomes are highly uncertain; however, they are more likely to view those risks as more severe once accepted |
| Dread | If a risk evokes fear or anxiety in people, they are less readily accepted as credible risks but judged to be greater threats |
| Trust in institutions | If people do not trust organizations, they are less likely to accept risks associated with them and those risks are more likely to create more threat than those associated with trustworthy or credible organizations |
| Reversibility | People are less likely to accept the credibility of risks that are viewed as irreversible but more likely to perceive greater threat than those whose effects are reversible |
| Personal stake | If people believe they could be directly and personally affected, they are less likely to accept the risk as credible; however, once accepted will feel a greater level of threat |
| Ethics and morals | When people perceive risks as being ethical or moral problems, they are less likely to view the risk as credible but perceive them as a greater threat |

Tab. 1: Continued

| Risk Perception Factor | Findings |
|---|---|
| Human vs natural | People are less likely to accept risks as credible threats when they are caused by people; however, they view them as bigger risks than natural disasters |
| Victim identity | When people can identify with specific real or potential victims of risks, they are less likely to accept the credibility of threat but are more likely to view the threats as more severe than if they connect risks with "nameless and faceless" people in general |
| Catastrophic potential | People are less likely to accept the credibility of a threat when it can produce fatalities, injuries, or illness; however, once accepted are perceived as greater risks than those threats whose impact may be either scattered or minimal |

[1]Adapted from Covello, et al.'s (2001) risk perception model

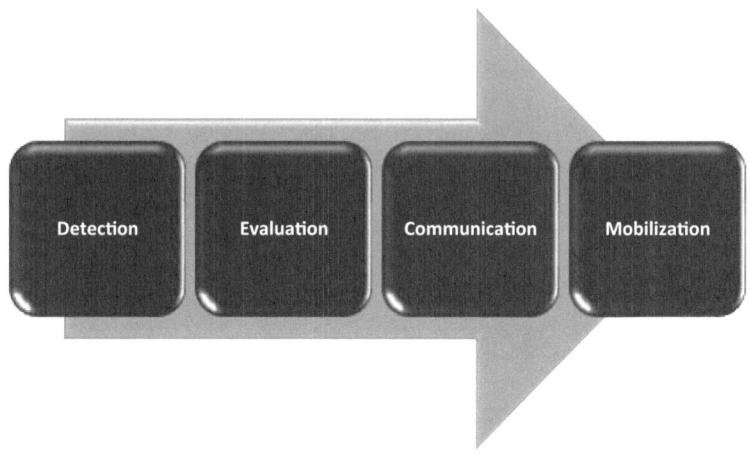

Fig. 2: Risk Management Process. Comfort (2007)

experience, those risks must be known (Comfort, 2007; Dilenschneider & Hyde, 1985; Hayes & Patton, 2001; Heath, 1998; Kash & Darling, 1998; Ritchie, 2004; Stacks, 2004). From there, the risk must be evaluated in the second step in as an objective and effective way as possible so that a

straightforward judgment of the likelihood and severity of the risk can be made (Comfort, 2007; Dilenschneider & Hyde, 1985; Freundberg, 1988; Massey & Larsen, 2006).

Third is the communication of risk (Comfort, 2007). As Freundberg (1998) pointed out, this is challenging because technical information does not always translate directly. Furthermore, peoples' perceptions of risks are affected by several factors (Covello et al., 2001). Nevertheless, communicating risk is vital to ensure that relevant stakeholders, like members of the organization, regulators, the media, and those directly affected, can appropriately understand the situation and are prepared to deal with it (Johansson & Härenstam, 2013; Ley et al., 2014). Thus, the communication of risk focuses on exchanging knowledge essential to managing the risk.

Finally, sharing information then allows for the organization to mobilize a response to reduce risk and respond to danger (Comfort, 2007; Dilenschneider & Hyde, 1985; Heath, 1998). The mobilization of collective response includes communication-related tasks like issue management, managing stakeholder relationships, developing communication plans and protocols, and staff development (Hayes & Patton, 2001; Heath, 1998; Heath & Millar, 2004; Johansson & Härenstam, 2013; Kash & Darling, 1998; Perry, Taylor, & Doerfel, 2003; Reilly, 2008). It also includes management-related tasks like developing teams and decision-making systems to facilitate the process (Hayes & Patton, 2001; Horton, 1988; Jindal, Laveena, & Aggarwal, 2015; Nunamaker, Weber, & Chen, 1989).

This means that if we think of issues management as the material part of risk communication, then it is clear that they are intertwined with the broad concept of crisis management. Jindal et al. (2015) define crisis management as a process allowing organizations to deal with major problems that pose a threat to the organization and/or its stakeholders. For organizations, crisis management is a learned behavior that focuses on mitigation and control of the internal and external dynamics of the crisis itself; yet it is not like being a mechanic that finds a problem in the car and fixes it – it is still about engaging with people's expectations and their decisions-making process.

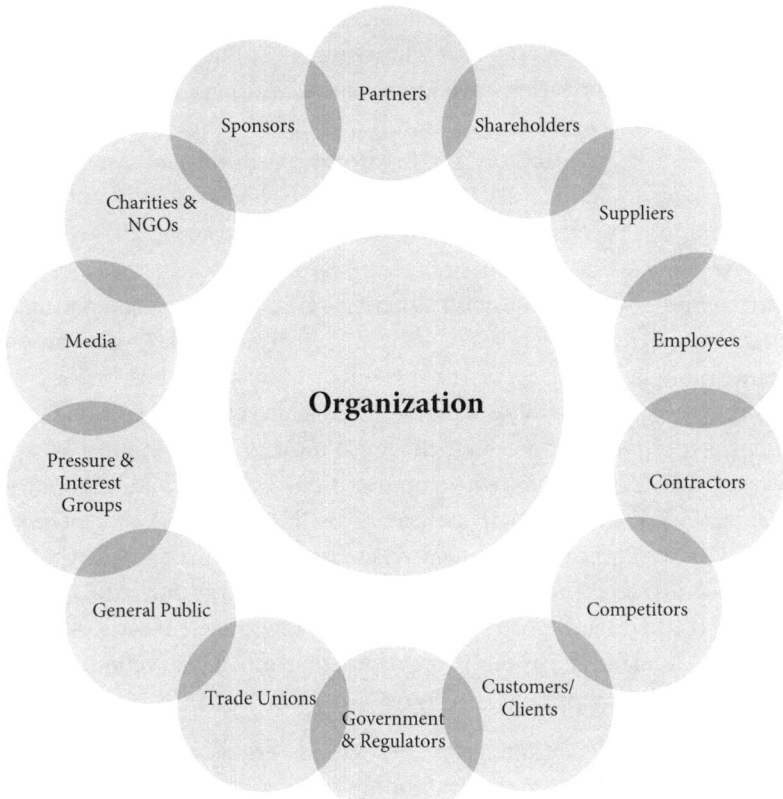

Fig. 3: Examples of Stakeholders Organizations May Have

## Stakeholders and Complex Environments

In the organizational context, stakeholders are those groups and/or people who can affect or be affected by an organization (Freeman, 1994). As if it was not complex enough for organizations to manage relationships with stakeholders, organizations are also subject to a lot of pressures because they serve multiple groups at any given time (Connolly, Conlon, & Deutsch, 1980; Frooman, 1999). Stakeholders range vastly and can include groups like employees, customers or clients, regulators, competitors, and the like (see Figure 3 for examples).

In an era where not only stakeholders are demanding different forms of engagement but also crises are increasingly common, stakeholders' expectations of organizations are changing as well. For example, as new generations (e.g., Generations Y and Z) are gaining voice as young adults and workers, their expectations of organizations like social responsibility, transparency, and ethical decision-making are fundamentally influencing public relations practice (Curtin, Gallicano, & Matthews, 2011).

These changes mean that organizations must change the ways they relate to and communicate with different stakeholder groups in competitive message environments. For example, instead of just positioning an organization as having a desirable product or service, they feel increasingly pressured to have more socially responsible value propositions – they cannot just sell a good product, they also must do good – all in an environment where their competitors and critics might be talking about the organization relative to their own interests. Haley (1996) was interested in understanding how consumers reacted to such advocacy in the context of advertising. In particular, he was interested in how stakeholders reacted to different types of cause-related advertising messages. In his work, Haley identified three perceptions that affect how compelling an organization's promotional messages:

1. **Perception of the organization and self.** He argued that a central component of consumers' understanding of advocacy messages from organizations was based on their perception of the relationship between the organization and the consumer. On the whole, if the organization was recognizable and likeable, it was more likely to be persuasive.
2. **Perception of organization and issue.** Next, Haley argued that how consumers understand the relationship between the advocacy issue and the organization would influence their acceptance of the advocacy message.
3. **Perception of the issue and self.** Finally, in order for advocacy advertising to be effective, Haley argued that consumers also had to have a measure of investment in the issue.

In the context of public relations, Haley's (1996) discussion of the relative success of advocacy advertising makes a lot of sense because it encourages us to focus on the relationships between stakeholders, organizations, and

issues. Yet, unlike interpersonal relationships, stakeholder relationships are necessarily based on perceived vested interests – that is the organization and/or the stakeholder want something relatively tangible from the other and, as Heath (2002) argues, the relationship should be mutually beneficial. For me this provides something concrete and measurable that can be tested in order to diagnose, manage, and improve relationships (Diers-Lawson, 2017a; Diers, 2012).

## Stakeholder Relationship Management Model

Unfortunately, in reflecting on the primary theoretical perspectives often articulated, the narrative is unclear about the relationship between organizations, stakeholders, and the issues that are important to them. In part, this is because the academic literature focuses much attention on describing and analyzing response strategies (Oles, 2010; Piotrowski & Guyette, 2010; Samkin, Allen, & Wallace, 2010; Seeger & Griffin-Padgett, 2010; Sung-Un, Minjeong, & Johnson, 2010; Weber, Erickson, & Stone, 2011) with less meaningful attention paid on stakeholder needs.

The SRM provides a way to organize previous findings that establish that stakeholder characteristics, public pressure from interested stakeholders, and engagement are all likely to influence stakeholder evaluations and behavioral intentions toward organizations. The model aligns with previous research establishing that consumer attitudes (Claes, Rust, & Dekimpe, 2010), public pressure from interested stakeholders in the face of crises (Piotrowski & Guyette, 2010; Uccello, 2009), and engagement with stakeholders (Hong et al., 2010) are all likely to influence consumer evaluations and behavioral intentions toward organizations. Previous applications of the model to the analysis of post-crisis communication have demonstrated its effectiveness in identifying factors influencing consumer evaluations of the firm, such as an organization's reputation, consumer knowledge of the organization, perceptions of the organization's concern regarding the crisis, and consumers' interest regarding the crisis (Diers-Lawson, 2017a; Diers, 2012). However, I argue that in the context of issues management and risk mitigation, the model is a useful diagnostic tool to help organizations more effectively solve problems before crises are triggered. The SRM focuses on the stakeholder's perspective and tries

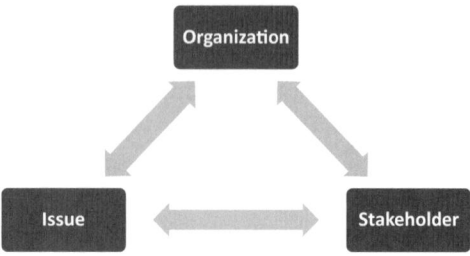

Fig. 4: Stakeholder Relationship Management Model

to understand that perspective in order to better understand and predict stakeholder judgments about organizations, issues, and their behavioral intention (see Figure 4 for the summary of the model).

## The Relationship between the Organization and Issues

First, let us evaluate the types of judgments that stakeholders make about the relationship between the organization and issues. Stakeholders make judgments about whether and how organizations are connected to issues the stakeholders care about. While research is still identifying factors influencing this judgment, four have emerged across a large body of research – from multiple authors, books, and journal articles in the last 10–15 years.

**Blame or Responsibility Attribution.** This is an evaluation of the degree to which stakeholders believe that an organization has control over an issue (Weiner, 1985, 2006). The more responsibility that a stakeholder attributes to the organization, the more likely they are to ascribe expectations to the organization with regards to the issue. Blame attribution is one of the most important predictors of stakeholder attitudes about an organization after a crisis and is a core concept in situational crisis communication theory (Coombs, 2007; Coombs & Holladay, 2004; Jeong, 2009; Schwarz, 2008) but is also applied in other related crisis communication research connecting to other factors like corporate social responsibility, crisis history, and ethics (Kim, 2013; Ping, Ishaq, & Li, 2015).

One of the reasons that organizations should be motivated to care about issues and risk management is that we can think about blame attribution as

the potential threat to an organization's reputation. Reputational threat is a multistep process combining evaluations of severity and blame attribution followed by considering situational intensifiers like the organization's history of crises (Coombs, 2007; Maresh & Williams, 2007) and its reputation (Coombs, 2007; Sisco, Collins, & Zoch, 2010; van Zoonen & van der Meer, 2015). For example, previous research suggests that higher perceptions of blame attribution results in greater reputational damage for crises (e.g., Coombs & Holladay, 1996; Kim, 2014; Schwarz, 2012). All of this generates emotions on the part of the stakeholders, which thus influences their understanding of the situation as well as their interpretation of the organization's crisis response (Choi & Lin, 2009; McDonald & Cokley, 2013). When the perception toward the organization is more negative, the greater responsibility is attributed on the organization, and thus the greater the reputational threat created by the crisis (Weiner, 1985). As such, better understanding factors that serve as intensifiers to a crisis is vital to better understanding the attribution of blame and the reputational risk crises carry with them.

**Competence, Commitment, and Clear Association.** Questions about how stakeholders assign blame to organizations have been asked since the 1970s with Schwartz and Ben David's (1976) analysis of blame, ability, and denial of responsibility in the face of emergencies. Evaluations of an organization's competence in crisis management is, by contrast, a newer evolution in the field's understanding of this relationship (see e.g., Diers, 2012; Sohn & Lariscy, 2014). While competence had long been considered from the crisis management perspective, it has not always been considered from the stakeholder perspective. Competence asks whether or not stakeholders judge that the organization has the capacity to successfully address the issue (de Fatima Oliveira, 2013; Hyvärinen & Vos, 2015; Sohn & Lariscy, 2014).

Positive intention, concern, and commitment all represent value judgments stakeholders make regarding the authenticity of the organization's interest in the issue (Huang, 2008). Stakeholder evaluations of an organization's intentions toward an issue are largely governed by their evaluation of the authenticity of the organization's actions. If a stakeholder believes an organization's intentions authentic when it comes to social responsibility, then they will most likely view the organization's

connection to the issue as positive and productive. However, if stakeholders believe the organization's interest in an issue is inauthentic, then it does not matter how good the organization's behaviors are, it is unlikely to positively influence their judgments about the organization's intentions toward the issue (Lacey, Kennett-Hensel, & Manolis, 2015).

Finally, clear association also matters. If stakeholders believe there is a logical connection between an issue and the organization's core business or mission, then the organization's interest in the issue is more compelling to the stakeholder and can thus change the stakeholder's judgment about the organization, particularly after a crisis emerges (Claeys & Cauberghe, 2015; Coombs & Holladay, 2015; De Bruycker & Walgrave, 2014; Kernisky, 1997; Knight & Greenberg, 2002). Clear association influences not only the judgments stakeholders make about the organization and the issue but also, broadly speaking, the organization's credibility to manage issues and risks as they emerge (Heinze, Uhlmann, & Diermeier, 2014; Pang, Begam Binte Abul Hassan, & Chee Yang Chong, 2014; Park & Cameron, 2014).

**Outcomes of the Relationship between the Organization and Issues.** If we take what we know about blame, severity, competence, commitment, and clear association into account, then we should have a pretty good picture of what frustrates stakeholders. Jin's research (2009, 2010, & 2014) clearly indicates that perceptions of the "controllability of the crisis" are likely to generate stakeholder anger, which is one of the critical reasons for issues management and risk mitigation. The more perceived control that an organization is believed to have, the more likely a triggered crisis angers stakeholders because the organization could have potentially prevented the crisis. Thus, the question of an organization's perceived competence is likely to affect stakeholder anger as one indicator of perceived control. Likewise, in these situations, we also see a clear indicator of whether stakeholders are angry – they are more likely to blame the organization for the crisis (Jin, 2009; 2010). Therefore, we can think of perceived control as being a combination of blame attribution and competence.

If stakeholders believe the organization could reasonably have controlled the situation leading to the crisis and that makes them angry, then the degree to which they feel helpless will only intensify the situation.

Think about it this way – it is bad enough knowing that we cannot do anything about the situation but knowing the situation could have been avoided if those who had the ability to change it just would drive most people to the point of frustration (to put it mildly). Thus, in considering factors that produce anger in a crisis context, the stakeholder relational model provides a framework for considering both antecedent and indicators of emotion together to more fully understand the complex dynamics of stakeholder relationships with organizations, issues, and crises (Diers, 2012).

As such, knowing stakeholder attitudes about how organizations are connected to issues and risks helps predict their reaction to the organization when it tries to manage emergent issues or triggered crises. For example, stakeholders' prior experiences within an industry or with a particular issue can potentially create a "negative communication dynamic," suggesting that two of the critical indicators of stakeholder anger could be negative word-of-mouth (nWOM) (Coombs & Holladay, 2007; Kim, 2014; McDonald & Cokley, 2013; Pace, Balboni, & Gistri, 2014; Yin, Feng, & Wang, 2015) as well as a risk that the stakeholder will not want to engage with the organization (ranging from purchase intention to donation, to following guidance the organization provides to keep stakeholders safe) (Coombs & Holladay, 2007; Ping et al., 2015; Sellnow et al., 2015; Yum & Jeong, 2014). All of this makes it more difficult for the organization to solve the problem once a crisis emerges. We see the greatest evidence of this with social issues and problems where people fundamentally do not believe governments on topics like climate change, security, social justice, or vaccination all because people do not trust the connection between the government and controversial issues.

## The Relationship between Stakeholders and Issues

Not surprisingly, research and practice connected to issues, risk, and crisis management is very diverse – not only because the types of crises that we try to understand are global and diverse but also because the field is still developing. In reviewing the broad body of journal articles published on crisis communication from 1953 to 2015 (Diers-Lawson, 2017a), one of the core findings is that the stakeholder relationship to

issues is fundamentally ignored in most crisis communication research. This is part of the reason why shifting the field's focus to define crisis communication as beginning with issues and risk management is essential.

At the same time as the stakeholder experience with risk, issues, and crisis is often ignored by focusing on organizational outcomes, issues that stakeholders are confronting can be incredibly emotional and result in a lot of emotionally charged communication (van der Meer & Verhoeven, 2014). Though our understanding of the role that emotion plays in risk and crisis is still developing, there is an increasing recognition that emotional reactions affect the outcomes of crises (Hajibaba, Gretzel, Leisch, & Dolnicar, 2015). For example, research has demonstrated that beliefs about stakeholders' susceptibility to risk, efficacy to avoid risk, uncertainty regarding the risk or its outcomes, and severity substantially affect stakeholders' emotions and decision-making about issues and organizations and also demonstrated that how angry they were likely to be both about the issue and the organization at the onset of a crisis (Diers-Lawson, 2017b; Jin, Liu, Anagondahalli, & Austin, 2014; McDonald & Cokley, 2013; Mou & Lin, 2014). Thus, from a risk or crisis management perspective, the more intensely that stakeholders feel connected to issues, the more likely those issues are going to trigger the stakeholders to act in less predictable ways. However, to apply the framework ahead of crises provides better intelligence regarding issue management and risk mitigation. But in order to do that, we must better understand the factors influencing strong emotional reactions to crisis.

**Factors Influencing Strong Emotional Reactions to Crises.** In a global environment there are several individual factors identified in different studies as influencing emotional reactions to crises. One important study of individual factors within the tourism industry focused on "crisis resistant tourists" – that is those people whose attitudes and planned behaviors were less likely to be affected by emerging crises. Hajibaba et al. (2015) found that people who are more likely to take risks – travel more, actively involve in travel planning, are younger, are interested in a number of other activities, and have a number of personal and lifestyle preferences – are less likely to perceive substantial risk from individual crises. This suggests that we must assume that individual factors like gender, age, income,

experience with the crisis issue, and attitudes about the crisis issue are likely to influence emotional reactions to crises.

In addition, there is increasing evidence to suggest that media use is likely to influence peoples' reactions to crises and so we must better understand how traditional and social media use – both reading and posting – influences emotional reactions to crises (Brummette & Sisco, 2015; Brynielsson, Johansson, Jonsson, & Westling, 2014; Kim & Cameron, 2011; Pace, Balboni, & Gistri, 2014; Utz, Schultz, & Glocka, 2013; Yin, Feng, & Wang, 2015). Based on the previous research, we should expect that there is a connection between use, posting, and strong emotions. In fact, McDonald and Cokley's (2013) taxonomy of emotional reactions to expect online found that there were two key ways to classify reactions – those that were problem focused and those that were emotional focused. They found several online behaviors indicating direct action taken against the "offending" organization ranging from different word-of-mouth (WOM) behaviors to boycotts, reduced product usage, and buying alternative brands. As such, these findings suggest that there are many individual factors that help us to understand and predict emotion in reactions to risks and issues.

Finally, understanding the impact of culture on stakeholder reactions to issues is vital if we are to make reliable evaluations and predictions about issue management to inform risk and crisis communication strategy. For example, many of the indicators of an organization's reputation like its trustworthiness (Sohn & Lariscy, 2014), values (Austin, Liu, & Jin, 2014; Falkheimer & Heide, 2015), or even brand appeal (Brown, Brown, & Billings, 2015) represent stakeholders' judgments rooted in culture and similar enduring identities (Scollon, Diener, Oishi, & Biswas-Diener, 2004) as well as existing attitudinal constructs like uncertainty avoidance (Coombs, 2008; Siew-Yoong Low, Varughese, & Pang, 2011). Understanding cultural identities is important because it gives people the sense of belonging, provides guidelines for behavior, and a sense of morality or identity (Moran, Abramson, & Moran, 2014, 2014). Identities can range from national, social, cultural, religious, and/or political identities and often influence a host of attitudes including our understanding of situations as well as our belief that we can control our surroundings

(Ajzen, 2005; Bandura, 1986; Hajibaba et al., 2015; Ratten & Ratten, 2007; Yum & Jeong, 2014).

Today, many if not most issues and risks have cultural components – no matter whether we are discussing challenges within countries (Olofsson, 2007) or we are discussing global crises (Gurman & Ellenberger, 2015). For example, increasing globalization poses unique challenges for practitioners as many do not feel prepared to handle multicultural issues or adapt their communication strategies across different cultures (de Fatima Oliveira, 2013). In fact, in Zhao's (2014) discussion of crisis communication in a global context, she suggests that nationalist, statist, classist, and often even cultural analyses are often too static rather than relational and dynamic. There have also been a number of examples of multinational organizations that have failed to effectively respond to risks and crises in an international environment because they have chosen strategies that were culturally "tone deaf" (An, Park, Cho, & Berger, 2010). Unfortunately, much of issues, risk, and crisis communication theory is based on a Western-oriented paradigm with little reference to its cross-cultural aspects (Haruta & Hallahan, 2003). However, that problem has begun to be meaningfully addressed in research and practice. In recent years, there has been an increasing recognition of the importance of national identity in crisis communication (Chen, 2009; Molleda, Connolly-Ahern, & Quinn, 2005; Rovisco, 2010). However, that is not the only way to define and describe the impact that culture can have on stakeholders' reactions to crises.

Globally, one of the most important cultural factors influencing issues, risk, and conflict is religion (An et al., 2010; Goby & Nickerson, 2015; Haruta & Hallahan, 2003; Jindal et al., 2015; Palmer-Silveira & Ruiz-Garrido, 2014; Taylor, 2000). There is a strong body of research suggesting that religion or religiosity – which is an indicator of how much religious identifications influence decision-making – influences people's attitudes and perceptions (Moran et al., 2014; Ursanu, 2012). Additionally, Croucher's (2013) research indicates that conflict management, a construct related to crises, is influenced by religion as well. Though this is an emergent area for issues and crisis research, case studies indicate that stakeholders are likely to react more negatively when crises or their related issues violate their religious beliefs. Al-Hyari's research indicates

that conflict management, a construct related to crises, is influenced by religion as well (Al-Hyari, 2012; Jaques, 2015).

Further, depending on the nature of the issue or risk, understanding cultural values applying common cultural dimensions like individualism, collectivism, uncertainty avoidance, power distance, masculinity, and ethical ideology (Leonidou, Leonidou, & Kvasova, 2013) or other values-based identities like political identities (Zeri, 2014) will be necessary if we are to fully understand stakeholder attitudes about issues and organizations. Though challenging, for issues and risk management, the good news is that multinational organizations may even be able to avoid or manage crises by communicating more effectively with local populations based on what is important to them (Hoffmann, Röttger, Ingenhoff, & Hamidati, 2015; Taylor, 2000).

## The Relationship between Stakeholders and Organizations

Finally, we consider the relationship between the organization and the stakeholder. Stakeholders' attitudes toward organizations, especially those in crisis, have been studied the most in crisis communication (Diers, 2012). Often treated as an outcome of a crisis, these judgments have been assessed across multiple fields of study from communication and marketing to industry-specific studies in such different areas like health care and tourism. If researchers and practitioners want to understand this relationship, they should directly analyze factors like an organization's reputation (Benoit, 1995; Carroll, 2009). There is considerable work in public relations that explores topics like the influence of a favorable pre-crisis reputation in protecting an organization's reputation during and after a crisis (Claeys & Cauberghe, 2015), the role of the media and other external groups in influencing an organization's reputation during crises (Einwiller, Carroll, & Korn, 2010), and the growing influence of social media on an organization's reputation in the context of crises (Brown & Billings, 2013; Ott & Theunissen, 2015; Utz, Schultz, & Glocka, 2013), to name just a few ways that reputation influences the stakeholder evaluations of organizations.

However, there are other factors that influence the relationship like stakeholders' perceived knowledge of the organization because it not only

changes under different circumstances but also is influenced by stakeholder perceptions of risks (Diers, 2012). Additionally, when stakeholders form attitudes toward organizations, they often invoke more personal feelings about organizations, like decisions about whether the organization is trustworthy (Freberg & Palenchar, 2013), if they believe the organization has values that are congruent to their own (Koerber, 2014), whether they feel the relationship itself is satisfactory (Ki & Brown, 2013), or even whether the stakeholders feel loyalty to the organization (Helm & Tolsdorf, 2013). All of this influences not only how the stakeholder feels about the organization but also the realistic possibility the organization can effectively manage risks and issues with different stakeholder groups. We should, therefore, better understand some of the critical building blocks for the relationship between organizations and stakeholders: reputation, trustworthiness, value congruence, and identification.

**Reputation.** Reputation represents stakeholder perceptions of how an organization has behaved across its functional domains or how well it treats its stakeholders (Coombs, 2007). There is no shortage of studies highlighting the importance of a good reputation before a crisis (Helm & Tolsdorf, 2013; Kim, 2014). But what makes for a good reputation? As it turns out, previous research identifies five factors that directly influence an organization's reputation:

1. Its overall appeal to stakeholders (Avraham, 2015; Brown, Brown, & Billings, 2015; Folkes & Karmins, 1999; Huber, Vollhardt, Matthes, & Vogel, 2010). Appeal is related to the degree to which the organization and/or its products, services, or advocacy is likable or desirable.
2. The degree to which the organization is viewed as socially responsible, which not only includes authentic "corporate social responsibility" initiatives, but also broader evaluations of its ethical behavior (Balmer, Blombäck, & Scandelius, 2013; Bowen & Zheng, 2015; Coombs & Holladay, 2015; Lacey et al., 2015; Shanahan & Seele, 2015).
3. An evaluation of the quality of the organization's values and whether those values are evidenced in the organization's actions (Austin, Liu, & Jin, 2014; Falkheimer & Heide, 2015; Ott & Theunissen, 2015).
4. Whether the organization itself is viewed as a credible source of information – especially about the crisis (Heinze, Uhlmann, & Diermeier,

2014; Pang, Begam Binte Abul Hassan, & Chee Yang Chong, 2014; Park & Cameron, 2014).
5. Whether stakeholders believe it can handle emergent problems (Hargis & Watt, 2010)

In short, an organization's reputation represents a judgment that stakeholders make about what they can expect from the organization.

**Trustworthiness.** Underlying reputation and this process of assessing reputational threat is a more fundamental concept – an organization's trustworthiness (Mal, Davies, & Diers-Lawson, 2018; Trettin & Musham, 2000). Shockley-Zalabeck, Morreale, and Hackman (2010) describe trust in organizations broadly as evaluations of their positive expectations about the intent and behaviors of the organization. Further, Mayer, Davis, and Schoorman (1995) argue that to be trusted, an organization must have integrity – that is, its stakeholders believe the organization's values are aligned with their own (Austin & Jin, 2015; Falkheimer & Heide, 2015). Naturally, this is also related to assessments of an organization's social responsibility – an important factor affecting its reputation (Coombs and Holladay, 2015, Kim and Lee, 2015).

Yet, previous research demonstrates that different types of issues create different risks in the relationship between the stakeholder and the organization including both a loss of reputation and trust. For example, Kim, Ferrin, Cooper, and Dirks (2004) found that violations of integrity are more damaging than violations of competence because the integrity violation points to a moral failure versus competence violation points to a personnel or procedural failure. Kramer and Lewicki (2010) emphasize that violations of trust are often based in unmet expectations such as broken promises, the inability to perform, or behaviors that are misaligned with core values.

**Value Congruence.** As we discuss trustworthiness, value congruence clearly emerges as a vital factor as well. This represents the degree to which organizations see a similarity between their own values and the values demonstrated by the organization (Koerber, 2014). This is why an organization's culture and its social responsibility initiatives should be considered as contributing to an organization's crisis capacity because as long as the organization's behavior is well-aligned with the values that its

stakeholders hold, then the organization has more freedom and flexibility to manage issues and risks that emerge without threatening its relationship to its stakeholders.

Value congruence also helps to explain why organizations can experience crises but seemingly few negative effects of those crises – if the organization's response is aligned with the stakeholder's values, then the crisis does not threaten the relationship. For example, several years ago, Bayer Aspirin had a short-lived campaign in the United States targeting women who have back pain as part of its broader campaign for "all of life's little pains." As a way to try to build the campaign's narrative, Bayer explained that it was natural for mothers to experience back pain and was evidenced by picking up children, doing household chores, and so on. They tried to inject a bit of humor into the campaign by using a double-entendre to refer to "all of life's little pains" as being both the back pain and the toddlers depicted in the commercial. Several hundred moms signed a letter of complaint to the company suggesting they were offended at the suggestion their children could be pains – apparently, they were unmoved by the humor. Instead of dismissing their complaint, the company issued a personal apology to each of the signatories and pulled the campaign. Though this cost them money, the same moms' group paid them back with praise and appreciation of the company's sensitivity to their concerns. In this way, what Bayer successfully communicated to this group and to the broader American public was that the company genuinely cared about the same things their consumers did and even if it cost them money, they would protect their consumers' interests. In short, their management of the issue demonstrated strong value congruence and instead of damaging the relationship, improved it.

**Identification.** When stakeholders view their relationship with an organization as satisfactory (Ki & Brown, 2013), they will often feel loyal to the organization (Helm & Tolsdorf, 2013). This is akin the concept of identification. Though identification is usually framed in terms of how members of an organization feel about it, in a modern and social media context, it is just as applicable to other stakeholders as well. Dutton, Dukerich, and Harquail (1994) explored the self-organization connection finding that no matter the stakeholder – internal or external – having a positive image led to greater stakeholder attachment to the organization.

Organizational identification focuses on how attached stakeholders are to the organization. Attachment forms when the stakeholder connects their own self-concept (e.g., values) with the organization. This produces perceptions of mutual connectedness, loyalty, and satisfaction with the organization.

This grounds an identification continuum where at its most positive, stakeholders see themselves cooperating with the organization in the range of ways to co-create the value of the organization in the public sphere (Chandler & Lusch, 2015; Jaakkola & Alexander, 2014). Alternatively, if the identification is negative, stakeholders may see themselves as adversaries, actively working against the brand (Swaminathan, Page, & Gurhan-Canli, 2007). In managing risks and issues, one challenge is to ensure that stakeholders view their relationship to the organization as cooperative and not adversarial.

## Using SRM as a Diagnostic Tool to Guide Strategic Decision-Making

While I like to think of the stakeholder relationship model as a love triangle focusing on two-way relationships between stakeholders, issues, and the organization, if we are trying to understand the factors that build up stakeholder expectations for its relationship with an organization, we can also view the SRM as a recursive process as well. Figure 5 demonstrates what I mean. If we start on the left with the stakeholder, then we can better understand when risks and issues emerge, stakeholders' existing attitudes, experience with the organization, perceptions of susceptibility, efficacy, and reaction to the issue or risk provide a context for how they react to the risk. Based on their existing attitudes, stakeholders make judgments about the issue and the organization's relationship to that issue in the middle box assessing blame, evaluating the severity of the crisis, and then judging the organization's position on the crisis. Those attitudes then inform their judgments about the organization and their relationship to the organization in the final box on the right, which then loops around to influence future stakeholder attitudes.

When crises happen, we know that they can affect stakeholder's attitudes about issues and organizations, but the question is what happens

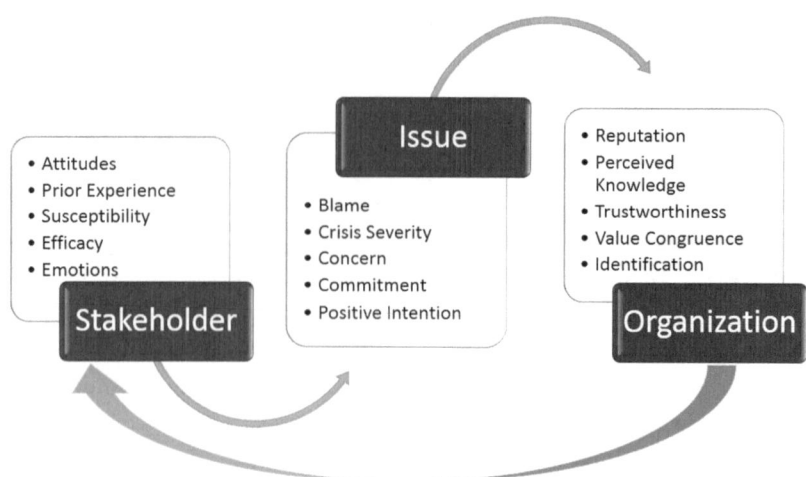

Fig. 5: Thinking about the SRM as a Recursive Process

as a result of changed stakeholder attitudes? Throughout the chapter I have argued, the extent to which an organization is successful in managing issues and risk mitigation is a likely indicator of its success in managing stakeholder relationships (Bendheim, Waddock, & Graves, 1998; Brown & White, 2010; Diers-Lawson, 2017b; Sellnow & Brand, 2001). Moreover, the relationships among external stakeholders can represent a measure of that organization's strengths and weaknesses as they are linked to the relationships between an organization's social, ethical, and financial performances – known as the triple bottom line (Barnett, 2019; Graafland & Smid, 2019).

Additionally, the link between stakeholder evaluations of organizations and strategic decision-making by organizations has been discussed in three ways. First, the extent to which organizations are able to manage stakeholder "activism" on issues that matter to stakeholders reflects an acknowledgment that economics is socially embedded (Jin & Drozdenko, 2010; Shepard, Betz, & O'Connell, 1997). Therefore, organizations that are likely to be successful consider the reactions of their stakeholders in making strategic decisions. Second, a study by Waddock and Graves (1997) demonstrated that an organization's management success was linked to

its performance in managing perceptions of the quality of its innovations or actions with critical stakeholders – specifically in this case the owners, employees, customers, and surrounding community. Third an organization's success is also contingent upon its ability to build trust with its stakeholders and act ethically (Nielsen & Bartunek, 1996; Valentini, 2015).

Thus, one of the reasons to manage stakeholder relationships is so that organizations can be perceived as engaging their social responsibilities (Bendheim et al., 1998). For this reason, I argue that SRM is a diagnostic and predictive tool for organizations to use to improve their decision-making and strategy for managing issues, reducing risk, and improving the likelihood of successful crisis response in the event a crisis is triggered.

## References

Ajzen, I. (2005). *Explaining intentions and behavior: Attitudes, personality, and behavior* (Vol. 2nd). Berkshire, England: McGraw-Hill Education.

Al-Hyari, K., Alnsour, M., Al-Weshah, G., & Haffar, M. J. J. o. I. M. (2012). Religious beliefs and consumer behaviour: from loyalty to boycotts. 3(2), 155–174.

An, S. K., Park, D. J., Cho, S., & Berger, B. (2010). A cross-cultural study of effective organizational crisis response strategy in the United States and South Korea. *International Journal of Strategic Communication, 4*(4), 225–243.

Argenti, P. (2002). Crisis communication: Lessons from 9/11. *Harvard Business Review*, 2002 (December), 103–109.

Austin, L., & Jin, J. (2015). Social Media and Crisis Communication Explicating the Social-Mediated Crisis Communication Model. In A. Dudo & L. Kahlor (Eds.), *Strategic Communication New Agendas in Communication*. New York: Routledge.

Austin, L. L., Liu, B. F., & Jin, Y. (2014). Examining signs of recovery: How senior crisis communicators define organizational crisis recovery. *Public Relations Review, 40*(5), 844–846. doi: http://dx.doi.org/10.1016/j.pubrev.2014.06.003.

Avraham, E. (2015). Destination image repair during crisis: Attracting tourism during the Arab Spring uprisings. *Tourism Management, 47*, 224–232.

Bandura, A. (1986). *Social Foundations of Thought and Action: A Social Cognitive Theory*. Englewood Cliffs, NJ: Prentice Hall.

Barnett, M. L. (2019). The business case for corporate social responsibility: A critique and an indirect path forward. *Business & Society, 58*(1), 167–190.

Bendheim, C. L., Waddock, S. A., & Graves, S. B. (1998). Determining best practice in corporate-stakeholder relations using data envelopment analysis: An industry-level study. *Business and Society, 37*(3), 306–339.

Benoit, W. L. (1995). Sears' repair of its auto service image: Image restoration discourse in the corporate sector. *Communication Studies, 46*(1–2), 89–105.

Blombäck, A., & Scandelius, C. (2013). Corporate heritage in CSR communication: a means to responsible brand image?. *Corporate Communications: An International Journal, 18*(3), 362–382.

Botan, C. (1997). Ethics in strategic communication campaigns: The case for a new approach to public relations *The Journal of Business Communication, 34*(2), 188–203.

Bowen, S. A., & Zheng, Y. (2015). Auto recall crisis, framing, and ethical response: Toyota's missteps. *Public Relations Review, 41*(1), 40–49. doi: http://dx.doi.org/10.1016/j.pubrev.2014.10.017.

Brown, K. A., & White, C. L. (2010). Organization–public relationships and crisis response strategies: Impact on attribution of responsibility. *Journal of Public Relations Research, 23*(1), 75–92.

Brown, N. A., & Billings, A. C. (2013). Sports fans as crisis communicators on social media websites. *Public Relations Review, 39*(1), 74–8

Brown, N. A., Brown, K. A., & Billings, A. C. (2015). "May no act of ours bring shame" Fan-enacted crisis communication surrounding the Penn State sex abuse scandal. *Communication & Sport, 3*(3), 288–311. doi: 10.1177/2167479513514387.

Brummette, J., & Sisco, H. F. (2015). Using Twitter as a means of coping with emotions and uncontrollable crises. *Public Relations Review, 41*(1), 89–96. doi: 10.1016/j.pubrev.2014.10.009.

Brynielsson, J., Johansson, F., Jonsson, C., & Westling, A. (2014). Emotion classification of social media posts for estimating people's

reactions to communicated alert messages during crises. *Security Informatics, 3*(1), 1–11. doi: 10.1186/s13388-014-0007-3.

Carroll, C. (2009). Defying a reputational crisis–Cadbury's salmonella scare: Why are customers willing to forgive and forget? *Corporate Reputation Review, 12*(1), 64–82.

Chandler, J. D., & Lusch, R. F. (2015). Service systems: A broadened framework and research agenda on value propositions, engagement, and service experience. *Journal of Service Research, 18*(1), 6–22. doi: 10.1177/1094670514537709.

Chen, N. (2009). Institutionalizing public relations: A case study of Chinese government crisis communicationon the 2008 Sichuan earthquake. *Public Relations Review, 35*, 187–198.

Choi, Y., & Lin, Y. H. (2009). Consumer response to crisis: Exploring the concept of involvement in Mattel product recalls. *Public Relations Review, 35*(1), 18–22.

Claes, F., Rust, R. T., & Dekimpe, M. G. (2010). The effect of consumer satisfaction on consumer spending growth. *Journal of Marketing Research, 47*(1), 28–35. doi: 10.1509/jmkr.47.1.28.

Claeys, A.-S., & Cauberghe, V. (2015). The role of a favorable pre-crisis reputation in protecting organizations during crises. *Public Relations Review, 41*(1), 64–71. doi: 10.1016/j.pubrev.2014.10.013.

Claeys, A., Cauberghe, V., & Vyncke, P. (2010). Restoring reputations in times of crisis: An experimental study of the situational crisis communication theory and the moderating effects of locus of control. *Public Relations Review, 36*(3), 256–262. doi: 10.1016/j.pubrev.2010.05.004.

Comfort, L. K. (2007). Crisis management in hindsight: Cognition, communication, coordination, and control. *Public Administration Review, 67*(s1), 189–197.

Connolly, T., Conlon, E. J., & Deutsch, S. J. (1980). Organizational effectiveness: A multiple-constituency approach. *Academy of Management Journal, 5*(2), 211–217.

Coombs, W. T. (2004). Impact of past crises on current crisis communication: Insights from Situational Crisis Communication Theory. *The Journal of Business Communication, 41*(3), 265–290.

Coombs, W. T. (2007). Attribution theory as a guide for post-crisis communication research. *Public Relations Review, 33*(2), 135–139.

Coombs, W. T., & Holladay, S. J. (1996). Communication and attributions in a crisis: An experimental study in crisis communication. *Journal of Public Relations Research, 8*(4), 279–295.

Coombs, W. T., & Holladay, S. (2007). The negative communication dynamic: Exploring the impact of stakeholder affect on behavioral intentions. *Journal of Communication Management, 11*(4), 300–312.

Coombs, W. T., & Holladay, S. J. (2015). Public relations' "relationship identity" in research: Enlightenment or illusion. *Public Relations Review, 41*(5), 689–695. doi: http://dx.doi.org/10.1016/j.pubrev.2013.12.008.

Covello, V. T., Peters, R. G., Wojtecki, J. G., & Hyde, R. C. (2001). Risk communication, the West Nile virus epidemic, and bioterrorism: responding to the commnication challenges posed by the intentional or unintentional release of a pathogen in an urban setting. *Journal of Urban Health, 78*(2), 382–391.

Croucher, S. M. (2013). Religion and conflict: An emerging field of inquiry. In J. G. Oetzel & S. Ting-Toomey (Eds.), *The SAGE handbook of conflict communication: Integrating theory, research, and practice* (pp. 563–584). CA: Sage Publishing.

Curtin, P. A., Gallicano, T., & Matthews, K. (2011). Millennials' approaches to ethical decision making: A survey of young public relations agency employees. *Public Relations Journal, 5*(2), 1–22.

De Bruycker, I., & Walgrave, S. (2014). How a new issue becomes an owned issue. Media coverage and the financial crisis in Belgium (2008–2009). *International Journal of Public Opinion Research, 26*(1), 86–97.

de Fatima Oliveira, M. (2013). Multicultural environments and their challenges to crisis communication. *Journal of Business Communication*, doi: 10.1177/0021943613487070.

Diers, A. R. (2012). Reconstructing stakeholder relationships using 'corporate social responsibility' as a response strategy to cases of corporate irresponsibility: The case of the 2010 BP spill in the Gulf of Mexico. In R. Tench, W. Sun, & B. Jones (Eds.), *Corporate Social Irresponsibility: A Challenging Concept* (Vol. 4, pp. 177–206). United Kingdom: Emerald.

Diers-Lawson, A. (2017a). Crisis Communication Oxford Research Encyclopedia of Communication: Oxford University Press. Retrieved from http://communication.oxfordre.com/view/10.1093/acrefore/9780190228613.001.0001/acrefore-9780190228613-e-397. doi: 10.1093/acrefore/9780190228613.013.397.

Diers-Lawson, A. (2017b). Will they like us when they're angry? Antecedents and indicators of strong emotional reactions to crises among stakeholders. In S. M. Croucher, B. Lewandowska-Tomaszczyk, & P. Wilson (Eds.), *Conflict, Mediated Message, and Group Dynamics* (pp. 81–136). Lanham, MD: Lexington Books.

Dilenschneider, R. L., & Hyde, R. C. (1985). Crisis communications: Planning for the unplanned. *Business Horizons, 28*(1), 35–38.

Dutton, J. E., Dukerich, J. M., & Harquail, C. V. (1994). Organizational images and member identification. *Administrative Science Quarterly, 39*(2), 239–264.

Einwiller, S. A., Carroll, C. E., & Korn, K. (2010). Under what conditions do the news influence corporate reputation? The roles of media dependency and need for orientation. *Corporate Reputation Review, 12*(4), 299–315.

Elsbach, K. D., Sutton, R. I., & Principe, K. E. (1998). Averting expected challenges through anticipatory impression management: A study of hospital billing. *Organization Science, 9*(1), 68–86.

Falkheimer, J., & Heide, M. (2015). Trust and brand recovery campaigns in crisis: Findus Nordic and the Horsemeat Scandal. *International Journal of Strategic Communication, 9*(2), 134–147. doi: 10.1080/1553118X.2015.1008636.

Folkes, V. S., & Karmins, M. A. (1999). Effects of information about firms' ethical and unethical actions on consumers' attitudes. *Journal of Consumer Psychology, 8*(3), 243–259.

Freberg, K., & Palenchar, M. J. (2013). Convergence of digital negotiation and risk challenges: Strategic implications of social media for risk and crisis communications *Social Media and Strategic Communications* (pp. 83–100). London: Palgrave Macmillan.

Freeman, R. E. (1994). *Ethical theory and business.* Englewood Cliffs, NJ: Prentice-Hall.

Freundberg, W. R. (1988). Perceived risk, real risk: Social science and the art of probabilistic risk assessment. *Science, 242*, 44–49.

Frooman, J. (1999). Stakeholder influence strategies. *Academy of Management Journal, 24*(2), 191–205.

Goby, V. P., & Nickerson, C. (2015). The impact of culture on the construal of organizational crisis: perceptions of crisis in Dubai. *Corporate Communications: An International Journal, 20*(3), 310–325.

Graafland, J., & Smid, H. (2019). Decoupling among CSR policies, programs, and impacts: An empirical study. *Business & Society, 58*(2), 231–267.

Gurman, T. A., & Ellenberger, N. (2015). Reaching the global community during disasters: findings from a content analysis of the organizational use of Twitter after the 2010 Haiti earthquake. *Journal of Health Communication, 20*(6), 687–696. doi: 10.1080/10810730.2015.1018566.

Hajibaba, H., Gretzel, U., Leisch, F., & Dolnicar, S. (2015). Crisis-resistant tourists. *Annals of Tourism Research, 53*, 46–60. doi: 10.1016/j.annals.2015.04.001.

Haley, E. (1996). Exploring the construct of organization as source: Consumers' understandings of organizational sponsorship of advocacy advertising. *Journal of Advertising, 25*, 19–36.

Hargis, M., & Watt, J. D. (2010). Organizational perception management: A framework to overcome crisis events. *Organizational Development Journal, 28*(1), 73–87.

Haruta, A., & Hallahan, K. (2003). Cultural issues in airline crisis communications: A Japan-US comparative study. *Asia Journal of Communication, 13*(2), 122–150.

Hayes, D., & Patton, M. (2001). Proactive crisis-management strategies and the archaeological heritage. *International Journal of Heritage Studies, 7*(1), 37–58.

Heath, R. (1998). Dealing with the complete crisis—the crisis management shell structure. *Safety Science, 30*(1), 139–150.

Heath, R. L. (2002). Issues management: Its past, present, and future. *Journal of Public Affairs, 2*(2), 209–214.

Heath, R. L., & Millar, D. P. (2004). A rhetorical approach to crisis communication: Management, communication processes, and strategic responses. In D. P. Millar & R. L. Heath (Eds.), *Responding to Crisis: A Rhetorical Approach to Crisis Communication* (pp. 1–18). Mahwah, NJ: Lawrence Erlbaum Associates.

Heath, R. L., & Palenchar, M. J. (2009). *Strategic Issues Management* (2nd ed.). Thousand Oaks, CA: Sage.

Heinze, J., Uhlmann, E. L., & Diermeier, D. (2014). Unlikely allies: Credibility transfer during a corporate crisis. *Journal of Applied Social Psychology, 44*(5), 392–397. doi: 10.1111/jasp.12227.

Helm, S., & Tolsdorf, J. (2013). How does corporate reputation affect customer loyalty in a corporate crisis? *Journal of Contingencies and Crisis Management, 21*(3), 144–152. doi: 10.1111/1468-5973.12020.

Hoffmann, J., Röttger, U., Ingenhoff, D., & Hamidati, A. (2015). The rehabilitation of the "nation variable" Links between corporate communications and the cultural context in five countries. *Corporate Communications: An International Journal, 20*(4), 483–499.

Hong, S., Yang, S., & Rim, H. (2010). The influence of corporate social responsibility and customer–company identification on publics' dialogic communication intentions. *Public Relations Review, 36*(2), 196–198. doi: 10.1016/j.pubrev.2009.10.005.

Horton, T. R. (1988). Crisis management. *Management Review, 77*(9), 5–8.

Huang, Y. (2008). Trust and relational commitment in corporate crises: The effects of crisis communicative strategy and form of crisis response. *Journal of Public Relations Research, 20*(297–327).

Huber, F., Vollhardt, K., Matthes, I., & Vogel, J. (2010). Brand misconduct: Consequences on consumer-brand relationships. *Journal of Business Research, 63*, 1113–1120. doi: 10.1016/j.jbusres.2009.10.006.

Hyvärinen, J., & Vos, M. (2015). Developing a conceptual framework for investigating communication supporting community resilience. *Societies, 5*(3), 583–597. doi: 10.3390/soc5030583.

Jaakkola, E., & Alexander, M. (2014). The role of customer engagement behavior in value co-creation: A service system

perspective. *Journal of Service Research, 17*(3), 247–261. doi: 10.1177/1094670514529187.

Jaques, T. (2009). Issue and crisis management: Quicksand in the definitional landscape. *Public Relations Review, 35*(3), 280–286.

Jaques, T. (2015). *Issues and Crisis Management: Exploring Issues, Crises, Risk and Reputation*. Melbourne: Oxford University Press.

Jeong, S. H. (2009). Public's Responses to an oil spill accident: A test of the attribution theory and situational crisis communication theory. *Public Relations Review, 35*(3), 307–309.

Jin, Y. (2009). The effects of public's cognitive appraisal of emotions in crises on crisis coping and strategy assessment. *Public Relations Review, 35*(3), 310–313.

Jin, Y. (2010). Making sense sensibly in crisis communication: How publics' crisis appraisals influence their negative emotions, coping strategy preferences, and crisis response acceptance. *Communication Research, 37*(4), 522–552. doi: 10.1177/0093650210368256.

Jin, Y. (2014). Examining publics' crisis responses according to different shades of anger and sympathy. *Journal of Public Relations Research, 26*(1), 79–101. doi: 10.1080/1062726X.2013.848143.

Jin, K. G., & Drozdenko, R. G. (2010). Relationships among perceived organizational core values, corporate social responsibility, ethics, and organizational performance outcomes: An empirical study of information technology professionals. *Journal of Business Ethics, 92*, 341–359.

Jin, Y., Liu, B. F., Anagondahalli, D., & Austin, L. (2014). Scale development for measuring publics' emotions in organizational crises. *Public Relations Review, 40*(3), 509–518. doi: http://dx.doi.org/10.1016/j.pubrev.2014.04.007.

Jindal, S., Laveena, L., & Aggarwal, A. (2015). A comparative study of crisis management-Toyota V/S General Motors. *Scholedge International Journal of Management & Development, 2*(6), 1–12.

Johansson, A., & Härenstam, M. (2013). Knowledge communication: A key to successful crisis management. *Biosecurity and Bioterrorism: Biodefense Strategy, Practice, and Science, 11*(S1), S260–S263. doi: 10.1089/bsp.2013.0052.

Kash, T. J., & Darling, J. R. (1998). Crisis management: Prevention, diagnosis and intervention. *Leadership & Organization Development Journal, 19*(4), 179–186.

Kernisky, D. A. (1997). Proactive crisis management and ethical discourse: Dow Chemical's issues management bulletins 1979–1990. *Journal of Business Ethics, 16*(8), 843–853.

Ki, E. J., & Brown, K. A. (2013). The effects of crisis response strategies on relationship quality outcomes. *Journal of Business Communication, 50*(4), 403–420. doi: 10.1177/0021943613497056.

Kim, H. J., & Cameron, G. T. (2011). Emotions matter in crisis: The role of anger and sadness in the publics' response to crisis news framing and corporate crisis response. *Communication Research*, 0093650210385813.

Kim, J. T., & Lee, W. H. (2015). Dynamical model for gamification of learning (DMGL). *Multimedia Tools and Applications, 74*(19), 8483–8493.

Kim, P. H., Ferrin, D. L., Cooper, C. D., & Dirks, K. T. (2004). Removing the shadow of suspicion: The effects of apology versus denial for repairing competence-versus integrity-based trust violations. *Journal of Applied Psychology, 89*(1), 104.

King, G. I. (2002). Crisis management and team effectiveness: A closer examination. *Journal of Business Ethics, 41*, 235–249.

Kim, S. (2013). Corporate ability or virtue? Relative effectivenss of prior corporate associations in times of crisis. *International Journal of Strategic Communication, 7*(4), 241–256. doi: 10.1080/1553118X.2013.824886.

Kim, S. (2014). The role of prior expectancies and relational satisfaction in crisis. *Journalism & Mass Communication Quarterly, 91*(1), 139–158. doi: 10.1177/1077699013514413.

Knight, G., & Greenberg, J. (2002). Promotionalism and subpolitics: Nike and its labor critics. *Management Communication Quarterly, 15*(4), 541–570.

Koerber, D. (2014). Crisis communication response and political communities: The unusual case of Toronto mayor Rob Ford. *Canadian journal of communication, 39*(3).

Kramer, R. M., & Lewicki, R. J. (2010). Repairing and enhancing trust: Approaches to reducing organizational trust deficits. *Academy of Management Annals, 4*(1), 245–277.

Lacey, R., Kennett-Hensel, P. A., & Manolis, C. (2015). Is corporate social responsibility a motivator or hygiene factor? Insights into its bivalent nature. *Journal of the Academy of Marketing Science, 42*(3). doi: 10.1007/s11747-014-0390-9.

Leonidou, L. C., Leonidou, C. N., & Kvasova, O. (2013). Cultural drivers and trust outcomes of consumer perceptions of organizational unethical marketing behavior. *European Journal of Marketing, 47*(3/4), 525–556.

Ley, B., Ludwig, T., Pipek, V., Randall, D., Reuter, C., & Wiedenhoefer, T. (2014). Information and expertise sharing in inter-organizational crisis management. *Computer Supported Cooperative Work (CSCW), 23*(4–6), 347–387.

Mal, C. I., Davies, G., & Diers-Lawson, A. (2018). Through the looking glass: The factors that influence consumer trust and distrust in brands. *Psychology & Marketing, 35*(12), 936–947.

Maresh, M., & Williams, D. (2007). *Toward an industry-specific crisis response model: A look at the oil crises of British Petroleum and Phillips Petroleum.* Paper presented at the National Communication Association, Chicago, IL.

Massey, J. E., & Larsen, J. (2006). Crisis management in real time: How to successfully plan for and respond to a crisis. *Journal of Promotion Management, 12*(3/4), 63–97. doi: 10.1300/J057v12n0306.

Mayer, R. C., Davis, J. H., & Schoorman, F. D. (1995). An integrative model of organizational trust. *Academy of Management Review, 20*(3), 709–734.

McDonald, L. M., & Cokley, J. (2013). Prepare for anger, look for love: A ready reckoner for crisis scenario planners. *PRism, 10*(1), 1–11.

Meng, M. (1992). Issue life cycle has five stages. *Public Relations Journal, 48*(3), 23.

Mitroff, I., Alpaslan, M. C., & Green, S. E. (2004). Crises as ill-structured messes. *International Studies Review, 6*(1), 165–182.

Molleda, J. C., Connolly-Ahern, C., & Quinn, C. (2005). Cross-national conflict shifting: Expanding a theory of global public

relations management through quantitative content analysis. *Journalism Studies*, 6(1), 87–102.

Moran, R. T., Abramson, N. R., & Moran, S. V. (2014). *Managing Cultural Differences*. London: Routledge.

Mou, Y., & Lin, C. A. (2014). Communicating food safety via the social media the role of knowledge and emotions on risk perception and prevention. *Science Communication*, 36(5), 593–616. doi: 10.1177/1075547014549480.

Nielsen, R. P., & Bartunek, J. M. (1996). Opening narrow, routinized schemata to ethical stakeholder consciousness and action. *Business and Society*, 35(4), 483–520.

Nunamaker, J. F., Weber, E. S., & Chen, M. (1989). Organizational crisis management systems: Planning for intelligent action. *Journal of Management Information Systems*, 5(4), 7–31.

Oles, D. L. (2010). Deny, delay, apologize: The Oprah Winfrey image-defense playbook. *Northwest Journal of Communication*, 39(1), 37–63.

Olofsson, A. (2007). Crisis communication in multicultural societies: A study of municipalities in Sweden. *International Journal of Mass Emergencies and Disasters*, 25(2), 145–172.

Ott, L., & Theunissen, P. (2015). Reputations at risk: Engagement during social media crises. *Public Relations Review*, 41(1), 97–102. doi: http://dx.doi.org/10.1016/j.pubrev.2014.10.015.

Pace, S., Balboni, B., & Gistri, G. (2014). The effects of social media on brand attitude and WOM during a brand crisis: Evidences from the Barilla case. *Journal of Marketing Communications*, 1–14. doi: 10.1080/13527266.2014.966478.

Palmer-Silveira, J. C., & Ruiz-Garrido, M. F. (2014). Examining US and Spanish Annual Reports Crisis Communication. *Business and Professional Communication Quarterly*, 1–17. doi: 10.1177/2329490614543176.

Pang, A., Begam Binte Abul Hassan, N., & Chee Yang Chong, A. (2014). Negotiating crisis in the social media environment: Evolution of crises online, gaining credibility offline. *Corporate Communications: An International Journal*, 19(1), 96–118. doi: http://dx.doi.org/10.1108/CCIJ-09-2012-0064.

Pang, A., Cropp, F., & Cameron, G. T. (2006). Corporate crisis planning: Tensions, issues, and contradictions. *Journal of Communication Management, 10*(4), 371–389.

Park, H., & Cameron, G. T. (2014). Keeping it real exploring the roles of conversational human voice and source credibility in crisis communication via blogs. *Journalism & Mass Communication Quarterly*, 1077699014538827. doi: 10.1177/1077699014538827.

Pearson, C. M., & Clair, J. A. (1998). Reframing crisis management. *Academy of Management Review, 23*(1), 58–76.

Perry, D. C., Taylor, M., & Doerfel, M. L. (2003). Internet-based communication in crisis management. *Management Communication Quarterly, 17*(2), 206–232.

Ping, Q., Ishaq, M., & Li, C. (2015). Product harm crisis, attribution of blame and decision making: An insight from the past. *Journal of Applied Environmental and Biological Sciences, 5*(5), 35–44.

Piotrowski, C., & Guyette, R. W. (2010). Toyota recall crisis: Public attitudes on leadership and ethics. *Organizational Development Journal, 28*(2), 89–97.

Ratten, V., & Ratten, H. (2007). Social cognitive theory in technological innovations. *European Journal of Innovation Management, 10*(1), 90–108. doi: 10.1108/14601060710720564.

Reilly, A. (1987). Are organisations ready for a crisis? *Columbia Journal of World Business, 22*(1), 79–87.

Reilly, A. H. (2008). The role of human resource development competencies in facilitating effective crisis communication. *Advances in Developing Human Resources, 10*(3), 331–351.

Ritchie, B. W. (2004). Chaos, crises and disasters: A strategic approach to crisis management in the tourism industry. *Tourism management, 25*(6), 669–683.

Rovisco, M. (2010). One Europe or several Europes? The cultural logic of narratives of Europe views from France and Britain *Social Science Information, 49*(2), 241–266. doi: 10.1177/0539018409359844.

Samkin, G., Allen, C., & Wallace, K. (2010). Repairing organisational legitimacy: The case of the New Zealand police. *Australasian Accounting Business & Finance Journal, 4*(3), 23–45. doi: 2170715441.

Schwartz, S., & Ben David, A. (1976). Responsibility and helping in an emergency: Effects of blame, ability and denial of responsibility. *Sociometry, 39*(4), 406–415.

Schwarz, A. (2008). Covariation-based causal attributions during organizational crises: Suggestions for extending Situational Crisis Communication Theory (SCCT). *International Journal of Strategic Communication, 2*(1), 31–53.

Schwarz, A. (2012). How publics use social media to respond to blame games in crisis communication: The Love Parade tragedy in Duisburg 2010. *Public Relat. Rev., 38*(3), 430–437. doi: 10.1016/j.pubrev.2012.01.009.

Scollon, C. N., Diener, E., Oishi, S., & Biswas-Diener, R. (2004). Emotions across cultures and methods. *Journal of Cross-Cultural Psychology, 35*(3), 304–326.

Seeger, M. W., & Griffin-Padgett, D. R. (2010). From image restoration to renewal: Approaches to understanding postcrisis communication. *The Review of Communication, 10*(2), 127–141. doi: 10.1080/1535859090354526.

Seeger, M. W., Heyart, B., Barton, E. A., & Bultnyck, S. (2001). Crisis planning and crisis communication in the public schools: Assessing post Columbine responses. *Communication Research Reports, 18*(4), 375–383.

Sellnow, D. D., Lane, D., Littlefield, R. S., Sellnow, T. L., Wilson, B., Beauchamp, K., & Venette, S. (2015). A receiver-based approach to effective instructional crisis communication. *Journal of Contingencies and Crisis Management, 23*(3), 149–158. doi: 10.1111/1468-5973.12066.

Sellnow, T. L., & Brand, J. D. (2001). Establishing the structure of reality for an industry: Model and anti-model arguments as advocacy in Nike's crisis communication. *Journal of Applied Communication Research, 29*(3), 278–296.

Shanahan, F., & Seele, P. (2015). Shorting Ethos: Exploring the relationship between Aristotle's Ethos and Reputation Management. *Corporate Reputation Review, 18*(1), 37–49. doi: 10.1057/crr.2014.19.

Shepard, J. M., Betz, M., & O'Connell, L. (1997). The proactive corporation: Its nature and causes. *Journal of Business Ethics, 16*(10), 1001–1011.

Shockley-Zalabak, P. S., Morreale, S., & Hackman, M. (2010). *Building the high-trust organization: Strategies for supporting five key dimensions of trust* (Vol. 7). CA: John Wiley & Sons.

Siew-Yoong Low, Y., Varughese, J., & Pang, A. (2011). Communicating crisis: How culture influences image repair in Western and Asian governments. *Corporate Communications: An International Journal, 16*(3), 218–242.

Sisco, H. F., Collins, E. L., & Zoch, L. M. (2010). Through the looking glass: A decade of Red Cross crisis response and situational crisis communication theory. *Public Relations Review, 36*(1), 21–27.

Sohn, Y., & Lariscy, R. W. (2014). Understanding reputational crisis: Definition, properties, and consequences. *Journal of Public Relations Research, 26*(1), 23–43. doi: 10.1080/1062726X.2013.795865.

Stacks, D. W. (2004). Crisis management: Toward a multidimension model of public relations. In D. P. Millar & R. L. Heath (Eds.), *Responding to Crisis: A Rhetorical Approach to Crisis Communication* (pp. 37–49). Mahwah, NJ: Lawrence Erlbaum Associates.

Sung-Un, Y., Minjeong, K., & Johnson, P. (2010). Effects of narratives, openness to dialogic communication, and credibility on engagement in crisis communication through organizational blogs. *Communication Research, 37*(4), 473–497. doi: 10.1177/0093650210362682.

Swaminathan, V., Page, K. L., & Gurhan-Canli, Z. (2007). "My" brand or "our" brand: The effects of brand relationship dimensions and self-construal on brand evaluations. *Journal of Consumer Research, 34*(2), 248–259. doi: 10.1086/518539.

Taylor, M. (2000). Cultural variance as a challenge to global public relations: A case study of the Coca-Cola scare in Europe. *Public Relations Review, 26*(3), 277–293.

Trettin, L., & Musham, C. (2000). Is trust a realistic goal of environmental risk communication? *Environment and Behavior, 32*(3), 410–427.

Uccello, C. (2009). Social interest and social responsibility in contemporary corporate environments. *Journal of Individual Psychology, 65*(4), 412–419.

Ursanu, R. (2012). Models for ascertaining the religiosity's effects on the consumer's behaviour. *Anuarul Institutului de Cercetari Economice*, *21*(1), 17.

Utz, S., Schultz, F., & Glocka, S. (2013). Crisis communication online: How medium, crisis type and emotions affected public reactions in the Fukushima Daiichi nuclear disaster. *Public Relations Review*, *39*(1), 40–46.

Valentini, C. (2015). Is using social media "good" for the public relations profession? A critical reflection. *Public Relations Review*, *41*(2), 170–177. doi: http://dx.doi.org/10.1016/j.pubrev.2014.11.009.

van der Meer, T. G., & Verhoeven, J. W. (2014). Emotional crisis communication. *Public Relations Review*, *40*(3), 526–536. doi: http://dx.doi.org/10.1016/j.pubrev.2014.03.004.

van Zoonen, W., & van der Meer, T. (2015). The importance of source and credibility perception in times of crisis: Crisis communication in a socially mediated era. *Journal of Public Relations Research*, *27*(5), 371–388. doi: 10.1080/1062726X.2015.1062382.

Waddock, S. A., & Graves, S. B. (1997). Quality of management and quality of stakeholder relations: Are they synonymous? *Business and Society*, *36*(3), 250–280.

Weber, M., Erickson, S. L., & Stone, M. (2011). Corporate reputation management: Citibank's use of image restoration strategies during the U.S. banking crisis. *Journal of Organizational Culture, Communication and Conflict*, *15*(2), 35–55. doi: 2439571401.

Weiner, B. (1985). An attributional theory of achievement motivation and emotion. *Psychological Review*, *92*(4), 548.

Weiner, B. (2006). *Social motivation, justice, and the moral emotions: An attributional approach.* New Jersey: Psychology Press.

Xu, K., & Li, W. (2013). An ethical stakeholder approach to crisis communication: A case study of Foxconn's 2010 employee suicide crisis. *Journal of Business Ethics*, *117*(2), 371–386. doi: 10.1007/s10551-012-1522-0.

Yin, J., Feng, J., & Wang, Y. (2015). Social media and multinational corporations' corporate social responsibility in China: The case of ConocoPhillips Oil Spill incident. *IEEE Transactions on Professional Communication*, *58*(2), 135–153. doi:10.1109/TPC.2015.2433071.

Yum, J. Y., & Jeong, S.-H. (2014). Examining the public's responses to crisis communication from the perspective of three models of attribution. *Journal of Business and Technical Communication*, 1050651914560570. doi: 10.1177/1050651914560570.

Zeri, P. (2014). Political blogosphere meets off-line public sphere: Framing the public discourse on the Greek crisis. *International Journal of Communication, 8*, 17.

Zhao, Y. (2014). Communication, crisis, & global power shifts: An introduction. *International Journal of Communication, 8*, 26.

Camelia Cmeciu

# Risk Communication and Message Convergence in Product Recalls. Case Study: The Brădet Dairy Products and an *E.Coli* Outbreak

**Abstract** This study seeks to apply a message-centered approach to the online content generated by the Romanian public authorities, the Lactate Brădet company and the online users throughout the *E.coli* outbreak in Romania in 2016. This study had a twofold purpose: (a) to identify the frequency and co-occurrence of the best practices for risk communication within the posts of the Brădet company, of the Minister of Agriculture and of the National Sanitary Veterinary and Food Safety Authority; (b) to identify the frequency and co-occurrence of the levels of interpretation within the online users' comments. The following clusters emerged from the analysis, whereas the Brădet company focused on "confidence regain" and "participative rebirth," and the Romanian public authorities construed the meaning on (misunderstood) "'transparency" and "morality." The public assessment was clearly polarized. Online users expressed their "trust" in the Lactate Brădet company and denounced the "conspiracy" between the government and the foreign dairy producers whereas they focused on the "multifaceted incompetence" of the Romanian public authorities.

**Keywords:** risk communication, message-centered approach, cluster analysis, best practices, levels of interpretation

## 1. Introduction

Effective risk communication involves various levels of ambiguity and uncertainty. The beginning of the year 2016, in Romania, brought high levels of uncertainty related to the origin of the *E.coli* bacteria, which was supposed to have caused the hemolytic uremic syndrome (HUS) to a high number of babies. By April 16, 2016, three babies died in the hospitals from Arges County[1] and the authorities did not know the cause of their death exactly. Within this context of fright and doubt, the Minister of

---

[1] https://evz.ro/inca-un-copil-din-arges-mort-in-cazul-infectatiei-cu-ecoli.html, accessed October 20, 2018.

Agriculture (Achim Irimescu) claimed on February 29, 2016, that a national dairy company, Lactate Brădet, was to be blamed for the illness of the Romanian children with the HUS since 20 kilograms of cheese made of cow milk, produced by this company was infested with the *E.coli* bacteria, which caused the UHS. The Arges Health Public Direction confirmed that three of the Brădet employees were infected with the *E.coli* bacteria.[2] Meanwhile, some journalists revealed that the cheese presumedly infested coming from the Lactate Brădet was produced on February 22, 2016, and the babies from the Arges county died before this date.[3]

The manager (Marius Badea) of the dairy company recalled the products and insisted that all the necessary tests should be run. The results of the tests showed that the genetic profile of the *E.coli* strains taken from the patients and from the Brădet dairy were not identical.[4] In an interview, Marius Badea highlighted that the three employees could not have infested the cheese since they did not work in the packing department where employees touch the cheese (Cioacă, Briciu, 2017, p. 308). Throughout this time, the spokesman of the Lactate Brădet was the manager, and the main channel of communication was Facebook. After the results showed that the Lactate Brădet was not the cause of the children's illnesses, Marius Badea decided to turn the company into Brădet Romanesc S.A., where Romanians could become shareholders by donating on the crowdfunding platform, sprijina.ro.[5] Within two months since its launching, 212 people invested in this project and around 25,000 euros were raised out of 2,000,000 euros (Cioacă, Briciu, 2017, p. 314). A greater support for the Lactate Brădet was shown on the Facebook page. The level of engagement significantly grew from 2,984 followers

---

2  https://www.romaniajournal.ro/new-accusations-related-to-Brădet-cheese-3-employees-diagnosed-with-ecoli-romanian-14-baby-hospitalised-in-italy-with-food-poisoning/, accessed November 19, 2018.
3  https://agrointel.ro/50455/argumentul-pentru-care-lotul-de-branza-de-la-lactate-Brădet-nu-putea-cauza-moartea-bebelusilor/, accessed October 20, 2018.
4  https://www.romaniajournal.ro/cantacuzino-institute-Brădet-cheese-and-chicken-have-not-caused-the-childrens-illness/, accessed October 20, 2018.
5  https://www.sprijina.ro/cauze/Brădetromanesc, accessed December 3, 2018.

(March 1, 2016) to 21,159 followers (March 7, 2016) and the four posts triggered 4,103 comments, 41,299 likes and 19,414 shares.[6]

Following Sellnow et al.'s viewpoint that "risk communication must consist of an interactive process where all parties are given access to multiple messages" (2009, p. 17), I will go beyond an agency approach, and I will employ what Heath and Palenchar (2016, p. 441) identify as a collaborative perspective. I aim at identifying the points of convergence that serve as means for making sense of the Lactate Brădet product recall. The study will focus on the analysis of the best practices for risk communication as they were used by the Lactate Brădet company, the Ministry of Agriculture and the National Sanitary Veterinary and Food Safety Authority (NSVFSA), and insights into the ways in which meanings were construed in the online users' comments to the Facebook posts of the Lactate Brădet manager and to those of the Romanian Minister of Agriculture.

## 2. Risk Communication and the Message Convergence Framework

Prevention and reaction are the two keywords that highlight what Finn Frandsen and Winni Johansen (2017) claim: "Risk society and crisis society are two sides of the same coin" (p. 21). Thus, the manifestation of risks will eventually trigger the occurrence of crises. The issue of risk has been tackled upon by various scholars who used different approaches, ranging from a sociological approach (Ulrich Beck) to a psychometric approach (Paul Slovic, Baruch Fischhoff, Kasperson and Kasperson) or to an anthropological approach (Mary Douglas). Whereas the psychological approach mainly focuses on the idea that a risk is subjectively experienced, the anthropological and sociological approaches claim that risk itself is a "collective construct." Thus, dangers are "selected for public concern according to the strengths and direction of social criticism" (Douglas, Wildavsky, 2010, p. 18) and risks are socially and culturally contextual,

---

6 http://www.facebrands.ro/blog/2016/03/lactate-Brădet-evolutie-atipica-categoria-pagini-facebook-din-industria-lactate-nivel-engagement/, accessed December 3, 2018.

thus becoming an accepted way of life, a "systematic way of dealing with hazards and insecurities induced and introduced by modernization itself" (Beck, 1992, p. 21).

On the one hand, the social amplification of risk framework developed within the psychological approach attempts to explain why some risks, considered minor by experts, may trigger strong public concerns and may have a significant impact upon a society. This conceptual framework claims that the subjective assessment of risk depends on various psychological, social, cultural factors that may have an amplification effect on an individual's public reaction to risk. On the other hand, a sociological approach links risks to a social production of wealth: "the social production of wealth is systematically accompanied by the social production of risks" (Beck, 1992, p. 19). This new way of life brings forth "various types of *anticipative risk behavior* at the personal, the organizational and the societal level" (Frandsen, Johansen, 2017, p. 29), thus placing an emphasis on the generalization of risk awareness within various areas of society. The future-oriented risk awareness related to the active role of preventers, played by us as individuals, is also present in a public relations approach to risk. According to M. Palenchar and R.L. Heath (2007, p. 127), risk communication is "a tool for communicating values and identities as much as being about the awareness, attitudes and behaviors related to the risk itself [...] At its best, risk communication can be used to increase awareness and understanding of emergency response measures, heighten [...] appropriate levels of vigilance [...] in the community, and work to adjust behavioral intentions [...]."

Public relations bring the dialogic perspective on risk communication, which "[...] provides the opportunity to understand and appreciate stakeholders' concerns related to risks generated by organizations, engage in dialogue to address differences and concerns, carry out appropriate actions that can reduce perceived risks, and create a climate of participatory and effective discourse to reduce friction and increase harmony and mutuality" (Palenchar & Heath, 2007, pp. 121). In the same line, Lundgren and McMakin (2013, p. 2) consider that risk communication, besides being a "subset of technical communication," it involves a two-way dialogue with the public and relies on a scientific process to assess the probability of occurrence and possible outcomes of risk.

Starting from the definition of risk provided by the National Research Council, Sellnow et al. (2009, p. 4) acknowledge that risk communication is "an interactive process of exchange of information and opinion among individuals, groups, and institutions" and that it "involves multiple and competing messages." Thus, Sellnow et al. (2009) do not place their emphasis on behavior trends in general population or on individual behavior, as the above-mentioned approaches do. On the contrary, they encompass a message-centered approach (Sellnow et al., 2009, pp. 10–13), providing a perspective of interacting arguments to risk communication. Starting from Perelman and Olbrechts-Tyteca's concept of plurality (1969), a message convergence framework (Sellnow et al., 2009; Anthony et al., 2013) is developed, thus admitting that stakeholders play an active role in a risk situation by collecting information from various (credible or biased) sources. This framework "illustrates the function of interacting arguments for audiences who observe competing messages" (Anthony et al., 2013, p. 350). Within the situational context of uncertainty and ambiguity that characterizes any risk situation, people try to make sense of contradictory information, by assessing (1) the degree of source credibility and authenticity, (2) the ways in which the arguments coming from various sources interact and (3) the evolution of source and message convergence.

The analyses using a message-centered approach focus on a two-fold stage:

a. An examination of the risk messages issued by the organizations involved in the respective situation, by using the conceptual framework of the best practices of risk communication (Sellnow et al., 2009, pp. 24–28, p. 57). Some of the best practices used in this study are: (1) *acknowledge levels of risk tolerance* (instructions provided to the public about the levels of risk to be experienced); (2) *account for uncertainty inherent in risk* (reinforcement of the unknown as an argument when framing risk messages to the public); (3) *present risk messages with honesty* (congruence is based on true and complete arguments); (4) *meet the risk perception needs by remaining open and accessible to the public* (convergence implies the access of the public to organizations for clarification and assurance).

b. An examination of the four-level process of interpretation (Sellnow et al., 2009, pp. 8–9) provided by people since they actively seek and recognize points of convergence: (1) *systematic versus heuristic interpretation* (an evaluation based on cognitive evidence or on the source's identity and non-content cues); (2) *high versus low probability* of a risk situation to evolve into a crisis situation; (3) *high versus low self-efficacy* (people's degree of conviction that they will perform the activities mentioned in the risk messages); (4) *high versus low credibility* (the degree of openness, objectiveness and competence that people associate with the organization sending their risk messages).

Using a message-centered approach, this study attempts to assess the content issued by three organizations (the Lactate Brădet company, the Ministry of Agriculture and the National Sanitary Veterinary and Food Safety Authority) and to explore how Romanian citizens construed meaning throughout this process of the Lactate Brădet cheese recall. This study addresses the following research questions:

RQ1: How do the best practices of risk communication co-occur in the messages of the three organizations involved?

RQ2: How do the four levels of interpretation co-occur in the comments generated by Romanian citizens to the organizational messages? And which ones are the most salient?

## 3. Method

The data will include the Facebook posts of the Brădet company (n=4) and of the Minister of Agriculture (n=3), the Romanian citizens' comments to these Facebook posts (n=820 for the Brădet posts[7] and n=322 for the posts of the Minister of Agriculture) and the press releases issued by the National Sanitary Veterinary and Food Safety Authority (n=4).

---

7  The total number of comments to the Brădet posts was 4103, but for this study comments were sampled by choosing every fifth applicable comment for analysis.

## 3.1. Content Analysis and Cluster Analysis

For the qualitative content analysis, I used the QDA miner 5 – WordStat software, I text-mined the posts, press releases and comments by means of the code systems, crafted from the best practices for risk communication and the four levels of interpretation, presented above. The QDA miner 5, under the form of the best practices and levels of interpretation facilitated a cluster analysis of coding co-occurrences. Using WordStat 7.1.19., a computer-program-assisted text analysis based on a text mining program, a correspondence analysis was employed to identify the relationship between keywords or phrases) and the best practices in risk communication, on the one hand, and the levels of interpretation, on the other hand.

## 3.2. Coding Scheme

The four best practices for risk communication employed for the analysis of the Brădet Dairy recall in the context of the *E.coli* and UHS outbreaks were:

– Levels of risk tolerance: *high level of risk tolerance* (information of interest about what *E.coli* and UHS are, possible diseases, symptoms, instructions about the levels of risk experienced if the dairy products had not been recalled and tasks provided to people) vs *low level of risk tolerance* (no explanation related to *E.coli* or UHS and no message about possible tasks).
– Uncertainty: *lack of uncertainty* (all the information the three organizations know about the potentially contaminated products, about the possible effects of *E.coli* on the babies suffering from UHS, the efforts made to rectify the situation) vs *high level of uncertainty* (the organizations do not show what products are contaminated and do not show people what to look out for).
– Honesty: *equivocal messages* (open to interpretation and to uncertainty) vs *reassuring messages* (focus on removal of doubts or fear) vs *overly reassuring messages* (may lead to trust undermining and credibility compromise).
– Openness: *high level of openness* (organizational delivery of accessible information about receiver characteristics, location, communication channels) vs *low level of openness* (not accurate delivery of messages, usage of only one or two information sources).

The four levels of interpretation used for the analysis of the comments generated by Romanians to the posts of the Lactate Brădet and of the Minister of Agriculture were the following:

- Evaluation: *systemic* (reference to objective evidence related to the competing claims of the organizations involved in the dairy product recall) vs *heuristic* (reference to the organizational representatives' identity or other cues not related to the product recall).
- Perceived Probability: *high perceived probability* (an event which would warrant immediate action) vs *low perceived probability* (an event would instill little concern).
- Self-Efficacy: *high self-efficacy* (reference to people's conviction that they will perform the activities that would reduce their level of risk) vs *low self-efficacy* (reference to people's doubts about the activities suggested in the organizational risk messages).
- Credibility: *high credibility* (reference to the trust, openness or information accuracy associated to the organizations involved in the dairy product recall) vs *low credibility* (reference to the lack of confidence and trust in the organizations).

The author of this study and another coder coded the data to establish intercoder reliability. The first coder coded all of the posts and comments, while the second coder coded 10 % of the posts for the study codes. After pre-testing and subsequent changes to the coding protocol, the intercoder reliability test with the ReCal statistical program showed Scott's Pi was on average .82 (Scott, 1955).

## 4. Findings

### 4.1. Practices for Risk Communication – Lactate Brădet Company and Romanian Authorities

The graphical representation in Figure 1 (a, b, c) shows the resulting dendrogram[8] for the clustering of the most frequently used practices for risk

---

8 The conditions for the dendrograms were the following: for *clustering* – occurence (Windows of n paragraphs – nb of paragraphs – 5), index (Jaccard's coefficient); for *multidimensional scaling options* – tolerance – 0,000001, maximum iterations – 100.

Risk communication and message convergence 61

**Fig. 1a:** Risk communication best practices in the Facebook posts of the Lactate Brădet company – cluster analysis

**Fig. 1b:** Risk communication best practices in the Facebook posts of the Minister of Agriculture (Achim Irimescu) – cluster analysis

**Fig. 1c:** Risk communication best practices in the Facebook posts of the National Sanitary Veterinary and Food Safety Authority – cluster analysis

communication employed in the Facebook posts of the Lactate Brădet, of the Romanian Minister of Agriculture and in the press releases issued by NSVFSA.

### 4.1.1. Lactate Brădet – Facebook Posts

The qualitative analysis of these posts showed the salience of two major thematic clusters that I labeled: "confidence regain" and "participative rebirth."

**Cluster 1 – "Confidence Regain" Cluster.** The first cluster comprised the co-occurrence of two practices used by the Lactate Brădet manager: lack of uncertainty and reassuring messages.

In the first Facebook message posted on March 1, 2016, the Lactate Brădet manager (Marius Badea) wanted to dispel any uncertainty related to the cheese produced by laying an emphasis on tradition and on personal consumption of the Brădet products: "We are a small factory, that type of factory where the whole family is involved and from where each one of us eats. Throughout this period, out of this factory there were delivered products in the European community and we have never had any incident" (March 1, 2016). Eight days later, another lurking uncertainty related to the Brădet cheese was dispersed: "It is official. The Cantacuzino Institute[9] published the final result. Our cheese was not the cause of the children's illnesses" (March 9, 2016). Within this context of trust regain, Marius Badea positioned himself as a true-born Romanian who has always helped the Romanian economy ("[…] paid the best price for the milk from the local farmers," "[…] reinvested in Romania in order to face the competition coming from foreign companies," "[…] I worked 15 years, […] I was convinced that I could make something for the community where I grew as a honest human being" (March 9, 2016).

**Cluster 2 – "Participative Rebirth" Cluster.** In the second cluster, two best practices for risk communication co-occurred: high level of openness and high level of risk tolerance.

---

9 The Cantacuzino Institute is a National Research and Development Institute for Microbiology and Immunology in Romania whose main activity focuses on public health.

The Lactate Brădet manager uses reciprocity (Cialdini, 2014) to influence Romanians to become shareholders in the new joint stock company (Brădet Romanesc S.A.) by subscribing for shares on the crowdfunding platform (sprijina.ro): "You made *lactate Brădet* a nationally known brand" (March 3, 2016); "I am very convinced not to give up, due to all of you. I want to lead this project to show everybody that Romanians can make a true Romanian product. [...] After raising the capital, we will set up a joint stock company and depending on the subscribed money, we will decide: either we build up a new factory or we are going to expand the current factory. I will get personally involved to make it the biggest processing factory of milk with full Romanian capital" (March 9, 2016). Thus within this context of Romanians' solidarity toward the Lactate Brădet, Marius Badea was very transparent in this process of risk tolerance of starting from the very beginning: "I put all the firm assets at your disposal, to all of you who supported us unconditionally" (March 3, 2016).

### 4.1.2. *The Romanian Minister of Agriculture (Achim Irimescu) – Facebook Posts*

The qualitative analysis of these posts showed the salience of two major thematic clusters that I labeled as follows: "misunderstood transparency" and "in quest of morality."

**Cluster 1 – "Misunderstood Transparency" Cluster.** The first cluster comprised the co-occurrence of three practices which were mostly used[10] by the Minister of Agriculture: [[high level of openness + lack of uncertainty] + high level of risk tolerance].

Achim Irimescu, the Minister of Agriculture, delivered all his risk messages related to the 20 kilos of cow milk cheese contaminated with *E.coli* only on one channel, namely Facebook. His initial post (February 29, 2016) focused on blaming the Lactate Brădet for the illness and even death of several children from a county in Romania. The next day, Irimescu explained his overt openness by stating that "it was the duty of

---

10 On left side of the dendrogram the frequency of a code is shown through the length of the horizontal bars.

authorities to mention the name of the producer in order to prevent some other possible cases of illness." He even complained that he had been accused of providing accessible information about the origin of this contaminated cheese and of being too transparent. In the same post, he tried to justify his previous post by mentioning that he acted according to the European and national legislation, thus communicating what he knew at that time: the existence of contaminated cheese and the name of the producer. He even claimed that the journalists had already known about this situation before he did: "[...] the information was already known by mass-media, the journalists just asking me for confirmation." He tried to justify his actions within this context of potentially harmful Brădet cheese and to show that he was willing to take risk tolerance by complying to the redraw procedure. The Minister of Agriculture provided a twofold explanation for the official procedure of the product recall:

– *a macro-level explanation*, by highlighting the importance of product recall both in the automobile and food industry: "This practice is applied in the automobile industry as well, so it should be even more rigorously applied in the food industry" (March 3, 2016).
– *a micro-level explanation*, by mentioning the guide of the Romanian National Sanitary Veterinary and Food Safety Authority (NSVFSA) on recall of foodstuffs: "In case of a non-conformity of a food product which highly endangers the health of the population [...] and when some other measures are not sufficient to provide a high level of health protection, the PROCEDURE OF PRODUCT RECALL IS INITIATED" (March 3, 2016).

***Cluster 2 – "In Quest of Morality" Cluster.*** The second cluster comprised the co-occurrence of four practices in the Minister's Facebook posts: [[low level of risk tolerance + reassuring messages] + high level of uncertainty]+equivocal messages].

The Minister of Agriculture did not provide any information about the possible threats that *E.coli* may have upon the people's health or about what Romanians who purchased the presumably contaminated Brădet cheese should do. He even acknowledged that there was no evidence between the Brădet cheese and the cases of the children infected with UHS and that it was the duty of the Ministry of Health to carry

out the investigation. Although Achim Irimescu was implicitly aware of his unethical behavior of having related the name of the Lactate Brădet with the *E.coli* contamination, his Facebook posts revealed a high level of uncertainty: "And those people "DO NOT KNOW WHAT THEY HAD IN THEIR REFRIGIRATOR AND WHAT THEY COULD GIVE THEIR CHILDREN" (his highlights, March 2, 2016). In his attempt to justify his behavior ("Maybe I was wrong, maybe not," March 2, 2016), the Minister of Agriculture used both equivocal and reassuring messages. He mentioned the facts that this situation was open to interpretation and that a huge confusion of values had been made: "I do not think that we could compare children's lives with something else" (March 2, 2016). He positioned himself as the savior of children's lives and at the same time, he hoped that the producer had not been severely affected: "[…] this morally gives me inner peace. If other children had been affected, I would have been blamed that I had known the name of the producer and I hadn't made it public" (March 2, 2016).

### 4.1.3. *The Romanian National Sanitary Veterinary and Food Safety Authority (NSVFSA) – Press Releases*

The qualitative analysis of the four press releases showed the salience of one major thematic cluster that I labeled: "transparency." The cluster was formed of the co-occurrence of three practices: [[high level of openness + lack of uncertainty] + high level of risk tolerance].

The NSVFSA stated three days later after the Romanian Minister of Agriculture's accusations targeting the Lactate Brădet products that there was "[…] no direct link of causality between the cow cheese produced on February 22, 2016, and the children suffering from UHS" (March 4, 2016). In the press releases, the NSVFSA provided thorough explanations of all the procedure steps they had undertaken throughout their investigation: the selection of a number of samples (411), the exact evolution of the sample analysis (312 samples analyzed, 2 of them were positive, 99 under analysis), the consequences of the pasteurization process, the inspection of the products consumed at the households of the children suffering from UHS, or the inspection of the Lactate Brădet factory. The results of these investigations were transparently transmitted in the press releases, the

purpose being that of dispelling any uncertainty or any doubt about the Lactate Brădet and the children suffering from UHS.

The two food samples that were found infested with *E.coli* should have triggered clear messages of self-efficacy from the NSVFSA. Sellnow et al. (2009, p. 124) mention that risks situations which bring serious harm to stakeholder's health should be accompanied by instructions, by providing tasks to be accomplished. The NSVFSA claimed that the dairy products were safe for consumption and that the positive sample coming from the poultry (the Bacau county) was not dangerous as long as the heat treatment would prevent the transmission of *E.coli*. But the NSVFSA did not mention a concrete task, such as "to boil the poultry" or "to bring back the poultry purchased from a certain producer."

## 4.2. Online Users' Assessment

The graphical representation in Figure 2 (a, b) shows the resulting 2D map[11] for the clustering of the levels of interpretation employed by the online users in their comments generated for the Facebook posts of the Lactate Brădet manager and those of the Romanian Minister of Agriculture.

### 4.2.1. Online Users' Comments to the Lactate Brădet Manager's Posts

The qualitative analysis of the Facebook comments (Figure 2.a.) to the posts generated by the Lactate Brădet manager showed the salience of two clusters in terms of the strength of links among the four levels of interpretation: "multifaceted conspiracy" and "building trust."

**Cluster 1- "Multifaceted Conspiracy" Cluster.** This cluster focused on the co-occurrence of *low credibility* and *heuristic evaluation*. Although *low credibility and heuristic evaluation* were not as frequently used (17.7 %) as *high credibility* (34.6 %), see Figure 3.a., these two levels of interpretation are the first ones which were closely linked together in the online users' comments. The online users revealed the existence of a

---

11 The conditions for the 2D maps were the following: for *clustering* – occurrence (Windows of n paragraphs – nb of paragraphs - 5), index (Jaccard's coefficient); for *multidimensional scaling options* – tolerance – 0,000001, maximum iterations – 500.

Fig. 2a: Cluster formation (2D map) – online users' comments to the Lactate Brådet manager's posts

**Fig. 2b:** Cluster formation (2D map) – online users' comments to the posts of the Minister of Agriculture

**Fig. 3a:** Usage of levels of interpretation in online users' Facebook comments to the Lactate Brădet manager's posts

conspiracy between the government, dairy industry, hypermarkets and foreign investors.

The crosstabulation (constructs & words or phrases by keyword frequency) shows that online users brought an emotional and often angry element to the narrative on Lactate Brădet cheese recall demanding from the Brădet manager to file a lawsuit either against the State or against the Minister of Agriculture and to claim damages ("If I were you, I would ask for damages from the State for the negative advertising," March 9, 2016; "It is not the State against whom they should file a suit, but against the individual who uttered this nonsense," March 9, 2016).

The *heuristic evaluation* is clustering with "idiots," "irresponsible," "thieves," "scumbags" and "Romanian mafia," which describe the state of decay associated with the Romanian ruling authorities, while *low credibility* is associated with "a scapegoat to be found," "want to destroy" and "lack of values," which suggest online users' serious doubts upon the presumable causality between the Lactate Brădet cheese and the children's suffering from UHS. The online users construed a twofold meaning:

a. *Lactate Brădet – the micro-victim*. The Lactate Brădet was framed as the scapegoat of this situation, and the users believed that the Romanian authorities unjustifiably blamed the Lactate Brădet for the UHS outbreaks: "The cheese could have been contaminated in the store where it was sold. But, a scapegoat was to be found. When they checked the oranges, the authorities did not give the name of the supermarket. But now, let us destroy the Romanian producer" (March 1, 2016).
b. *Romanian authorities – the mafia*. This meaning should be closely related to the framing of the Lactate Brădet as a macro-victim. The users claimed that foreign investors wanted the Brădet business and they blamed the Romanian authorities for wanting to destroy everything that was connected with traditions and nationalism.

***Cluster 2 – "Building Trust" Cluster.*** It comprised two stages of clustering: (1) the co-occurrence of *high credibility* and *high self-efficacy*; (2) the additional linking of *systemic evaluation* to *low perceived probability*.

*High credibility* is closely related to phrases, such as "will support," "start the engines," "I am glad," "good luck," "bring the products back" and "I am a fan," which show the confidence in this national dairy company. The online users shaped their trust in the Lactate Brădet company in a threefold way:

- *objective evidence* – some online users provided a systemic evaluation to the probability that Lactate Brădet could be the cause of the children's illness by mentioning the results coming from the Cantacuzino Institute, which was thus represented as a credible source through expertise and competence ("The Cantacuzino Institute: the Brădet cheese and the poultry are not the sources causing the illnesses from which the children from the Arges county have been suffering.").
- *traditional consumption* – some of the online users considered that the association between the *E.coli* outbreak and the Brădet cheese was not an event that would instill concern since they were loyal consumers of the Lactate Brădet dairy: "I have been eating your products for at least ten years and I haven't had any problem" (March 1, 2016); "We

fully trust this factory, we have been eating these products since 2009" (March 1, 2016).
- *solidarity through action* – online users showed their confidence in the new joint stock company proposed by the Lactate Brădet manager in his Facebook post. *High self-efficacy* is clustering with words and phrases, such as "help," "involve," "producers to unite," "biggest dairy" and "farmers' cooperatives." They were self-assured that the Lactate Brădet could turn from a scapegoat into a prosperous national dairy company ("Let us make the biggest dairy factory in Romania! Not to mention that we have been drinking milk from Hungary, Holland, Germany or God knows from where and … our producers have to throw the milk away" March 4, 2016).

### 4.2.2. *Online Users' Comments to the Posts of the Minister of Agriculture*

The qualitative analysis of the Facebook comments (Figure 2.b.) to the posts generated by the the Minister of Agriculture (Achim Irimescu) showed the salience of two clusters in terms of the strength of links among the levels of interpretation: "multifaceted incompetence" and "confidence in public authorities."

**Cluster 1 – "*Multifaceted Incompetence*" *Cluster.*** This cluster embeds a twofold delegitimation: a) targeted toward the Romanian official authorities through low credibility using heuristic evaluations; b) targeted toward public institutions and international producers through the co-occurrence of two levels of interpretation (high perceived probability and low self-efficacy).

*Low credibility* (35.3 %) and *heuristic evaluation* (31 %) were the most frequently used levels of interpretation (see Figure 3.b.) in the online users' comments generated to Achim Irimescu's posts. They are associated with words and phrases, such as "incompetent," "criminal," "slaves," "no evidence," "resign" and "false information," which suggest a twofold layer of incompetence and ignorance:

- on the one hand, at a micro level, targeted toward the Minister of Agriculture, Minister of Health and journalists. The negative

72    Camelia Cmeciu

**Fig. 3b:** Usage of levels of interpretation in online users' Facebook comments to the posts of the Minister of Agriculture

presentation of the Romanian Minister of Agriculture through emotionally loaded metaphors ("You bring forth a clown and make him say stupid things," March 2, 2016), or aggressive words ("Resign, you criminal," March 3, 2016) clearly shows that this crisis situation triggered severe threats to Romanians' expectations regarding the competence of the technocrat minister. Besides Achim Irimescu, the Minister of Health was also blamed for the spread of rumors about the causal relation inferred between the Lactate Brădet and the children's illnesses: "First of all, to destroy a Romanian brand one should be incompetent. This task clearly is assigned to the Minister of Health who has not a single clue about why the children from Arges got ill" (March 2, 2016). Online users acknowledged the important role played by the Romanian media bias in the framing of this crisis. By selecting only some information about the national and international distribution markets, some journalists were accused of reframing the Lactate Brădet as a scapegoat: "The children got ill in Arges. If you are a paid journalist and want to destroy a Romanian company, then clearly you should ignore the following information: Lactate Brădet distribute their products in Arges, Bucuresti, Craiova, Brasov, Valcea [...] in England,

Spain, Germany, Cyprus, and Belgium. Well, why hasn't anybody got ill in all these places?"
- on the other hand, at a macro level, targeted toward all the Romanian governments. Some of the online users expressed their disappointment toward all the ministers from all the governments: "[...] all these ministers, since '89, have all been dust in the wind. They occupy their high positions and forget who actually put them there" (March 2, 2016). Although Achim Irimescu was part of the Cabinet run by Dacian Ciolos, a technocrat, he was also considered one of those ministers who do not remember how much the citizens helped him and he was even accused of mocking the Romanians, especially those whose death brought a resignation of the Ponta Cabinet and the appointment of the Ciolos Cabinet.[12]

*High perceived probability* and *low self-efficacy* are clustering with "destroy," "national producers," "supermarkets chains," "regulations," "EU" or "big brands." These phrases and words highlight a polarization between national and international producers that is encouraged by Romanian institutions. Online users suggested that these unfair official supportive activities toward supermarket chains and big international brands warranted immediate action: "[...] you should shut down those public institutions which have no role in this country, but to help foreign companies" (March 4, 2016); "I do not know what interest you have ... but your fight with small producers is an antinational fight. The Agency for Payments and Intervention in Agriculture is down" (March 2, 2016). Thus, online users showed serious doubts about the involvement of the Lactate Brădet in this crisis situation and shifted the blame onto the conspiracy between the Romanian public institutions and international companies.

***Cluster 2 – 'Confidence in Public Authorities' Cluster.*** This cluster focuses on a twofold co-occurrence: [[systemic evaluation + high

---

12 In 2015 the Colectiv crisis, when 27 people died because of the fire broken out at the Colectiv nightclub in Bucharest, brought political and social changes. After the Romanians' protest against a corrupted political system, the Cabinet at that time was replaced by a technocrat cabinet whose leader was Dacian Ciolos, the former Agriculture Commissioner of the European Commission.

credibility] + high self-efficacy]]. Although these levels of interpretation are not frequently used in the comments (see Figure 3.b.), some online users considered that the evidence brought by the Minister of Agriculture was justified, and they praised the fact that he made the name of the Romanian producer public. This action was not interpreted as a lack of patriotism, but rather as a normal way of acting since they experienced a high sense of risk if they carried on consuming the cheese produced by the Lactate Brădet.

## 5. Discussion and Conclusion

This study provides a national example of how a Romanian dairy company used social media to directly engage with its publics in order to gain support when it was accused by the Minister of Agriculture to have provoked the children's illnesses with UHS. The public concerns about the *E.coli* bacteria presumably found in the Lactate Brădet cow cheese were expressed through a threefold voice: two Romanian authorities (the Ministry of Agriculture and the National Sanitary Veterinary and Food Safety Authority), the voice of the Brădet company and the voices of the online users. This collaborative perspective upon the *E.coli* outbreak in Romania in 2016 was tackled upon using a cluster analysis and revealed the various meanings construed by these social actors.

In the Facebook posts of the Lactate Brădet company, two of the most salient practices in risk communication (lack of uncertainty and reassuring messages) co-occurred and formed the "confidence regain" cluster. The manager of the Lactate Brădet recalled all the products and laid an emphasis on tradition, personal consumption of the Brădet products, thus providing a self-presentation of a true Romanian who supported the national economy against all foreign competition. This cluster alongside with the "participative rebirth" cluster revealed that the Lactate Brădet company did not overemphasize the role of a scapegoat within this causal situation between the E.coli bacteria in the dairy products and the UHS illnesses. The manager of the Brădet company used the strategy of a reciprocal compensation by mobilizing Romanians to become shareholders of a new Romanian joint stock company. Although the necessary amount of money was not raised on the crowdfunding platform, the online solidarity

of Romanians was impressive: within six days, the level of engagement significantly grew (from 2,984 to 21,159 followers, see endnote 6).

The Brădet manager's strategy of posting more gain-framed messages triggered a huge support from Romanians. The qualitative analysis revealed two main clusters construed in the online users' comments to the manager's posts – "multifaceted conspiracy" and "building trust." The heuristic evaluation and the low credibility assigned to the Romanian authorities show that the online users do not trust national official institutions' ability to manage both the children's illnesses of UHS and the *E.coli* outbreak. They blamed both the government and the foreign dairy multinational companies of having found in the Lactate Brădet the perfect scapegoat for this crisis situation in order to justify further foreign investment in the Romanian dairy sector. Despite this prevalent otherpresentation of "Romanian authorities as mafia," the most salient level of interpretation used in the online users' comments was high credibility in the Lactate Brădet company. Trust was shaped through (a) a systematic evaluation of the objective evidence provided by the Cantacuzino Institute about the cause of the children's illness; (b) a low probability of the Brădet cheese being infected with the *E.coli* bacteria by highlighting their role of loyal consumers of the Lactate Brădet and (c) high self-efficacy of becoming shareholders in the new joint stock company through the online engagement on the crowdfunding platform.

Transparency was the main cluster used by both Romanian authorities. Whereas the NSVFSA laid an emphasis on all the procedures and the number of samples that were tested, the Minister of Agriculture claimed that he was misunderstood when he was transparent about the name of the producer. Trying to justify his openness, the Minister construed the cluster "in quest of morality," by self-presenting himself as a savior of other children who might get infected with the *E.coli* bacteria. Although both authorities tried to remain open and accessible to Romanians, none of them provided concrete tasks to be followed for those who purchased the Brădet cheese and the Minister unethically shifted the blame to the journalists claiming that they had known the name of the producer before his announcement.

Despite this attempt of justifying their openness and transparency, few online users showed confidence in the public authorities in their comments.

The "multifaceted incompetence" is the prevalent cluster in the meaning construed in the users' comments to the Facebook posts of the Minister of Agriculture. The emotional state of anger was highlighted through heuristic evaluations and low credibility targeted, on the one hand, toward the Romanian public authorities, which were not capable of handling either the children's illnesses from the UHS or the *E.coli* outbreak, and on the other hand, toward the conspiracy between the Romanian government and foreign dairy producers, which were accused of destroying the national dairy market. This lack of trust in the Romanian public authorities and the confidence in a national company clearly shows that the *E.coli* outbreak was rather framed as a polarization of self-presentation: the Minister of Agriculture – the destroyer of a national industry vs the manager of Lactate Brădet – the scapegoat of a corrupted system.

## References

Anthony, K. E., Sellnow, T. L., & Millner, A. G. (2013). Message convergence as a message-centered approach to analysing and improving risk communication. *Journal of Applied Communication Research*, 41(4), 346–364. doi: 10.1080/00909882.2013.844346.

Beck, U. (1992). *Risk society: Towards a new modernity*. Los Angeles: Sage.

Cialdini, R. B. (2014). *Influence. Science and practice*. 5th edition. Boston: Pearson.

Cioacă, R. E., & Briciu, V. (2017). „Lactate Brădet" – oportunitatea unei crize bine gestionate. *Revista Română de Sociologie*, 3–4, 303–317.

Douglas, M., & Wildavsky, A., (2010). *Risk and culture: An essay on the selection of technological and environmental dangers*. Berkeley: University of California Press.

Frandsen, F., & Johansen, W. (2017). *Organizational crisis communication*. Los Angeles: Sage.

Health, R. L., & Palenchar, M. J. (2016). Paradigms of Risk and Crisis Communication in the Twenty-First Century. In Schwarz, A., Seeger, M. W., & Auer, C. (Ed.), *The handbook of international crisis communication research* (pp. 437–446). Bognor Regis: John Wiley & Sons Ltd.

Kasperson, J. X., & Kasperson, R. E. (2005). *The social contours of risk (volumes 1 & 2)*. London: Earthscan.

Lundgren, R. E., & McMakin, A. H. (2013). *Risk communication: A handbook of communicating environmental, safety, and health risks*. 5th edition. New Jersey: John Wiley & Sons.

Palenchar, M. J., & Heath, R. L. (2007). Strategic risk communication: Adding value to society. *Public Relations Review*, 33(2), 120–129. doi: 10.1016/j.pubrev.2006.11.014.

Scott, W. A. (1955). Reliability of content analysis: The case of nominal scale coding. *Public Opinion Quarterly*, 19(3), 321–325. doi: 10.1086/266577.

Sellnow, T. L., Ulmer, R. R., Seeger, M. W., & Littlefield, R. S. (2009). *Effective risk communication. A message-centered approach*. NewYork, NY: Springer.

Slovic, P., Pidgeon, N. F., & Kasperson, R. E. (2003). *The social amplification of risk*. Cambridge: Cambridge University Press.

Hans Petter Fagerli and Laura Asunta

# The Paradoxes, Pitfalls and Potential of Public Terrorism Threat Assessments in Sweden, Denmark and Norway in 2018

**Abstract** This chapter scrutinizes the role of risk communication within various counterterrorism (CT) strategies, by analyzing the annual threat assessments of Norway, Sweden and Denmark in 2018, combined with interviews with representatives from the security services of the police. The research on this topic is yet scarce, first and foremost, due to the clandestine nature of these services. In this chapter, we argue that there is a reluctance to apply rhetorical means in terrorism threat assessments. Despite the cooperation on various levels between Norway, Sweden and Denmark, it seems to be little coordination when it comes to developing threat assessments, and the same applies to evaluation of the desired effects. On the other hand, all three assessments are to various degrees audience centered, but carry little advice for the public on how to react or respond. These findings demonstrate the paradoxes, pitfalls and potential of future public terrorism threat assessments within the Scandinavian countries.

**Keywords:** risk communication, counterterrorism, threat assessments, fear, media

## Introduction

Ultimately, it is the responsibility of a state to prevent terrorism. And terrorism threat assessment is *one* tool. Threat assessments may serve several purposes, also political. And as any tool, it can be misused. Historically, in USA, the "red scare" after World War 1 and World War 2 was exaggerated by many actors over decades, followed by the framing of the 9/11 attacks as "acts of war." However, in this chapter we focus on the Scandinavian perspective.

According to Covello (1987) and Renn (1998), the strict purpose of risk communication is fourfold: i) to inform and educate, ii) to influence behavior or stimulate to further actions, iii) to warn, or prepare for an emergency situation or accident, and finally, iv) to exchange information about risk in order to solve conflicts.

It's above and beyond the scope of this chapter to engage in the definition of the term "terrorism," since that is a question that is varied and under constant academic debate (Tuman 2010). But according to Schmid (2011), who has developed the so-called academic synthesized definition, there are five, common denominators that have to be in place in order to label an act of violence terrorism. First, the use of violence. Second, it must be a political act. Third, it has to create shock and fear of repetition. Fourth, an important intention with the act of violence is communication. Fifth, a component that is also seen as the most controversial (Sitter, 2017), is that the actors must be nongovernmental. But we'll leave that discussion for now, and concentrate on the role of risk communication in preventing terrorism.

The tricky question relating to risk communication and prevention of terrorism is how much, what and how the public should be told. Governments which warn regularly, but without anything happening, may be accused of alarmism (Freedman, 2005). Hence, the flip side of warning publicly about possible terrorist attack is creating fear. Moreover, the media coverage may amplify the fear dimension. Overall, media coverage of terrorist attacks facilitates a communication process between the terrorists and the public. Terrorism can, indeed, be understood as socially constructed in the public discourse (Tuman 2010). It is, however, not only the terrorists, media and general public who construct terrorism through the public discourse. Similarly, counterterrorism (CT) strategies are also part of the process. As briefly mentioned earlier, a propaganda dimension can be seen also in CT, when states try to influence the perceptions, opinions and attitudes of the public (Schmid & Crelinsten 1983, as cited in Sitter, 2017).

This chapter focuses on the element of warning, elaborating the topic through a case example of how Scandinavian police's secret services communicate publically their terrorism threat assessments. The aim is to shed light on the role of threat assessment reports as part of risk communication and CT strategies, and to take a critical look at the current approaches that are demonstrated in the terrorism threat assessment reports scrutinized here.

## Counterterrorism (CT) Strategies

Why are some CT strategies more successful than others? In order to understand that, it is important to define what CT strategies are, and,

equally important, to define success. There are four main CT strategies: i) law enforcement strategy, ii) military strategy, iii) diplomacy strategy and iv) containment strategy.

Sitter (2017) puts these strategies into context by taking one step back. His starting point is how terrorism is considered by each state; as acts of crime, war, politics or propaganda. Depending on how the state considers these actions, the state will give responsibility for handling the situation to either the police (when viewed as crime), the military (when viewed as war), the political establishment (when viewed as politics) or the police's agencies (when viewed as propaganda).

And, continues Sitter (2017), if the state views terrorism as armed propaganda, the core essence between the state and the actors is a battle about legitimacy. And the question of legitimacy represents both the pitfalls and potential in risk communication. If the legitimacy of the state is weakened and the actor's legitimacy is strengthened in the eyes of the public, even only those of potential supporters and new recruits, the terrorists may have won the battle. And how can that be? The bottom line of terrorism, according to Sitter, is that the act of terrorism is dependent on being perceived as substantial by the state that it addresses.

But let us concentrate on the four CT strategies again.

As noted by Sitter (2017), most democratic states use a combination of four strategies. In order to make sense of the different strategies, it is well worth taking a look at what Rapoport (2002) calls the terrorism waves: the "Anarchist Wave" the "Anti-Colonial Wave," the "New Left Wave," and the "Religious Wave." The Anarchist Wave began in the 1880s and continued for some 40 years, succeeded by the Anti-Colonial Wave beginning in the 1920s. That wave disappeared in the 1960s, when the New Left Wave started. In 1979, the Religious Wave began (Rapoport, 2002). This view has later been argued against by several (see e.g., Parker & Sitter, 2016), claiming that Rapoport missed out on the right wing-wave. Or, put in a popular and metaphorical way, he had been "blind" in the right eye.

## The Law Enforcement Strategy

Sitter (2017) suggests that the anarchistic terrorism wave was one of the contributors to the creation of modern law enforcement agencies in

Europe, Russia and US, because anarchistic terrorism was viewed as criminal offence; hence, the task of fighting terrorism was handed over to the police and law enforcement.

## The Military Strategy

After World War I, anti-colonial terrorism, however, was regarded more as a military threat to society. So the military, sometimes in combination with law enforcement, was given responsibility for fighting terrorism (Sitter, 2017).

## The Diplomacy Strategy

After realizing that terrorism was often a result of deeper, political problems, politicians and diplomats were given a greater role in fighting terrorism, more specifically negotiations and peace processes in combination with political reforms, in order to solve the underlying problems in society (Sitter, 2017).

## The Containment Strategy

All of the abovementioned strategies have been used simultaneously, and sometimes even in rivalry, between the governments. But since the 1970s, a fourth strategy, called the containment strategy, has been developed based on the view that terrorism is armed propaganda (Sitter, 2017). The core of this strategy, according to Sitter, is not only to prevent terrorism, protect possible targets and arrest and try the terrorists, but also to reduce the importance of terrorist attacks and to undermine the ideology and legitimacy of the terrorists.

In Europe, including Scandinavia, of course, containment and law enforcement strategies are the most common (Sitter 2017). Parker (2019), referring to Richardson (2008), offers a fruitful starting point in his book *Avoiding the Terrorist Trap* namely overreaction, often called the terrorism trap. According to Sitter (2017), the refrain in most terrorist organizations' manuals or doctrines, is TINA – *There Is No Alternative.* Likewise, as pointed out by Parker (2019, p. 96): "The government has no alternative except to intensify its repression. The people refuse to collaborate with the government and the general sentiment is that the government

is unjust (and) incapable of solving the problems." And, continuing, using the Israel security agency Shin Bet in the late 1990s as an example: "War against terrorism is part of a vicious cycle. The fight itself creates even more frustration and despair, more terrorism and increased violence" (Parker, 2019: 96).

However, there are voices that disagree. Wilkinson (2011:195) states that although terrorists tend to claim that their actions, such as bombings and kidnappings, are "the only means they have for removing a tyrannical or oppressive authoritarian regime," these claims do not hold up to serious scrutiny. According to Wilkinson, there are no instances of non-state terrorism removing autocracy, but there are many inspiring examples of relatively bloodless removal of dictatorships.

So where does risk communication fit in in all of these strategies? The answer is in all of them. But it is probably a more important component in the containment strategy, which rests heavily on propaganda as a tool from both sides, both the terrorist actors and the state. As explained by Sitter (2017), the law-enforcement strategy rests heavily on intelligence, which is considered as more important than addressing the population. The military strategy highlights both intelligence and warning. The diplomacy strategy emphasizes information exchange between the parties to create a common, realistic situational awareness and possible solutions (Sitter, 2017).

## The Paradoxes of Risk Communication

Enander (2017), referring to Otway and Wynne (1989) among others, points out that, historically, risk communication was understood as a quite straightforward activity: if just the risks were explained in terms of probabilities and consequences, the audience would understand and furthermore grasp what kind of risks to take into consideration and act accordingly, and what kind of risks must be accepted in a society.

According to Enander, the literature on risk communication is largely characterized by "good advices" on openness and transparency. Referring to Hance et al. (1990), good risk communication is based on courtesy between sender and receiver and other parties. But, in real life, other problems may occur that are not solved by courtesy. Communication about "what might happen" is often a challenging task.

As pointed out earlier, risk communication models used to be quite simplistic, and were based on one messenger, sending one message, using one channel to one receiver. In order to succeed, the sender had to be perceived as credible, the message had to be correct and taken as intended by the receiver. Also, the channel had to be the most suitable in order to address the receiver, according to Enander.

This model has been criticized and newer, dialogue-based models developed by, e.g., Heide and Simonsson (2016) have replaced the one-way communication models. And, clearly, today there is seldom one sender, one message and one channel that will be perceived similarly by all receivers.

So, over the years, a deeper understanding of how people perceive risks has been developed, based on Otway and Wynne (1989, as cited in Enander, 2017) who call their conceptualization the paradoxes of risk communication. Four of these, applying to terrorism and threat assessments, are:

- The calming/warning paradox occurs when the aim is to warn people of a possible threat, while not creating unnecessary or exaggerated concern.
- The paradox of audience centering, addressing the fact that different audiences may need different information and that this may cause a sense of insecurity since the information is not unified.
- The paradox of need for information, explained by the fact that people under normal circumstances in general are not too interested in risk communication, but when threatening situations and catastrophes occur, the need is almost insatiable.
- The paradox of reliability and fairness, meaning that it's not always sufficient that the information given is correct, since correct information isn't necessarily credible and vice versa.

Enander (2017) states that there is no quick fix to address these four, or the rest of the paradoxes of risk communication. However, a model developed by Witte (1992) is still today used within risk communication research. It's called the extended parallel processing model (EPPM), and very briefly put, is based on three possible human reactions to risk messages: i) no response, ii) danger response and iii) fear response. Which

response is determined by to what extent the message has convinced the receiver that there really is a threat, if he or she is vulnerable to this threat, and if there are ways of avoiding or reducing the danger. If the receiver is not convinced that there is a threat, the response is no response. If, however, the threat is perceived as real by the receiver, then the receiver may try to reduce the sense of fear, either by denial or by discrediting the sender, the so-called fear response. Or, if he or she feels capable of avoiding or reducing the danger, the response is based on control. The crucial point in understanding the model is the receiver's sense of self-efficacy. But also, according to Enander, the importance of combining risk messages with information on what the receivers may do to handle the risk.

## The Pitfalls of Risk Communication

So, to sum up briefly so far, risk communication theory, according to Enander (2017), should not only be instrumental and just focus on probabilities and consequences. In addition, the secret services should bear in mind the paradoxes of risk communication in order to ensure that their public threat assessments are understood, because this is what dictates what the receivers may or may not do with the information given. That can be seen as an indicator of success or lack of success of CT-related risk communication: if the communication creates fear and chaos, it plays into the hands of the terrorists, but if the risk communication creates no impact whatsoever, it cannot be considered successful either.

## Rhetorical Analysis on Terrorism Risk Communication in Scandinavia

Within the limits of this chapter, we present a case study of rhetorical analysis of the public terrorism threat assessments made by Sweden, Denmark and Norway published in 2018.

The Scandinavian countries are considered to be among the most open and democratic societies in the world (Freedom House, 2018). Still, they have a history of terrorism plots and acts. Particularly during the last decade, the threat has increased, necessitating clear CT strategies, and, most importantly, openness about them. The studied countries are quite similar, but there are also some differences; Sweden is a member of the

EU, but not NATO. Norway is a member of NATO, but not the EU, and Denmark is a member of both NATO and EU. However, these differences are not highlighted in this chapter. The main focus is to see how the terrorism threat is mediated in each countries with somewhat similar democratic-corporative systems.

The research questions are as follows:

RQ 1: What are the rhetorical elements in the terrorism threat assessment reports aimed at preventing terrorism?

RQ 2: How the scrutinized threat assessments serve the purposes of risk communication?

## The Threat Assessment Reports

It is fair to say that the threat assessments are quite different, both in length, hence form, and content. Therefore, it might be claimed that they simply cannot be compared. But nevertheless, these are the annual threat assessments offered to, respectively, the Norwegian, Swedish and Danish populations each year. Along with more specific threat assessments, of course, linked to imminent or already executed terrorist attacks in each country.

The public terrorism threat assessments are published on the websites of each country's police secret service (see references at the end of this chapter). The Norwegian Police Security Service published a 25-page summary, the Swedish summary is four pages and the Danish is 10 pages in 2018.

Moreover, it is worth noting that, as pointed out in Table 1, the threat assessment criteria between these countries also vary. All use a five-level scale but the definition of each threat level is different in each country.

## Expert Interviews

We also conducted four interviews with representatives of the secret services of the police in Norway, Sweden and Denmark. Although the interviewees are few, they provided valuable insight into how the threat assessments were produced, what was their aim and how they are evaluated. The average interview was about 30 to 45 minutes, by means

of one-to-one meetings in the workplace, or over the telephone. The interviewees received the questions beforehand. For all of them, it was an unconditional premise that the interview was conducted anonymously.

The interview data are used as a complementary insight in order to reflect the content and utility of the reports.

## Analysis of the Reports

We followed, to an extent, the rhetorical analysis methodology of Tuman (2010), modifying it for the purposes of this case study. According to Tuman's model (2010), one should first examine the notion of rhetoric, public speaking and persuasion as being audience centered, then examine the development of specific rhetorical appeals that affect that persuasion, and finally consider how these appeals translate into an actual persuasive message with the assistance of rhetorical figures of speech.

In our investigation, we have first scrutinized how audience centered the threat assessment documents are. Then we have focused on the usage, or lack, of different rhetorical appeals in the documents. Finally, we focused our attention on the main narrative of the reports. The findings are discussed in the light of the CT strategies described in the literature and the insights gained through the expert interviews.

## Findings

In the analysis, we were initially searching for expressions that would be used as rhetorical appeals (anaphora, accumulation, antithesis, catalogue, personification and prolepsis; see Tuman, 2010). However, no specific patterns or usage of rhetorical effects to create stronger responses was found.

The accuracy of the arguments in the reports seems to be at a high level. The reports seem to hold themselves to the facts which indicates, on the one hand, that one can have confidence in the ethos of the organization, but also about pleading to logos; that is, rational reasoning.

No rhetorical fallacies, such as generalizing based on single incidents, scare tactics, wrongly assumed cause-effect relation of events, absurd claims or name-calling attacks (Tuman, 2010) were found. However, in the Danish report on Islamic State (IS) was referred to by using an

expression the group that calls itself "Islamic State," which can be seen as a rhetorical manoeuvre to undermine the legitimacy of the group.

The Norwegian threat assessment clearly addresses both sectors and occupations, as seen in the table. But as Tuman (2010) states, audience is a diverse term, and therefore the reports should consider audiences more carefully, including also, for instance, lobbyists and the leaders of special interest groups.

Overall, it appears that the reports mainly point to an awareness of different audiences, but without much effort to show familiarity with those audiences. Also apparent is the lack of consideration of the different positions of those audiences regarding the topic of terrorism. One can easily assume that terrorists or potentially radicalizing groups are also reading the openly available documents. Thus, one can assume that not all audiences relate and respond similarly to the reports. Some audiences may thus have a hostile attitude toward the reports. This may also be a reason for keeping the tone in the reports very neutral, for instance, by not addressing different audiences in different ways. It is hard to evaluate whether the reports are neutral regarding different audiences on purpose or because they really treat all audiences as the same and assume all audiences will respond equally positively to the reports. However, what can be concluded is that no specific rhetorical techniques were used to emphasize familiarity with the audiences, nor recognition of the different positions of the audiences.

Ethos is emphasized in the Danish threat assessment by repeating frequently the organization that has developed the report. The report is divided into 59 sections and of these 59 sections 27 start with "CTA (either still or furthermore) assesses (26) or "CTA estimates…" (1). These highlight, on the one hand, the significance of CTA as the producer of knowledge, and, on the other hand, give an impression that what is stated is an established fact. This can be seen as appealing to the rational thinking of the audience.

Pathos seems to be lacking from all of the reports. Some weak signs of appealing to the emotions, or desire to raise them, could be seen in the repetition of the word threat. It seems, however, that emotional response is something that these reports wanted to avoid.

Paradoxes, pitfalls and potential of public terrorism threat 89

Tab. 1: Textual comparison of the threat assessments in Norway, Sweden and Denmark

|  | Norway | Sweden | Denmark |
|---|---|---|---|
| Content of the report | | | |
| - Main counter-terrorism strategy | Law enforcement (not clearly stated) | Law enforcement (not clearly stated) | Law enforcement (not clearly stated) |
| Recommendations for the target audiences | Producers, developers, sub-suppliers and intermediaries in Norwegian defense and technology industry. | N/A | N/A |
| Audience-centeredness of the reports | | | |
| Main target audiences | The Norwegian defense and public security sector, public administration, research and development and critical infrastructure. | N/A | Unprotected civilians, including crowded places and transport infrastructure, security authorities and other authorities, perceived violators of Islamic and Jewish targets. |
| How considering different target groups shows in the documents? (Common ground, familiarity with the topic) | N/A | N/A | N/A |
| How the dispositions of the target groups are considered? (hostile, sympathetic or neutral) | N/A | N/A | N/A |

*(continued on next page)*

**Tab. 1:** Continued

|  | Norway | Sweden | Denmark |
|---|---|---|---|
| Use of rhetorical figures | | | |
| Frequently repeated expressions (how many times occur in the report) | Attacks (20) Extreme/ extremist (38) Recruitment/ radicalization (10) Terrorist/terrorist attack (12) Threat (23) | Attacks (33) Extreme/ extremist (11) Recruitment/ radicalization (none) Terrorist/terrorist attack (23) Threat (4) | Attacks (68) Extreme/ extremist (11) Recruitment/ radicalization (18) Terrorist/terrorist attack (34) Threat (28) |
| Expressions directed to position an actor | N/A | N/A | Undermining the legitimacy of a terrorist group by the choice of words |

**Tab. 2:** Utilized rhetorical appeals in the terrorism threat assessment reports

| Rhetorical appeals | Norway | Sweden | Denmark |
|---|---|---|---|
| Ethos - pleading to the credibility of the sender | Explicit | N/A | Explicit |
| Pathos - pleading to the emotions | N/A | N/A | N/A |
| Logos - pleading to rational thinking | N/A | N/A | N/A |

# Discussion

The repetition of CTA as the one who assesses and states facts in the Danish report is an agreement in some of the interviews:

> "We have one goal with the annual threat assessment, and that is to be utmost precise. Rhetoric's are subordinate in that sense." (Scandinavian secret service representative)

But as pointed out by one of the other interviewees:

> "We don't want to scare people. But we want to be objective, so the public understand that there are problems 'out there' they need to relate to." (Scandinavian secret service representative)

And:

> "During my time, I worked hard to write a more informative, more detailed threat assessment that could have been published." (Scandinavian secret service representative)

On that note, another interviewee states:

> "And above all, besides scaring the population, we would definitely not scare our politicians, so then would start to make decisions that are overriding in any way." (Scandinavian secret service representative)

And:

> "Yes, I would very much like to see a public discussion on how to make these threat assessments more available and yet make people go about their ordinary life." (Scandinavian secret service representative)

But:

> "Sometimes, it can create bigger problems by publishing. So in fact it's a matter of transparency, but also a very political question." (Scandinavian secret service representative)

Without going into details of each quotation, the last remark points directly forward to our brief conclusion.

## Conclusion

Once again, bearing in mind instrumental risk communication as a battle for legitimacy, the threat assessments rest heavily on ethos in the Norwegian and Danish threat assessments.

The findings so far indicate that the paradox of calming/warning is taken into consideration to some extent. However, it seems somewhat random and not thoroughly planned. It also seems that while trying to avoid causing fear, the calming effect causes such neutrality in the tone of voice of the reports that some audiences may interpret it as ignorance or even as covering up what is really going on.

Regarding the paradox of need for information, explained by the fact that people under normal circumstances in general are not too interested in risk communication, it seems as if there is a willingness from the lower level in the secret services to be more open, more precise.

Also, the paradox of reliability and fairness, meaning that it is not always sufficient that the information given is correct since correct information does not necessarily seem credible and vice versa. This aspect is essential for our suggestions for further research.

The rhetorical style of these assessments published in 2018 suggests that the Scandinavian secret services are somewhat reluctant to use rhetorical means. According to our findings, this represents both the pitfalls and potential of the annual threat assessments.

The interviewees emphasized the importance of the threat assessments is to "maintain or enhancing the legitimacy of the authorities," meaning both the secret service police itself and the political authorities.

And, on that note, it seems as though there is no structured evaluation of how the threat assessment is being perceived, in terms of how the public is feeling informed, and thereby making informed choices. This is the case for at least two of the Scandinavian countries. That represents a pitfall, just as much as a potential in future threat assessments. On the one hand, the secret services seem to be very much occupied with the legitimacy of the services, but there is little focus on clear advice on how to react and respond.

Based on the analysis of the three threat assessments and the interviews, the following observations for future public threat assessments stand out as interesting areas for further research:

- Clarify which CT strategy that is followed in each country in order to gain understanding and thereby gain or rebuild legitimacy.
- Today, threat assessments are in danger of becoming less and less important for the public, and this threatens the agencies' struggle to retain and reinforce their legitimacy with the public in each country.
- Further develop audience-centered messages, in combination with recommendations in order to overcome the paradoxes of risk communication.
- Assess the potential for cooperation in respect of right wing extremism, e.g., the Nordic Resistance Movement[1], which is present in all three countries.
- Assess the advantages and disadvantages of developing a common, Scandinavian risk-level system.

---

1   The Nordic Resistance Movement https://www.frihetskamp.net/information-in-english/.

These indications of shortcomings also represent the potential of future threat assessments. Further empirical research should be conducted in order to evaluate how threat assessments effect human behavior, bearing in mind the possible political purposes, in order to reach their full potential.

## References

Börjesson, M. Lajksjö Ö., Enander A. (2007). *Risk, riskkommunikation och militärt ledarskap.* Stockholm: Försvarshögskolan.

Covello, V. T. (1987). Decision analysis and risk management decision making: Issues and methods. *Risk Analysis*, 7 (2), pp. 131–139.

Enander, A. (2017). Kommunikation om risker. In A. Enander & M. Börjesson, (Eds.) *Rustad för risk, Riskpsykologi för militärer och insatsorganisationer*, pp. 141–159. Lund: Studentlitteratur AB.

Freedman, L. (2005). The politics of warning: Terrorism and risk communication. *Intelligence and National Security*, 20 (3), pp. 379–418.

Freedom House (2018). Retrieved from https://freedomhouse.org/report-types/freedom-world.

Hance, B. J., Ches, C. & Sandman, P. M. (1990). *Industry risk communication manual: Improving dialogue with communities.* Boca Raton, FL.: Lewis Publishers.

Heide, M. & Simonsson, C. (2016). *Krisen inifrån.* Lund: Studentlitteratur.

Johansen, W. & Frandsen, F. (2007). *Krisekommunikation.* Frederiksberg: Forlaget Samfundslitteratur.

Otway, H. & Wynne, B. (1989). Risk communication: Paradigm and paradox. *Risk Analysis*, 9 (2), pp. 141–145.

Parker, T. (2019) Avoiding the Terrorist Trap. (*United Nations Counter Terrorism Implementation Task Force (CTITF)*).

Parker, T. & Sitter, N. (2016). The Four Horsemen of terrorism—It's not waves, it's strains. *Terrorism & Political Violence*, 28(2), pp. 197–216.

Rapoport, D. C. (2002). The four waves of rebel terror and September 11. *Anthropoetics*, 8 (1), pp. 42–43.

Renn, O. (1998). The role of risk communication and public dialogue for improving risk management. *Risk Decision and Policy*, 3 (1), pp. 5–30.

Schmid, A. P. (2011). The Definition of Terrorism. In A.P. Schmid (Ed.) *The Routledge Handbook of Terrorism Research*. London: Routledge.

Schmid, A. P. & Crelinsten, R. D. (1983). *Western Responses to Terrorism*. London: Frank Cass.

Sitter, N. (2017). *Terrorismens historie. Attentat og terror bekjempelse fra Bakunin til IS*. Oslo: Dreyers Forlag.

Schmid, A. P. & Jongman, A. (1998). Definition. In A. Schmid & A. Jongman (Eds.) *Political Terrorism*. New Brunswick, NJ: Transaction Publishers.

Sitter, N. (2017). *Terrorismens historie. Attentat og terror bekjempelse fra Bakunin til IS*. Oslo: Dreyers Forlag.

Tuman, J. S. (2010). *Communicating Terror. The Rhetorical Dimensions of Terrorism*. Thousand Oaks, CA: Sage.

Wilkinson, P. (2011). *Terrorism versus Democracy. The Liberal state response*. Third Edition. Cass Series on Political Violence. London: Frank Cass

Witte, K. (1992). Putting the fear back into fear appeals. Reconciling the literature. *Communication Monographs*, 59, pp. 329–349.

## Other sources

Danish threat assessment 2018 (summary). Retrieved from https://www.pet.dk/English/Center%20for%20Terror%20Analysis/~/media/VTD%202018/VTD2018ENGpdf.ashx, 14.11.2017.

Norwegian threat assessment 2018 (summary). Retrieved from https://www.pst.no/globalassets/artikler/trusselvurderinger/annual-threat-assessment-2018.pdf, 14.11.2017.

Swedish threat assessment 2018 (summary). Retrieved from http://www.sakerhetspolisen.se/download/18.5915abb616392094cf73b9/1529503049895/NCT-one-year-assessment-2018.pdf, 14.11.2017.

Şefik Peksevgen

# Remembrance of the Things Past: Crisis Management When a Sultan Dies

**Abstract** This chapter presents an unconventional analysis and navigates mostly in uncharted territories. It looks at the management of "crisis politics" in early modern context and brings together history and contemporary risk and crisis management studies. The crisis selected for analysis is a well-known episode in Ottoman history in which Sultan Süleyman I dies during his last siege in southern Hungary, far from the capital of the empire, and his death is kept secret by the grand vizier Sokollu Mehmed more than forty days. Despite the obvious challenge that the example it analyzes comes from a fundamentally different political world, this chapter tries to establish a relevance between the early modern world and contemporary crisis management studies by using a framework of analyses, which is relevant to both contexts. It is the contention of this chapter that "perception is the reality" as a key premise in risk and crisis management studies and "political secrets" or in its old Latin form *"arcana imperii"* as a perpetual ruling and management technique are applicable to both contexts and provide us a relevant framework for analysis. The chapter also comes to a controversial conclusion that during political crises there might not be much difference between a sixteenth- and a twenty-first century power-holder when it comes to the issues of state security and stability.

**Keywords**: political secrets, *arcana imperii*, Sokollu Mehmed, crisis management

## Crisis Management and Early Modern Context

Süleyman I of the Ottoman Empire (r. 1520–1566), known as Süleyman the Magnificent in the west, died in the early days of September 1566 while besieging fortress of Szigetvár with his army in southern Hungary. More accurately, he died in his tent more than one thousand kilometers away from the comforts of his palace in Istanbul only one day before his army finalized the siege and captured the fortress. In this intriguing incidence of Ottoman history, the grand vizier Sokollu Mehmed with great skill and effort kept the sultan's death secret until prince Selim

arrived to the army camp in Belgrade and succeeded to the Ottoman throne. Although dying during a campaign had been the fate of many predecessors of Süleyman, death of a sultan in the middle of action, be it a pitched battle or siege, always presents itself as a crisis. Considering the hardships of a campaign and the constantly deteriorating health of Süleyman even long before the Szigetvár campaign, it is difficult to claim that his death was unexpected. It became obvious during the long march to southern Hungary that Süleyman was old and sick and his decision to participate the campaign was definitely a risk. Even before the army left Istanbul, rumors about the health of the seventy years old sultan had become a serious concern for the Ottoman ruling elite. As a matter of fact, these rumors among the rivals and vassal states of the Ottomans were a major reason for Süleyman to take such a risk. Despite his resolution to prove the contrary of what had been said about his health, Süleyman must have shown a herculean effort to leave even the palace. Anyhow, Süleyman I of the Ottomans could not survive to see the end of the siege and died one day before the castle was taken by his army. The series of events that happened after Sultan Süleyman died presents us an invaluable opportunity to study the management of "crisis politics" in an early modern context.

Needless to say, the pre-modern context in which the event took place lacked all political, social and economic fundamentals of a modern society. The defining features of contemporary democratic discourse, which modern communications studies are also attuned were non-existent in the sixteenth century. In the early modern world, unlike today, the buzzwords were not political transparency or democratic accountability but *arcana* (secrets) and dissimulation. Politics was an elite affair, jealously protected from the interference of the masses. Rulers were advised to engage in dissimulation to guard the political secrets (*arcana imperii*). A famous axiom, attributed to Louis XI of France (r. 1461–1483) stated that "qui nescit dissimulare, nescit regnare" (He, who knows not how to dissimulate, cannot reign). Instead, kings and sultans ruled by divine rights, institutional and legal framework that might have circumscribed the authority of a ruler or other power-holders were a long time to come. Thus, notwithstanding the risk of stating the obvious, it is better to note

at the beginning that this chapter studies a political crisis from a world that is lost.

For this reason, considering the distance in time that separates us from the event, the following questions are not unwarranted. How do we fit an event, which happened more than four hundred years ago to a framework of analyses of present-day crisis communication and management studies? More basically, what do crisis communication and management studies have to do with pre-modern history? Since history, regardless of time and place is laden with crises, the answer to this question can be a quick one in the affirmative; "history should have to do a lot" with crises communication and management studies. When scrutinizing a little deeper, this easy "yes" is like an imaginary wonderland, which everybody heard about but nobody can show on the map. It is true that current risk communication and management studies do have an interest in historical examples and not in a tautological sense that history is related to everything. Yet this interest seems to be a very shortsighted one. In a much quoted study on "leadership during crisis" the authors state that they confine themselves "to crisis management in democratic settings. The embedded norms and institutional characteristics of liberal democracies markedly constrain the range of responses that public leaders can consider and implement" (Boin et al, 2005: 8). What happens if we do not confine our research to the "democratic setting" of liberal democracies? Are crisis management studies completely irrelevant in a pre-modern setting?

As a matter of fact, in the eye of a historian the whole debate on crisis communication and management seems to be confined to an overwhelmingly "modern setting." A while ago Reinhart Koselleck wrote that "in our century, there is virtually no area of life that has not been examined and interpreted through this concept with its inherent demand for decision and choices" (Koselleck & Richter, 2006: 358). The concept Koselleck was referring was "crisis" and by "our century" he meant twentieth century. He further suggested, "If we take the frequency of its use as indicating the actuality of a crisis, then the modern period since the turn of the nineteenth century can be called the age of crisis. The 'global crisis' encompassed all spheres" (Koselleck & Richter, 2006: 381). Despite the

theoretical weight of Koselleck's analysis of "crisis," and his declaration that "crisis becomes the structural signature of modernity" (Koselleck & Richter, 2006: 372), there is still a need to underline the unmistakable "nowness" in current crisis communication and management studies. On the one hand, this is hardly surprising when we take into account the pressing issues of the globe today from natural disasters to security issues. Yet, natural disasters such as earthquakes, tsunamis, epidemics, volcanic eruptions or human-made disasters like military catastrophes, diplomatic blunders and all kinds of political crisis did not happen only in the twentieth century or happening today. Therefore, it may not be a futile exercise to test and try to relate the analytical tool kit of current crisis management studies to historical crises. What matters is not the distance that separates the two contexts in time but finding ways of a workable relevance between the two contexts. To this end, this study proposes a *translatio studii* where current crisis communication and management scholarship is transported to a different historical setting and period (Knauth, 2011).

## Perception, Continuity and Secrecy

In corporate sector, crisis communication and management is an applied field and considerable portion of the scholarly production in this field, such as crisis public relations management, takes an action-oriented approach to provide guidance and instructions to deal with day-to-day issues. In such a book specifically written to deal with the practical issues of public relations (PR) professionals, it is proposed that "virtually every crisis contains within itself the seeds of success as well as the roots of failure. Finding, cultivating and harvesting the potential success is the essence of crisis management. The essence of crisis *mis*management is to make a bad situation worse" (Register & Larkin, 2008: 173). No doubt this is a good guidance and practical wisdom neatly packed for use. At the heading of the chapter where this wisdom is shared, authors make a fundamental claim. On the border where the theoretical and practical aspects of the field get blurred authors declared, "Perception is the reality." Considering the purposes of the book, this intriguing proposition is like a philosophical pop up in an entirely practical terrain. Yet this proposition

is not an original one, and it can be found in many other academically oriented crisis communication and management studies as well (Boin et al., 2005: 70; Tench and Yeomans, 2014: 345). Perhaps a good example is what Timothy Coombs wrote in his attempt to conceptualize crisis communication. He suggested, "Crises are largely perceptual. If stakeholders believe there is a crisis, the organization is in a crisis unless it can successfully persuade stakeholders it is not" (Coombs, 2009: 99). Origins of "Crises are perceptual" assumption go back to Thomas theorem in early twentieth century (Thomas and Thomas, 1928), and it provides a pivotal perspective in crisis communication and management studies today. More importantly, for the purposes of this chapter, it is one of the conceptual tools from the tool kit of crisis management scholars that will be transported and used for the analysis of the pre-modern crisis presented here. Below, with a more detailed presentation of the event, it will become clearer that what grand vizier Sokollu Mehmed successfully managed was to control the perception of one of the most important concerns of the pre-modern dynastic political systems, "continuity."

A second fundamental conceptualization utilized here in connection with "crises are perceptual" assumption is the relationship between crisis management and political secrecy. For centuries, before the advent of the modern era, politics was deemed a sphere conserved for a few, a jealously kept secret from the reach of the masses. Political writers of the sixteenth and seventeenth centuries gave a vital place to political secrets for the efficient political conduct. In modern times, political secrets acquired a bad reputation while open government and transparency became the defining features of contemporary democracies (Ives, 2003; Horn, 2011). However, even in modern times under the cloak of increasing security issues, governments tend to operate in a realm of secrecy. As a recent study argues, crises still give rise to political secrecy and European authority holders as legitimacy seekers "either manage or exploit crisis situations" (Kreuder-Sonnen, 2017). Thus, while again keeping an eye on the recent studies on the "crisis-related secrecy," I will try to show below how secrecy as an effective technique of crisis management in an early modern setting helped to create and maintain the perception of continuity. Without further ado, we can start looking at the historical crisis at hand in detail.

## The Event[1]

In the spring of 1566, when Sultan Süleyman I decided to march southern Hungary for the first time in twenty-three years, he was a sick seventy years old man. It had been forty-six years since he had succeeded to the Ottoman throne and many historians would later see his forty-six years reign as the peak of Ottoman power. In late summer of the same year, Ottoman army was besieging the fortress of Szigetvár in southern Hungary for a month. On September 7 of 1566, after midnight, grand vizier Sokollu Mehmed Pasha who had accompanied Sultan Süleyman to Hungary received a secret letter while he was at prayer. The letter was coming from the tent of the Sultan but not from the sultan himself. It was informing the grand vizier that the sultan had died. The letter was written and sent to Sokollu by the closest servants of the deceased sultan. When Sokollu learned about the death of the sultan, he ordered complete secrecy. Death of the sultan would be revealed to no one and anyone who revealed the secret would be severely punished. In the following days, these close attendants of the deceased sultan whose communication with the grand vizier would also take place in secrecy became the crucial aides of grand vizier's ruse to keep the sultan's death secret. After having assured that the information concerning sultan's death would be contained as secret in the very close circle of sultan's personal servants, Süleyman's body was temporarily buried under his tent, which actually was a breach in both religious and royal procedures.

---

1  Szigetvár campaign and the death of Sultan Süleyman I during the campaign is a well-known episode in Ottoman history. There are two eyewitness accounts of the event. The first one is the historian Selaniki who provided a detailed account of the campaign that he participated in his history book *Tarih-i Selaniki*. The second eyewitness account comes from Feridun Bey who was a protégé of the grand vizier Sokollu and perhaps his most trusted client. In his history book *Nuzhetu'l- Esrar* Feridun Bey gives detailed information both for his master's actions during the crisis created by Süleyman's death and also the final years of Süleyman's reign. Among the modern scholars, Nicolas Vatin contributed most with his articles on Szigetvár campaign and Süleyman's death. Bibliographic information for Vatin's works is included in the references. Since this chapter does not address only to the Ottomanists, continuous referencing to the sources is deliberately avoided. Bibliographic information for the sources is included in references.

The first move of Sokollu's ploy was to ensure the health of the sultan for the army. The master of the gatekeepers, the officer who brought the first letter to the grand vizier Sokollu without knowing its content, was chosen to spread the fake news. Completely opposite to what really happened, he was explicitly told that the sultan's health was getting better. However, he was also told that the sultan was feeling uneasy about the delay of the completion of the conquest, and his wish was to end the takeover that day. The oral confirmation of Süleyman's good health and his wish to end the siege quickly were mediated to the army through the perfect officer for the job, the master of gatekeepers. Besides this oral message, the sultan's wish was communicated to the army through a letter as well. The letter, which was actually fabricated by Sokollu's and Süleyman's private secretaries, was first sent to Sokollu. Then Sokollu pretended to meet with the sultan, and not to arouse any suspicion, he even wore sumptuous attire and strictly followed the protocol of meeting with the sultan. After the forged meeting of the grand vizier and the sultan, messengers were sent to all commanders in the battlefield, and they were informed about the will of the sultan. Eventually, our sources tell us, the order of the sultan revived the morale of the soldiers, and the Szigetvár fortress was captured immediately after the death of Süleyman.

Meanwhile grand vizier Sokollu secretly sent a letter to the only heir to the Ottoman throne, Prince Selim, who was at his post as prince-governor in Kütahya in western Anatolia. Sokollu had also planned how Selim should act after he received the letter. He specifically warned that the content of the letter should not be revealed to the messenger. Since the letter was actually an invitation to the throne, according to the customs, a present had to be given to the bearer of the news. However, not to expose the secret, such a present could not be given. Sokollu wrote everything to Selim in detail and again warned him not to reveal his father's death to anyone. According to the plan of Sokollu, Prince Selim would immediately leave Kütahya and come to Budin (western bank of Budapest). For the cover story of this sudden journey, Selim would say that the sultan had decided to winter in Budin and he would join him and winter in Budin as well.

While Sokollu managed to keep Süleyman's death a secret with series of skillful deceptions and trying to win time for Prince Selim to arrive

at Budin, an agitation began to grow among the soldiers to return to Istanbul. Since the campaign was successfully completed and the winter was closing in, soldiers did not see any reason to stay in Szigetvár. When Sokollu learned about the expectations of the soldiers, he fabricated a new command. In this new command, the sultan was ordering the repair of the castle, which was ruined during the siege. Thus, Sokollu managed to create a reasonable excuse for the extended stay in Szigetvár even if the siege was completed. Sokollu also placed spies in the army in order to learn any rumor among the soldiers about the health or the death of the sultan so that he could eliminate the danger of spreading such rumors. However, keeping such a secret from spreading was very difficult. The efforts of Sokollu and his aides to keep the secret in a tightly packed personal retinue of the deceased sultan were not as successful as Sokollu might have planned at first. According to the eyewitness accounts of the event, the viziers of the imperial council who were present in the campaign had apparently learned about the demise of the sultan, and they opposed the grand vizier for his method of dealing with the situation. In another occasion, Sokollu was even threatened by the exposure of the secret, when he declined the promotion of a high-level bureaucrat.

Concealment of sultan's death from the army and keeping it a secret among a very close circle of sultan's personal servants and top-level bureaucrats were not the only concern of the grand vizier Sokollu. The secret had also traveled to Kütahya in a sealed letter to Prince Selim. Selim appeared quite reluctant in keeping the secret from the very beginning. For instance, the next day after he received the news he told the preacher of the local mosque that his father had died and ordered him to deliver the Friday prayer in his name, which was the most important symbolic act of sovereignty in Islamic tradition. Selim faced another difficulty when he arrived Istanbul and tried to enter the palace. The deputy vizier, who remained in the protection of the city and unaware of Süleyman's death until that moment did not let Selim to enter the palace and even rebuked him.[2] Selim, in his reply to the deputy vizier, asked him to read the letter

---

2 In the Ottoman Empire during the succession crises of the fifteenth and sixteenth centuries, controlling the financial and administrative assets of the state, which were kept at the Topkapı Palace in Istanbul, was very critical and determined the outcome of the struggle among the candidates.

sent to the chief gardener, a high-ranking palace servant. At this point, we understand that another letter, explaining the situation, had been sent to Istanbul, to the chief gardener by the grand vizier Sokollu. In fact, after the state of affairs was known, Selim was allowed to enter the palace.

Selim stayed in Istanbul and performed the traditional ceremonies of succession to the throne. Meanwhile, Sokollu sent new letters to Selim and pleaded him to join the army as soon as possible. He wrote that they had been doing their best to conceal his father's death. However, they had reached the end of their provisions, and the news of Selim's succession in Istanbul was making control over the army more difficult. When Selim finally reached Belgrade and met with the army more than forty days after his father died, his recognition as the new sultan of the Ottomans would not be without further complications. Upon Selim's arrival to Belgrade, Sokollu gave advice about the necessary proceedings to maintain for the succession ceremony. He especially forewarned the new sultan that the *janissaries*, the elite infantry troops of the army, needed to hear about their gifts, promotions and increases in salaries from the very mouth of the new sultan since it was the ancient law of both previous sultans and the *janissaries*. However, Selim ignored the warnings of his experienced grand vizier and took action in accordance with the opinions of his courtiers who reasoned that such a proceeding was unnecessary since the succession ceremony had already been performed in Istanbul. The advice Sokollu gave Selim generated the first serious confrontation between the new sultan, his favorites and the old grand vizier. Yet, it turns out that Sokollu was right about his worries. When Selim and the army returned to Istanbul, the *janissaries* did not let Selim enter the palace until they had heard from him the words that he should have spoken days earlier.

As a final note to the event summarized above, it should be remembered that the grand vizier Sokollu had to navigate in a complicated political terrain with great caution. The last hundred years, roughly between mid-fifteenth and mid-sixteenth centuries Ottoman political scene had witnessed bloody struggles for the throne among rival princes. Roughly a hundred years ago, when Süleyman's great grandfather Mehmed the Conqueror (Mehmed II, r. 1451–1481) first came to the Ottoman throne in 1444, he was found inadequate to rule by the powerful military aristocracy and had to give the throne back to his father. Mehmed's son

Bayezid (Bayezid II, r. 1481–1512), Süleyman's grandfather, had to live under the threatening shadow of his brother Prince Cem (d. 1495) who had lived in exile and become a bargaining stick in the hands of European powers. After Prince Cem died in exile, Bayezid still had to deal with the increasing pressure of his son Selim in the last years of his reign and eventually abdicated the throne. Although Süleyman's succession to the Ottoman throne in 1520 was eventless, the rivalry among his sons was a major concern for the stability of the Ottoman rule. In 1553, Süleyman's eldest son, Prince Mustafa had been executed by his father's order on the grounds of his purportedly untimely ambition for the throne. Regardless of the accuracy of the claims about Prince Mustafa's ambitions, Süleyman deeply regretted his decision later. Lastly, the tragic rivalry between his two sons, Selim and Bayezid, only seven years ago lingered vividly in the memories of those who participated in the Szigetvár campaign. In this bitter confrontation of two brothers in 1559, Prince Selim defeated his brother with the support of the army sent by his father. The commander of the army sent by the sultan was Sokollu. Even so, Sokollu had contributed to the victory of Selim by not only commanding the army sent by the sultan but also convincing Prince Selim to behave more amicably toward the demands of his father and thus ensuring the sultan's help before the battle. In 1562, Sokollu married with Selim's daughter Ismihan Sultan. Four years later when Süleyman died in southern Hungary, the new sultan and the powerful grand vizier had already a very complicated liaison.

## Perception of Continuity: "The King Never Dies"

Throughout Eurasia during the early modern period, there were major similarities among different empires as much as there were fundamental differences. From Tudor and Stuart England to the Mughal India one major similarity was the dedication to the continuity of the political order. According to the dominant ideology that gave shape to the early modern political order, monarchs were permitted to rule, to control and order the world. Continuity of the order was inseparably tied with the person of the monarch who was the center of the system. Regardless of the "individual character, a monarch exemplified not an individual human being but the entire monarchy" (Feros, 2006: 348–349). Therefore, death of

a monarch be it a king, a sultan or an emperor was an extraordinary moment of rupture and political transition. When a monarch died, the threat of dissolution of the continuity might become so powerful that it felt like the entire order and justice died as well (Bertelli, 2001; 46). In these moments of transition, management and communication of the perception of continuity carried utmost importance. In Kantorowicz' words "the kingdom could not be left for ever so short a time without the continuity of law and justice which the king personified, and therefore the new Phoenix had to soar instantly and directly, without loss of time" (Kantorowicz, 1997: 415). This is why the early modern lawmakers and the kingmakers went great pains to formulate and express the continuities (Greengrass, 2006: 64–65). One of the most famous of these efforts was embodied in the celebratory exclamations "king never dies" and "king is dead long live the king" in English and "le roi ne meurt jamais" and "le roi et mort, vive le roi" in French traditions of political theology. Perhaps one of the most fantastic of all was the legal fiction "King's Two Bodies." It was theorized that the kings had two bodies, one is body politic, immaterial and immortal, and the other is body natural, material and mortal. During the English Civil War (1642–1651), another famous early modern political crisis, when King Charles I was executed in 1649 by the parliamentary forces, the parliament claimed that body politic of the king had been retained in the parliament whereas body natural was dead (Kantorowicz, 1997).

Ottomans shared a lot in this early modern political universe. The period between the death of a sultan and the accession of the new one was perhaps the most delicate moment in the Ottoman political order and always had the potential of evolving into a political crisis. As Inalcık aptly explained, "upon the death of a sultan no legitimate authority is considered to exist. All his legal dispositions, appointments, and the titles to possessions become null and void. At no other time then upon the accession and the death of a sultan did the nature of the sultanic power become explicit. Now the theory or fiction was superseded by reality" (Inalcık, 1993: 11–12). When a sultan dies, until the enthronement of the new sultan the political arena for a brief period becomes open to chaos and disruption. Therefore, providing a smooth passage to the reign of the new sovereign, without unsettling both the acquired privileges and

expectations, carries utmost importance. However, as much as I admire the precision that Inalcık describes the crisis at the hearth of the Ottoman order, I should disagree with the grand master in his last observation. When he was writing, "now the theory or fiction was superseded by reality" Inalcık probably referred to the legal fictions that gave Ottoman sultan his "absolute" power and the frailty of this power against the harsh and cold reality of death. Yet, contrary to the assumption of Inalcık, these are the exact moments where the situation needs a fiction more than ever. In these moments of crisis, all parties invested with privileges and expectations, like the shareholders of an international brand, need to be assured with a perception of stability and continuity. We have just mentioned how legal and political minds of England and France came with the brilliant man-made irrealities such as "king never dies" and "king's two bodies" in order to traverse the void created by the end of a reign and the beginning of the next. Now, if we return to the tool kit of modern crisis communication and management scholars, they argue that in a crisis authorities need to control the dramaturgy of the political communication by creating a persuasive storyline. Since crises create information vacuum, it is vital for the authorities to fabricate and tell their stories in order to shape people's understanding of the crisis (Boin et al., 2005: 69–70; Coombs, 2009: 103–104). A failure to communicate a story to fill the information vacuum can be detrimental for a successful crisis management since "the vacuum is soon filled with rumour, misrepresentation, drivel and poison" (Register & Larkin, 2008: 173).

It is very striking to see how grand vizier Sokollu implemented some of the fundamental principles of "leadership during crisis" as if he traveled into the future and smuggled the secrets of modern crisis communication and management studies into his times. What Sokollu did was to manage the political crisis by skillfully managing the perception of continuity. In order to do that as modern crisis management guidelines would suggest he controlled the dramaturgy of political communication, created a persuasive storyline, and while he was fabricating his own stories, he blocked the spread of alternative ones. Presumably, Sokollu was already anxious with the royal image his sultan propagated well before Süleyman died during the campaign. Thus, one can assume that storytelling was in place even during the long march to Hungary. While the army was marching to

Hungary, the pompous reception of John Sigismund Szapolyai, Süleyman's protégé for the Hungarian throne, to avert attention from the sultan's health can also be seen as a neatly planned act of PR to assure and propagate the never diminishing might and glory of the Ottomans and their sultan. When Süleyman died and Sokollu decided that it should be kept secret, he was very keen to control the information void and guarantee that there would be only one story about the health of the sultan circulating among the soldiers. He placed spies in the army to control the information flow and he knew very well that he had to fabricate his own story before others began telling stories of their own (Coombs, 2009: 103). The execution of a fortune-teller who participated the campaign with the army and predicted that the sultan would not see the end of the siege is an excellent example of Sokollu's strict surveillance over the rumors circulating in the army. In Sokollu's management of crisis, secrecy and dissimulation were the most effective tools. With the help of a very close circle of personal attendants of the deceased sultan, the grand vizier created a series of dissimulations and kept the death of his master secret for forty-eight days. As a master feigner, he had doctors pretended to cure the sultan, he forged orders bearing Süleyman's signature, and "he even showed the soldiers a double of their master" (Nicolas Vatin, 2019: 429). Below, we will take a closer look at this centuries old ruling technique of secrecy and dissimulation.

## Political Secrecy (*Arcana Imperii*)

The event that was told above as succinctly as possible is an example of political crisis that took place at the highest political level of an early modern state. Although grand vizier Sokollu skillfully managed the crisis, what he achieved and how he achieved it were not unique or exceptional for an early modern political leader. One can reasonably argue that this experienced and resourceful grand vizier of the Ottomans was just practicing the old craft of dissimulation. In the sixteenth century, it would be difficult to find someone involved in politics to disagree with the Sokollu's method of managing the crisis; as a Venetian law from 1583 stated, " 'Buon governo' required 'secretezza' " (de Vivo, 2007: 42). One can even speculate that if this event had happened during the lifetime of

Machiavelli (d. 1527) who was a keen observer of the Ottomans, he would have definitely used it as an example while he was advising the prince, "one must be a great feigner and dissembler ...a skillful deceiver always finds plenty of people who will let themselves be deceived" (Machiavelli, 1988: 62).

In the long span of pre-modernity, there was nothing wrong in dissimulation and secrecy over the information concerning politics. As opposed to our firm belief in transparent democratic political systems and institutions, dissimulation and secrecy were part of the practices through which the pre-modern systems were created. In fact, in European traditions of statecraft ruling through dissimulation and secrecy belonged to the occult domain of *arcana imperii* origins of which is generally traced back to Tacitus (Burke, 1991; 482; Gadja, 2009; 258). Again not surprisingly, Ottomans also had a very similar concept and a ruling technique, called *esrār-ı saltanat* in Ottoman Turkish. Both terms have almost the same meaning and can be translated to modern parlance as "political secrets." Toward the end of pre-modern period, the centrality of secrecy to the politics was first seriously challenged during the enlightenment and closely related to the transformation of the public sphere throughout the eighteenth century (Habermas, 1989). In 1784, in his famous essay "what is enlightenment," Kant declared, "publicity was the bedfellow of rationality" (Ives, 2003; 266). As Kant avidly expected, elimination of secrecy from politics, open government, democratic accountability through transparent political institutions would become the hallmark of modern societies in the next two hundred years.

However, even today there is still a call to purge the residual secretiveness in all levels of governmental actions and for a more open and transparent politics. In a recent study, which tries to theorize the relationship of crisis and political secrecy, it is argued that crises can still prompt political secrecy for European authority holders (Kreuder-Sonnen, 2017). In this study, two types of crisis-induced political secrecy are modeled. First type is *reactive secrecy*, which "denotes the deliberate concealment of information from the public with the aim of reducing immediate negative crisis consequences." It is suggested that authority-holders resort to this type secrecy "because they deem it functionally necessary for coping with the crisis." The second type is *active secrecy* and contrary to

the *reactive secrecy*, it is substantive and procedural. (Kreuder-Sonnen, 5) Obviously, early modern context does not overlap exactly with such a theoretical finesse. However, it can be proposed that this modeling for crisis-induced political secrecy is not completely irrelevant to evaluate the early modern *arcana*. The difference is undeniably a major one, but it can also be very explanatory, such as to understand Sokollu's success in crisis management. The difference is that the early modern *arcana* was not crisis induced, it was ever-present and systemic.

As the above quoted Venetian law from late sixteenth century stated that "the good government needs secrecy," Ottoman sultan Mehmed II already in the second half of the fifteenth century was promulgating laws to forbid the spread of political secrets *(esrār-ı saltanat)* beyond a few highest ranking bureaucratic elite (Peksevgen, 2005: 116–117). Two hundred years later, in the seventeenth century Ottoman Istanbul, a political adviser was still telling the sultan that the most important thing to do in ruling was to keep secret (Koçi Bey, 1939; 126–127). It should also be remembered that dissimulation and *arcana imperii* were closely related to the dominant *Reason of State (regione degli stato)* theory of sixteenth and seventeenth centuries. Reason of State theory marked a major transformation in the language of politics, and it was debated widely by political theorists in the sixteenth century (Burke, 1991; Viroli 1992; Soll 2008). These theorists "were keenly aware of the social and political risks and consequences of the disclosure of information … and tended to see political dissimulation as a legitimate technique of information-control for princes to practice in the interest of state security and dynastic stability" (Snyder, 2009: 106–107). Therefore, while grand vizier Sokollu was using secrecy and dissimulation as his most effective weapons to manage the crisis created by the death of his master he did not have any reservations concerning the accountability of his decisions or actions. On the contrary, what he achieved was something to praise. This is why Feridun Bey, a famous bureaucrat of the time and one of the most trusted protégé of Sokollu, celebrated and praised every decision of Sokollu in the history book that he wrote about the Szigetvár campaign. The curious fact is that Feridun Bey before rising to the top positions in bureaucracy had served Sokollu as his *sır kâtibi*, which is conventionally translated as "private secretary," but literally means "scribe of secret." In addition, the title of

the book where he gloriously revealed the secrets and dissimulations of his master only three years after the campaign was "Pleasures of the Secrets." Is it possible that what Feridun Bey did was an early modern version of "WikiLeaks"? The answer is "no," it was not. It is true that in the heat of the crisis early modern power-holders could tighten the secrecy "to stay on top of the information flow" (Kreuder-Sonnen, 8), which can be presented as an example of *reactive secrecy*. However, *arcana imperii* or its Ottoman version *esrār-ı saltanat* is not only about some information kept secret from the inquisitive eyes and ears of the people. Instead, *arcana* tradition is about creating an exclusive political space, a forbidden zone of politics, which is accessible only by few. As such, *arcana* creates hierarchies and serves as an "organizing principle of power relations" (Horn, 2011: 110). It is suggested that "social decisions about risk are always taken with an eye to an audience.... If there were no audience, no decision on acceptable risk would be publically announced" (Palmlund, 2009: 196). It is possible that the same can be true for political decisions and crisis management. Yet, it is also true that if there were no audience there would be no secrecy either because secrecy is "inextricably linked to communication" (Horn, 2011).

As a final note, it can be suggested that political secrets as a crisis management technique seem to endure in modernity as well. Democratic liabilities and legitimacy concerns of the modern political systems and political actors do not seem to guarantee an open, unhindered information flow in crisis situations. If crises provide windows of opportunity, it seems that crises also continue to provide windows for "secrecy opportunities" (Kreuder-Sonnen, 2017:5). It has to be admitted that traditions of political secrecy, both in its modern and pre-modern forms are utterly ambivalent. One can even argue that there might be not much difference between a sixteenth century Ottoman political elite and a twenty-first century European authority-holder when it comes to the disclosure of information concerning the issues of state security and stability.

## References

Bertelli, S. (2001). *The King's Body. Sacred Rituals of Power in Medieval and Early Modern Europe*. Pennsylvania. The Pennsylvania State University Press.

Boin, A., 't Hart P., Stern, E., Sundelius, B. (2005). *The Politics of Crisis Management Public Leadership under Pressure*. Cambridge. Cambridge University Press.

Burke, P. (1991). Tacitism, Scepticism, and Reason of State. J. H. Burns (Ed.), *The Cambridge History of Political Though 1450 – 1700* (p. 479–498). Cambridge. Cambridge University Press.

Coombs, T. (2009). Conceptualizing Crisis Communication. R. L. Heath and H. D. O'Hair (Eds.), *Handbook of Risk and Crisis Communication* (p. 99–118). New York and London. Routledge.

De Vivo, F. (2007). *Information & Communication in Venice. Rethinking Early Modern Politics*. Oxford. Oxford University Press.

Feros, A. (2006). The Power of the King. J. B. Collins and K. L. Taylor (Eds.), *Early Modern Europe. Issues and Interpretations* (p. 348–362). Oxford. Blackwell Publishing.

Gadja, A. (2009). Tacitus and Political Thought in Early Modern Europe, c. 1530–c. 1640. A. J. Woodman (Ed.), *The Cambridge Companion to Tacitus* (p. 252–268). Cambridge. Cambridge University Press.

Greengrass, M. (2006). Politics and Warfare. E. Cameron (Ed.), *The Sixteenth Century* (p. 58–88). Oxford. Oxford University Press.

Habermas, J. (1989). *The Structural Transformation of the Public Sphere. An Inquiry into a Category of Bourgeois Society*. Cambridge, MA. MIT Press.

Horn, E. (2011). Logics of Political Secrecy. *Theory, Culture & Society*, 28(7–8), 103–122.

Inalcık, H. (1993). Decision Making in the Ottoman State. C. E. Farah (Ed.), *Decision Making and Change in the Ottoman Empire* (p. 9–18), Portland. Truman State University Press.

Ives, R. J. (2003). The Rise and Rise of Open Government. *Contemporary Review*, 283, 265–270

Kantorowicz, E. (1997). *The King's Two Bodies. A Study in Medieval Political Theology*. Princeton. Princeton University Press.

Knauth, K. A. (2011). Translatio Studii and Cross-Cultural Movements or Weltverkehr. *Comparative Literature: Sharing Knowledges for Preserving Cultural Diversity Vol. II*, 250–267 EOLSS Publishers. UNESCO.

Koçi Bey, (1939). *Koçi Bey Risalesi.* A. K. Aksüt (Ed.). Istanbul. Vakit.

Koselleck, R., & Richter, M. (2006). Crisis. *Journal of the History of Ideas*, 67(2), 357–400.

Kreuder-Sonnen, C. (2017). Political Secrecy in Europe. Crisis Management and Crisis Exploitation. *West European Politics*, 41(4), 958–980.

Machiavelli, N. (1988). *The Prince.* Q. Skinner & R. Price (Eds.). Cambridge. Cambridge University Press.

Palmlund, I. (2009). Risk and Social Dramaturgy. R. L. Heath and H. D. O'Hair (Eds.), *Handbook of Risk and Crisis Communication* (p. 192–204). New York and London. Routledge.

Peksevgen, S. (2005). *Secrecy, Information Control and Power Building in the Ottoman Empire, 1566 – 1603.* (Unpublished doctoral dissertation). McGill University. Montreal.

Register, M., & Larkin, J. (2008). *Risk Issues and Crisis Management in Public Relations A Casebook of Best Practice.* London and Philadelphia. Kogan Page.

Snyder, J. R. (2009). *Dissimulation and the Culture of Secrecy in Early Modern Europe.* Berkeley, Los Angles and London. University of California Press.

Soll, J. (2008). *Publishing the Prince. History, Reading and the Birth of Political Criticism.* Ann Arbor. The University of Michigan Press.

Tench, R., & Yeomans, L. (2014). *Exploring Public Relations. Global Strategic Communication.* Harlow, England. Pearson.

Thomas, W., & Thomas, D. (1928). *The Child in America: Behavior Problems and Programs.* New York. A. A. Knopf.

Vatin, N. (2006). Comment on Garde un Secret : Note Confidentielle du Grand-Vizir Sokollu Mehmed Paşa en Septembre 1566. E. Kermeli and O. Özel (Eds.), *The Ottoman Empire. Myths, Realities and 'Black Holes'. Contributions in Honour of Colin Imber* (239–255). Istanbul. The ISIS Press.

Vatin, N. (2012). L'homme D'etat Ottoman, Maitre du Temps: La Crise de 1566. F. Georgeon and F. Hitzel (Eds.), *Les Ottomans et le Temps* (p. 77–98). Leiden, Boston. Brill.

Vatin, N. (2019). On Suleyman the Magnificent's Death and Burials. P. Fodor (Ed.), *The Battle for Central Europe* (p. 427–443). Leiden, Boston. Brill.

Venstein, G. (1997). Un Secret D'État: La Mort de Soliman Le Magnifique, *L'histoire*, 211, 66–71.

Viroli, M. (1992). *From Politics to Reason of State. The Acquisition and Transformation of the Language of Politics (1250–1600)*. Cambridge. Cambridge University Press.

Kristian Fuglseth

# Issues Management in Local Government: A Case Study of Risk Assessment and Issue Management in National Contingency Plans for Local Governments

**Abstract** This chapter examines how local municipalities assess risks in their local communities based on issues, potential threats and scenarios suggested by governmental regulations. A major child welfare case is analysed to test both municipal contingency plans and the governmental regulations as tools and guides for issues management, risk assessments and crisis management.

The case study illustrates that the contingency plans and the regulations they are based on do not include issue management strategies to cover a growing number of social crisis in local communities. It is argued that these crisis typologies have been overlooked because of an increased focus on national security typologies and disasters with huge media coverage, even though social crisis often have a deeper impact on municipalities and local communities.

An issue management strategy that recognise SOFT skills like, for example, communication skills, empathy and cooperation could be a solution to identify issues and prevent crisis from malevolence and human breakdowns, rumours and organisational misdeeds. A SOFT procedure model is suggested to include an issue management perspective in the current contingency plans and regulatory tools.

**Keywords:** issues management, risk communication, crisis management, risk society

## Introduction

The aim of this chapter is to evaluate crisis management in a local governmental and municipal administration and their ability to analyse and handle potential risks while applying the novel perspectives on issue management (Chase, 1984). An important objective is to achieve knowledge on how local authorities interpret, react and implement risk. Findings will be integrated in a proposal for an updated framework for risk assessment in local security, preparedness and contingency plans

based on the crisis typologies from Sellnow and Seeger (2013). Even though health and security, public preparedness and safety have gotten a lot of focus over the past two decades, my impression is that the risk assessment and the scenarios associated with them are obsessed with violence, natural disasters and huge accidents that attract media attention. Risk management *was* occupied with rational planning and physical measurements – but over the past decade, they have developed to focus more on information, cooperation and planning. We will have a look at these plans and the communication they depend on. The hypothesis is that the risk of being struck by miscommunication, misunderstanding or to underestimate one's stakeholders is higher than governmental contingency plans account for. This could represent a vulnerability in public management. Local communities are supposed to be transparent democracies in a manageable scale. But is it possible to belittle someone's opinion to such a degree that it represents an issue that could impact an organisation's performance and generate negative outcomes (Coombs, 2019) just as serious as crisis from violence, accidents or natural disasters that we usually plan for?

## Background

Local governmental bodies and the municipality with its administration have the primary or basic responsibility for all inhabitant's well-being, health and security. Guidelines for these basic responsibilities are given by the central government with the primary responsibility for emergency preparedness in Norway. This includes the overall political and administrative responsibility for planning and managing the preventive emergency response and crises that arise, as stated in the regulations of municipal preparedness and contingency plans ("Forskrift om kommunal beredskapsplikt," 2011), and given by e.g. the Civil Defence Law (Sivilbeskyttelsesloven, 2010).

The regional and local municipality is responsible for regional coordination in all phases of social security work: overview, prevention, preparedness, crisis management and normalisation. The regulations on preparedness, risk and security state already in the introduction that local government have a key role in working with security and preparedness,

an overarching sector coordination, overview of requirements and expectations for the municipal preparedness, risk and security work.

To fill the obligations given to any municipality from the law and the regulations, it is required to assess potential risks. The law does not say anything about how one should define risk in itself, but states that municipalities are obliged to identify and map potential risks. Translated to English: "The municipality is obliged to identify which undesirable incidents may occur in the municipality, assess the likelihood of these events occurring and how they may affect the municipality" (Sivilbeskyttelsesloven, 2010, Chapter 5, § 14). From this risk assessment, municipalities are obligated to produce a contingency or preparedness plan that must include: "The contingency plan shall contain an overview of the measures the municipality has prepared to deal with undesirable incidents. At a minimum, the contingency plan shall include a plan for the municipality's emergency management, alert lists, resource overview, evacuation plan and information plan for the population and the media" (2010, Chapter 5, § 15). The contingency plan must be revised once a year and the content can be given through regulation, with the objective to work systematically to protect inhabitants from situations or events that "deviate from the normal and that have led to or may lead to loss of life or damage to health, the environment, material values and critical infrastructure" ("Forskrift om kommunal beredskapsplikt," 2011, § 1).

## Research Question and Method

The objective of this chapter is to discuss whether local communities – the first line of social security and preparedness – are capable of identifying issues, analyse risk, and managing crisis with the above-mentioned tools given by national authorities. Could a better understanding and focus on issue management be a strategical approach in order to assess risk and manage crisis? In order to take a stand on this main question, the following subset of research questions will be answered.

RQ1: What issues are left out in major crisis in local municipalities?
RQ2: What capacity do local municipalities have in assessing risk without considering these issues?

RQ3: Do the national regulations and contingency plan cover risk from these issues in local communities?

RQ4: Could the proposed SOFT model be implemented to apply a better issue and risk assessment in local contingency plans?

To answer the first two question (RQ1 and RQ2), a review of issue, risk and crisis management literature offer a perspective for an analysis of a major child welfare conflict that resulted in a crisis on different levels for the municipality, the community and the families involved. To answer the last two questions, (RQ3 and RQ4), we will use findings from three crisis exercises in local municipalities and interviews with two other local organisations that have been examined. The results from RQ1–4 will integrated in a new model for categorising scenarios that is suggested to improve the risk management and crisis management in local municipalities.

## Literature Review

The issue management perspective on crisis management is a tool for identifying early signs of bad decisions and being able to prepare and act so that we can regain control and normalise. National regulations are tools to analyse and manage potential risks. In the assessment regulations and guidelines as tools for local municipalities – the perspective of issue management will be a focal point in its ability to manage the unpredictable. Magne V. Aarset (2016) is addressing the fact that "we always should be searching for signs of an imminent crisis" (Aarset, 2016: 16). Organisations know that they will be hit by a crisis, but Aarset's important point is that we "just do not know which crisis and when they will arrive" (Aarset, 2016, p. 548). Herein lies the difficult tasks of issues management. How can we search for signs of an imminent crisis, when we do not know where to look?

Heath (2013: 494–498) summarise the development of issues management as a practical and later an academic field since W. Howard Chase coined the term in the late 70's. Chase's (1984) definition states the importance of strategic and proactive approach to issues management. The original definition has become a widely used quote, "Issues management is the capacity to understand, mobilise, coordinate, and direct all strategic

and policy planning functions, and all public affairs/public relation skills, towards achievement of one objective: meaningful participation in creation of public policy that affects personal and institutional destiny" (Heath, 2013: 496).

Heath writes that Chase and others realised that issues management had to adapt new organisational approaches toward the public. Heath explains that they "realized that merely putting new paint on a barn does not change its age" (Heath, 2013: 96). There have to be real substance in managers' efforts toward an improved business approach, not just talking about it, but actually adapting and implementing lessons learn from public engagement. "Thus, to reduce the legitimacy gap, industry had to adopt new philosophies, practices, and policies" (Heath, 2013: 496). Heath himself have been part of a maturing process in the academic field to describe this thinking, and opens his chapter by writing that "Issue Management is a managerial philosophy and multidisciplinary set of strategic functions used to reduce friction and increase harmony between organizations and their stakeholders" (Heath, 2013:495).

## Issues Management and Public Dialogue

Local government and municipalities in Norway are obligated by law to communicate cases of interest to the public by publishing the agenda of political meetings, and through the "system of public hearing" for input by anyone who think they could have an opinion on the matter (Forvaltningsloven, 2019). The case in matter must be as thoroughly proceeded as possible, and the regulations are related to each sector, but are regulated by e.g. the Public Administration Act, Local Government Act, the Planning and Building Act and so on[1].

---

1 In chapter IV § 16, the public hearing is stated to serve to inform the case, prepare the affected for what can be decided, give the affected the opportunity to influence the outcome of the case and help coordinate regulations and other public measures. The right to be heard before decisions that may affect one is a central right in administrative law. When it comes to regulations, the right to speak is also important from a democratic point of view. It indicates that affected private organisations and individuals are given the opportunity to comment. In addition, they will often be able to supplement or correct the knowledge that the administration itself has. The public bodies concerned can make

Could this be local municipalities chance to meet the public dialogue when managing issues? The backside of this scheme is that not all implicated actors know that a case is on the agenda before it is too late. Another problem with this "hearing institute" – as it directly translates from Norwegian – is that the law only says that only "suggestions on laws and regulations that regulate people's rights and obligations, organization of the administration, change of area of jurisdiction and statements" require a public hearing, and it is up to the administrative director in a municipality to decide whether the case should be circulated to the public or not. A lot of sensitive cases are subject to privacy or other considerations that impede access from the public, and therefore hinder public debate. However, interest groups and identified stakeholders do raise their voice where they can and engage in the public debate.

Since anyone can utter their opinions on social media, the public agenda is more open than ever – and could also make it easier for organisations to find, identify and act on. Windahl (2009) is one of the writers who have bridged the gap between communication theory and practice, and writes that organisations "may want to act on the media, rather than limiting themselves to reacting to it" (Windahl, 2009:255), adapting strategic and proactive management tactics. This was easier towards traditional media, but with the introduction of social media it has become a challenge to keep up with fragmented and pluralistic voices in the public domain.

Risk management, issue management and crisis management are closely connected. Any activity or operation in an organisation represents a certain degree of risk. No organisation operates in a vacuum. In order to avoid groping blindly in unfamiliar surroundings, organisations are encouraged to being aware of both the internal and of external stakeholders. Employees' understanding of situations, their experience and opinions matter, just as much as the surrounding environment,

---

a statement, both to highlight various general interests and to promote good coordination of public measures and regulations. The consultation regulations are therefore a means of promoting information about the case, democratic influence on the decision-making process and coordination of public measures. In addition, a hearing can prepare those concerned about what may be adopted and give them time to possibly address this (Forvaltningsloven, 2019).

stakeholders, external factor influencing the organisation and an ever more active opinion and public debate on the organisation's operations and their effect on society. According to Aarset, risk management is the activity of "assessing the objective of an activity in relation to the pertaining risk" (Aarset, 2016:14). In this context, issue management is to monitor and control an organisation and its surroundings looking for traces of possible forthcoming crisis" (Aarset, 2016:14). This identification process enables the organisation to act on issues in time to implement measures and possibly also make changes early in the decision-making process to meet surrounding expectation. This is not only the definition of reputation management[2], but also a way to become aware and include a better understanding and favourable solutions that most likely can be learned from a transparent relation to the public and open debate with internal and external stakeholders and identified interest groups. Aarset states that crisis management should enable us to be mentally and physically prepared for a crisis so that we can regain control as soon as possible (Aarset, 2016:16). Local government, municipalities and even the police department are present on social media to engage with the public. It is an opportunity to have an open channel if needed, to publish content either on a daily basis or in "peacetime," but also the moment urgent and correct communication necessary for an organisation as a publisher and a listener. "Social media creates immediate opportunities for cooperation, dialogue and a tighter bond between the organisation and its interest groups and stakeholders" (Ndlela, 2019:101). This also comes with a risk.

---

2 Reputation management is well covered by Martin N. Ndlela (2019) who discusses a variety of perspectives on how reputational management affect crisis management, how it can inflict issues management and in particular how social media has played a role in changing organisations relation to the public. Ndlela refers to e.g. Coombs (2015) who emphasise strategies on establishing good relations according to interest groups expectations, maintaining these relations and defending them. In particular on digital platforms and social media, the fifth ed. of Coombs (2019) urges managers to "focus on three broad categories: public opinion experts, activists, and the organisation's own stakeholders…" as they "…provide insights into public attitudes, lifestyles and value…" (2019: 35), which can be systematically collected online to monitor how the public judge an organisation. And it is this judgment that constitutes an organisation's reputation.

Ndlela refers to Griffin (2014) that addresses risks of organisations being scrutinised by ever more people that are engaging with their opinions online. Traditional approaches to communication are not adequate in the information "anarchy" any longer – and represent reputational challenges (Griffin, 2014: 19–21). Issues management are closely linked with reputational management because issues or incidents that damage reputation can undermine organisations benefits like e.g. building strong relationships, recruitment or avoiding intrusive regulations (Griffin, 2014:6). For governmental bodies or non-commercial organisations, building strong relationships and maintaining trust to implement regulations are their important objective.

## Bureaucracy's Dialogue and Communicative Dilemma

However, if the risk management process has not been done with a subjective, open mind, the analysis is not able to identify and calculate the probability of what could go wrong and therefore not enabling the organisation to meet its objectives and prioritised targets. Martin N. Ndlela (2019) presents a dialogic view on managing risk as a two-way communication process which includes an ethical principle of not only convincing target groups in favour of an organisations, but to actively invite and include identified interest groups and stakeholders about issues related to them (Ndlela, 2019:73–74). This represents a dilemma for local government. It is not in the traditional bureaucracy's nature to have the media and public's logics of involving the user or often private and subjective perspective of citizens, interest groups or specific stakeholders. The nature of governments and the bureaucracy is to apply rules and regulation in the interest of an entire population for the overall good of society – not particular interests. Decisions, rule and operations are done based on a schematic system where prudence and a discretional assessment on behalf of the surroundings are looked upon as the best way to obtain the whole societies interest over subjective, often private interests. However – it is often in these subjective views one finds issues that can be identified as possible problems or obstacles that elevates risk and represent things that can go so wrong that the organisation is not able to control the situation and avoid a crisis. Rørvik (2011) did an analysis of communicators

entering the public sector and explains the differences in the nature of the bureaucracy and the media and publics logics when they are engaging in a negotiation of perspectives on their operations (Røvik, 2011:11). He addresses the problem of public sector losing sight of their origin of profession when hiring communication consultants in the pursuit of good reputation. He explains this trend by writing about the nature of the non-expressive bureaucrat who struggles with an increasingly pace in the media, less space for fact-based information, pressure from journalists with not time to understand their complex professional opinions, and other interest groups with a user/customer perspective on their services (Røvik, 2011, pp. 74–77). We can learn an additional lesson from this study by asking how capable the municipal administration or bureaucracy is in identifying issues, risks or even handling crisis that occur. The identification and analysis of risks constitutes the fundamental knowledge and perspective on which one manage priorities, politics and all recourses, plans and preparation work. It influences scenarios – basically what you are preparing for and what you are able to handle to avoid crisis in becoming too severe. In addition to the public sector vs the media logical dialogue problem, we will later present the problem of presumed scenarios and planned table top exercises that tend to follow a rehearsed procedure and are unable to identify issues and expose organisations weak points (Rykkja, 2014b:149).

## Analysis

Before we go on, we'll have in mind that local government handle difficult issues every day. They face a heavy administrative burden and increasing stress on services with limited recourses. Public sector has to cut budgets costs due to rising salaries and expenses, despite an increase in duties given by central government. Society demands better quality and politicians legislate advanced public services, regulations and systems to comply. An example is the governments focus on substance abuse treatment and mental health care programmes as a political objective. The political package addresses the problem of drugs abuse and mental health issues, and an understanding of the fact that if one manages these issues, other crisis further on can be avoided.

However, in regional hospitals, specialised health services and local health care they still face budget cuts and closing of institutions that were supposed to implement the national programmes (Tomasgård, 2020) (Berg-Hegelund & Arild, 2018). This can represent issues in itself – but that's another story.

## The Child Welfare Services Case

In 2005, four boys were born in a local community in Norway. They had supporting families and a supportive society around them. They were healthy and active. Everything around them indicated that they would have very good lives. They all attended kindergarten and started school five years later. But already in kindergarten, some of them showed signs of not being able to adapt very well to other children and had issues with their relations to adults. Their parents were cooperative with the staff as best they could. As the boys got older, new teachers took over one year after another and the boys floated further up towards secondary school and became teenagers. Then something happened. Turning 14 years of age – their free spirit, small tendencies of misfit behaviour was not possible to reverse. Their issues towards adults had grown, and what was seen as childish behaviour now was seen as more severe in the eyes of society's expectations.

However, reports to child welfare services had not been alarming. There were signs of potential issues, but the municipality bearing the overall responsibility for social service did not identify them as serious enough to interfere.

In cases like these, a municipal system of up to five sectors are organised to intervene as an interdisciplinary service team, including the school, the local health service, child welfare service, the inter-municipal pedagogical specialist service and the local police. The innovative system has become well known for handling multi-faceted and complex cases and is used as a best practice system implemented to act together instead of sectors working in silos – highly regarded by administrators, politicians and others. It was trusted to manage potential issues with persons in risk of falling behind in society, leading to possible crime, substance abuse or other social problems. The method was that all services should be informed of each other's cases in order to learn from each other and to

better manage every client's interest. The social service approach was able to implement solutions for a person that struggled in society, and cases should be coordinated through the SLT-model with a dedicated coordinator function between sectors.[3] But in the child welfare case, neither the school, the local health service, child welfare service, the inter-municipal pedagogical specialist service, nor the local police contact had been involved in any particular degree with these four boys. Through almost a ten-year period with these services available for the boys, no issues were identified and no coordinated measurements were taken to foresee any particular risks.

The boys were suddenly out of control. They found each other in common disinterest of school, authorities, lack of trust to societies institutions and found a freedom in seeking borderline criminal tendencies with weapons, online crime, and was also suspected of theft. Police have a no-tolerance policy to this and reacted swiftly with arrests and a report to child welfare services about potential family neglect. For the young teenagers and their families, this is a full-blown crisis. The result is forced relocation to residential care and correctional institutions, broken families at huge social, personal and also financial cost for the families, the institutions involved and also the municipalities. No one had acted on the small issues among the four young children and the crisis was a fact. The much trusted five sector system had become a breather, a pretext almost, a risk in itself. One could almost suspect that each sector trusted that someone else within the system would address the issue. As mentioned before, Aarset (2016) warns about implementing measures that becomes risk themselves. An important perspective learned from Ulrich Beck's (1992) Risk Society Theory warns us that we impose risk through implementing measures that originally was supposed to improve our lives.

---

3   SLT stands for Coordination of Local Drugs and Crime Prevention Measures. SLT model shall coordinate substance abuse and crime prevention programs for children and youth. The goal is for the municipality's children and young people to get the right help at the right time, by an aid system that cooperates well across sectors and professional groups. Read more at: http://kriminalitetsforebygging.no/slt/slt-modellen/ (Last visited: 15.03.2020).

The professional responsibility of an individual local service is pulverised in a bigger system.

Reports from an audit in 2016 show that clients and families are not followed up as they should and that regulations are not met.[4] Members of the local police and members of the municipal administrative team stated after the report was published, with the case of the four boys in mind, that the inter-disciplinary services was very surprised that none of the individual services had identified issues with these four boys, communicated this or acted on them before the crisis was a fact.[5] It seems that within the system, the responsible institutions had lost sight of the boy's individual needs because they no longer managed them personally, but via a new organisation in a system without formalised communication and dialogue between the different offices and responsible institutions. The cost of managing a child or pupil with social or pedagogical challenges in kindergarten or school in early stages can result in a very positive development if handled following "a planned and systematically executed in collaboration with others to reduce the risk of crime"[6]. The strategy includes SOFT approaches like tackling multi-cultural factors, communication, attitudes, cultural challenges, leadership and public perceptions to mention some of the terms[7]. None of these factors are outlined in the

---

4  "Child welfare – measures, supervision, routine – Ulstein municipality" (Prepared by Søre Sunnmøre municipal Audit IKS, dated 09.11.2016). The political case with a summary of this audit is published and open to the public at www.vestkontroll.no. Last accessed 20.2.2020.

5  Statement from the police in local newspaper des. 2018: He was "… surprised (Edited in: "by") the case and that the police in (not identified for anonymisation reasons) have not had similar cases before." "– It is a young man who is not known by the police." Statement from local administrative leader (anonymisation by Editor) also states that she has not heard of the cases before.

6  New Crime Preventing Strategies "Politiet mot 2025: Politiet virksomhetsstrategi" at https://www.politiet.no/om/strategier-og-planer/virksomhetsstrategi/. Last visited 20.2.2020.

7  The terms used in the chapter "Social Development Requires Restructuring" p. 5 in the new strategy are compatible with skills suggested in Table 2: SOFT procedures/approaches.

regulations from DSB – and not implemented in local plans, and therefore not subject to exercises. Despite being a serious factor in managing issues, reducing risk and minimising consequences of a crisis by avoiding situations escalating unnecessarily. In the case of the four boys, municipality could have acted on issues earlier. They could have acted on them with less recourses than after the social and personal crisis was a fact, spending their economical recourses on prevention instead of reactive responses and reparation. Not mentioning the personal and social cost for individuals involved, one institutionalised child alone costs almost double of a school assistant with pedagogical SOFT skills. Further on, the boys involved need to be followed up for many years. Individuals with risk of becoming the national security issue are profiled in the DSB regulations as young, male outsiders with frustration and the feeling of failure, lack of support and with symptoms of mental health issues that haven't been diagnosed or treated. If the municipality do not have the ability to implement programs for substance abuse and mental health, they do not recognise SOFT issues and disregard such issues in their risk assessment and scenarios for crisis exercises, risk and crisis management are failing.

There is however a sign in Police Strategies and in particular the new SLT-program that starts to cover these new approaches. After 2011, cooperation and interaction have become a creed in governmental regulations and are frequent phrases in contingency plans, but as the case shows, it is not always working in practice.

Cooperation and communication with an issue management perspective do not seem to be taken into account in regulations and contingency plans, and they need to be exercised.

## What Do the Regulations Cover?

So, what do the national regulations and contingency plans cover? The child welfare case had huge human and economic cost, where local government through misconduct disregard a family's right to support, resulting in a public enquiry and police investigation. These kinds of cases are not found as tutorials in the government's guidelines. They are not regarded as PLIVO, a shorthand for "Ongoing and life-threatening

violence" in English, or "Pågåande, livstruande vold" in Norwegian[8]. These cases are issues, sneaking up on the local community, like a Python-crisis, as Magne Aarset (2017) describes the two categories with a Cobra-crisis as the opposite – a crisis that hits you without warning. The latter being natural disasters, fire, flood or killings that often are hard to expect and unexpected for the victims. Even if PLIVOs are hard to detect on beforehand, these are the visible crisis that are easier to learn from afterwards. Issues are closed, scenarios are exercised and preventive measures can be taken in building regulations, hiring more police or fire fighters or evacuating people out of harm's way. Issues are identifiable, visible and easy to measure and manage, at least for the organisations that the PLIVO procedures were planned for. The procedure covers crisis like terror attacks, school shootings and huge accidents with many causalities. When municipalities or other organisations than police, hospitals or the fire departments learn, adapt, plan and organise their risk assessments and crisis response – PLIVO-procedure and the experiences from 22nd July events in Oslo and Utøya in 2011, it seems to have set as a standard. Evaluation of crisis exercises with municipalities shows that they handle accidents, injuries, evacuation and even fatal accidents. Learning points and improved procedures after the attacks in 2011 have to a certain degree been implemented locally, but the perspectives on risk and the risk scenarios stated in local plans do not include risk that e.g. Aarset (2016) would characterise as unpredictable[9].

---

8  A new procedure for handling life-threatening incidents has been introduced by the government as one of several follow-up measures after the events of 22 July 2011. The National Procedure for Emergency Cooperation in Continuing Life-threatening Violence (PLIVO) has been developed jointly by the Directorate of Police, the Directorate of Health and the Directorate for Social Security and Emergency Response (DSB). Training is conducted throughout the country, and other public sector services, including local authorities, municipalities have included the term in their crisis response plans and operations (Peter Langlo, Per Lægreid, & Rykkja, 2014, pp. 60, 67–74).

9  Regional County Governors have the responsibility to coordinate social security and emergency response between central government and local municipalities. It also implies a supervisory role. This role has gotten a lot of focus and has improved after 2011. A study referred to by Rykkja (2014a, pp. 126, 143) shows lack of communication and coordination. There is a variation in the results, but also a report from National Audit in 2007 shows lack of

Issues that are hard to detect and impossible to measure and manage do not seem to occur in the government's guidelines, nor in policy documents regulated by the Civil Protection Act (Sivilbeskyttelsesloven, 2010). The only category found in the Directorate for Social Security and Emergency Response (DSB) guidelines for risk assessment are economic loss connected to material values (DSB, 2014, p. 18). In the regulations of municipal emergency response (DSB, 2018), local government however, are required to plan and manage preparedness in a systematic and interdisciplinary manner, which then also includes social, educational and health sectors. But in exercises done by Volda University College, the crisis response team from assessments done e.g. in 2020, issues related to physical and mental health were restricted to altering the mental health response team (See footnote 9). Examples given in DSB regulations are human misconduct, harassment or embezzlement – but are still in a category where the municipality could limit their efforts to measuring e.g. bullying, workplace social environment on a scale from not happy to fine or the amount of embezzlements investigated by the police. Rules, regulations and checklists on contracts can easily be put in place, but we do not see crisis exercises with these objectives very often. Policy and regulations require a minimum risk assessment related to five points: 1) existing and future risk and vulnerability factors in the municipality, 2) risk and vulnerability outside the municipality's geographical area that may be of significance to the municipality, 3) how different risk and vulnerability factors can affect each other, 4) special challenges related to critical social functions and loss of critical infrastructure and 5) the municipality's ability to maintain its activities when it is exposed to an undesirable event and the ability to resume its activities after the incident has occurred. The last factor is an

---

priorities. The evaluation from e.g. Møre og Romsdal County after Exercise Åknes 2016 shows that risk and crisis management plans have been a priority. Municipalities follow up on implementing new policies. However, these local policies are characterised of issues in society only in regards of violence, terror, disasters or for example pandemic scenarios. The perspective on risk seen to be influenced by a perception of fear of terror, experienced from attacks on World Trade Center's 9.11.2001, the new procedures and learning points after the Swine Flu Pandemic in 2009 and in particular the 22.7.2011 shooting.

assessment of the need for population warning and evacuation ("Forskrift om kommunal beredskapsplikt," 2011, § 1).

The understanding of risk from the governmental regulations is general, and it is not easy to assess the probability, nor the consequences. But if we look at, e.g., the category, life and health, it is nearby to consider physical risk of human injuries, illness, clinical health issues or death. In such cases, local authorities can initiate local health services like ambulances, fire department, police, general practitioners and perhaps hospitals. A local psychology service and the local priest are very often members, or at least on alert if needed. All these services – the "blue light" sector – are alerted if a sudden accident occurs. Even if some municipalities have interdisciplinary meeting across these sectors – a lack of staff, time and budgets, and the pure nature of their professions, limit their strategic abilities to tackle issue with individuals or groups in a longer time frame – preferable throughout the pre-crisis phase where risks and possible issues should have been identified and managed. The consequence of waiting until the crisis occurs hinders their ability to limit the impact of the crisis. The category life and health should not only be limited to the immediate risk of getting hurt in accidents, but also the mental health of individuals, families and groups.

The five categories of potential themes or risk categories are given as examples to the local municipalities. Any local plans or policies that want to look at other categories have to come up with these themselves and put these into the example schemas given in the regulations. What we have found in available plans that have been made available through the workshops, exercises and an analysis done by master students after the exercises in Volda (See footnote 9) is that PLIVO cases and natural disasters were the dominating example and created the basis for all local crisis plans. The absence of scenarios related to human misbehaviour, misconduct, embezzlement, fraud, sexual harassment, bullying, bad personnel handling, drug abuse, psychological issues, reputational damage by some sort of incident etc. was obvious. The proposed schemas given in the guideline to the duties written in the law are risks on life and health, stability (on infrastructure, society and so on), nature and the environment and material assets.

## Crisis Exercises with SOFT Issues

The regulations are updated after crisis based on threats on national security, ongoing violence and international pandemic scenarios. This offers us with a problem. We assess risk, plan for and exercise on scenarios that we know how to handle or the one we can imagine and expect, but at the same time evade the unexpected risks and possible crisis. Evaluation of five different crisis exercises run by the Media Department at Volda University College[10] shows that local government have an increasing ability to manage scenarios related to PLIVO, natural disasters and accidents. However, when SOFT Crises are played into the exercise, the crisis management team quickly find themselves in situations that are not so straightforward to handle. A study of evaluation videos, live observations and debriefs after exercises show that the crisis management team spend longer time in responding and initiate a debate on what direction to take or strategies to choose from. Exercises that run different scenarios, perhaps a weather-related scenario with accidents in a storm with employees facing accidents or a bus crash, combined with misconduct or embezzlement by members of staff could have resulted in communication crisis occurring in an otherwise relatively stable operation when handling the original crisis. The organisation was able to handle even fatal accidents with their crisis management preparedness plans – but when introducing a situation of misconduct between a pupil and a supposedly trusted member of staff – the crisis management team lost control both with communication, social media and other relations to the press, and in following procedures and

---

10 Institute of Communication at Volda University College assessed risk and crisis communication and preparedness plans and ran crisis exercises on vulnerable parts with Møre og Romsdal County Governor (2013), Fosnavåg Ocean Academy (2016–2), (Åknes Tafjord Inter-Municipal Org. (2016-8-29), University Executive Management Team (2016–11), Vanylven Municipality (2018) and Herøy Municipality (2020). An assessment of the "Aksla murder 2013" at Ålesund University College and interviews with central members of the crisis management team conducted in 2014 also show relatively well crisis response and crisis management, but the assessment reveals lack of control in the most intense periods where communication to the public and the press and other sources of information where competing about fact finding and relevant sources of information.

policies on human resources and personnel policies." We felt that we had control over the situation in the initial phases dealing with the bus crash. But when the press started to ask about the reason for the bus crash, and implying that faulty brakes could be a reason, we were caught off guard. We were not prepared for it."[11]

The municipality tested with the bus crash scenario understood that some members of the public and of course the press had more information than they did. It did not take much time before markers in the media play connected to the exercise published rumours on social media that the bus failed the EU-control implying a lack of internal routines. Even if the crisis management team did not know if this was true – it became the focus and the frame that stuck with the media, disabling the team to handle the original situation.

This fit with the findings presented by Rykkja (2014b:148–149). She refers to Boin (2004) and his cowriters who found that table top exercises with predicted scenarios result in routine based and rigid patterns of management that do not detect underlying problems or organisational weaknesses (Rykkja, 2014b:149).

This is often where the issues are hidden. Underlying problems or organisational weaknesses represent issues that lead to crisis within the crisis. As Aarset explains, this would be a secondary effect that occurs while implementing risk-reducing measures, ... "this often entails introducing a new risk at the same time, or it can lead to the introduction of secondary effects of one or more other risks" (Aarset, 2016: 319). It can be the measures themselves that represent another crisis – like a faulty traffic light that originally was installed as a safety measure but now represents a risk. But it could also be in the context of communication, the risk communication or the crisis communication, or the lack of, in itself. One need to be open minded on potential issues during a risk period – during the pre-crisis stages, and also into a crisis and post crisis. Improvising and a willingness and ability to adapt tactics are important characteristics in issue management. Many issues can be solved with good

---

11 Quote from member of crisis management team given at the immediate debrief after the crisis exercises 2016, 2018 and in 2020. See above. The bus crash scenario was tested in all three cases.

communication, and in cases the issue itself is actually a lack of communication. This communication vacuum has the potential to accelerate issues into real problems if not handled. A proactive and adaptive tactic outside the planned schema can not only reveal issues as underlying problems or organisational weaknesses, but also be the channel to get vital information and input in difficult situations.

This was found in relation to the case of the Aksla murder, where the head of the crisis team at the time stated in a case study[12] later that even if all plans according to regulations were in place on beforehand, no one could prepare for the extraordinary situation, the massive pressure and collective reactions and surprisingly large parts of the surroundings found themselves in. A very diverse group of spectators and interested parties and groups in the public somehow found themselves connected to the case with a variety of expectations. This forced the crisis management team to handle a communication crisis simultaneously with the actual search and rescue operation. The scenarios we had planned for were peanuts compared to what we were up against.[11]

Even though the unexpected often represents a greater risk, hits us harder and is able to put organisations and communities out of play, organisations handle the situations better if they are exercised. Organisations, not only local government, often have little time and recourses set aside for crisis management. Therefore, they implement plans within the minimum requirements of the regulations. All five organisations studied after exercises in Volda stated that they did not feel that they spent enough time planning, exercising or preparing for crisis. They just followed minimum requirements. Rykkja (2014b) has found several evidences for this and writes that even if a lot of the management literature emphasises preparation and the development of policies and regulations, a lot of exercises are taken for granted. Freely translated from Norwegian, she writes "...It

---

12 A student was missing and later found murdered in Ålesund in 2013. In the recorded in-depth interview study assessing the crisis management, Roar Tobro, Director at the time, stated that "the scenarios we had planned for on beforehand were peanuts compared to what we were up against." Interviews were conducted by Associated Professor Jan Arne Halvorsen at Volda University College in 2014.

Tab. 1. Sellnow and Seeger's (2013) Overview of Crisis Typologies

| Lerbinger (1997) | Seeger, Sellnow and Ulmer (2003) | Coombs (2010) |
|---|---|---|
| Natural disaster | Public perception | Natural disasters |
| Technological crises | Natural disasters | Malevolence |
| Confrontation | Product or service crisis | Technical breakdowns |
| Malevolence | Terrorist attack | Human breakdowns |
| Organisational misdeeds | Economic crisis | Challenges |
| Workplace violence | Human resource crisis | Mega damage |
| Rumours | Industrial crisis | Organisational misdeeds |
| Terrorist attacks/ | Spills (oil, chemical) | Workplace violence |
| man-made disasters | Transportation disasters | Rumour |
|  | Crises from environmental factors |  |

is taken for granted that exercises are useful, but how they are organised and done, what purpose, function and effect they have are often not on the agenda" (Rykkja, 2014b:149).

## A SOFT Approach to Issue Management

As this text presents from experience in assessments of municipalities issues, risk and crisis management, they in large parts relate to natural disasters, ongoing violence and large accidents. This has been on the agenda and gotten a lot of attention after events like for example 9/11, international pandemic in 2009 or the Utøya-shooting in Norway in 2011.

Sellnow and Seeger (2013) have made an overview of crisis typologies (Table 1) comparing their own typologies written with Ulmer in 2003, and Lerbinger from 1997 and Coombs from 2010 (T. L. Sellnow & Seeger, 2013:6). They do have differences, but all three lists include typical PLIVOs like natural disasters, terror attacks, technical/industry crisis and so on. Compared to the scenarios featured in the government regulations and the proposed issues that can cause these, we find malevolence, organisational misdeeds, rumours, public perception and human breakdowns in Sellnow and Seeger's table.

To include Sellnow and Seeger's missing typologies in the regulations, an additional approach could be suggested. A new approach or procedure to ensure detection of softer categories learned from Table 1, could help municipalities to identify and manage unpredictable soft issues. Regulations and preparedness plans related to mental health are regulated by law,[13] but not communicated in exercise guidelines used by municipalities. Municipalities use guidelines from DSB, and are obligated to follow National Health Care Emergency Plan (see footnote 7), but regulation writes that "municipalities are responsible for protecting the health of the population and preventing illness and injury - infection protection, environmental health protection, food safety, drinking water and radiation protection" (Helsedir, 2018). This becomes the focus – while mental or personal services like psychosocial preparedness tend to be forgotten despite being part of political programs that regard these issues as vital.

Soft skills can be added as a guide in identifying issues or weak points in issues, risk and crisis management. These skills could include abilities of collaboration, communication abilities, language skills, personal habits, workplace culture, cognitive or emotional empathy, framing and perception, time management, teamwork and leadership traits. The terms of skills are gathered from the Organisation for Economic Co-Operation and Developments (OECDs). *Skills for Jobs Indicators* report examines how countries measure changing skill needs and how they develop skills that respond to labour market needs and how they ensure that these skills are fully utilised by individuals and employers (OECD, 2018, p. 50). The soft skills are not intended for risk or crisis management but do provide us

---

13 The Health and Social Contingency Act's (Health Emergency Act) objective is to safeguard the life and health of the population and contribute to the provision of necessary health care, health and social care services and social services to the population during war and in times of crisis and disaster during peacetime. The law includes being able to continue and, if necessary, change and expand operations. There are several regulations, like the Health and Care Services Act that regulated municipality's duties. The regulations that includes mental and social health as issues related to risk and crisis management are the National Health Emergency Plan which states that municipalities are "responsible for providing necessary health and care services to everyone staying in the municipality, including psychosocial preparedness and service" (Helsedir, 2018:16).

with management skills required to tackle a more fragmented work environment in organisations facing challenges, perspectives and expectations as a global phenomenon. There is a lot to learn from OECD's indicators. They relate to issues very often being affected by international attention from the media, interest groups and stakeholders that spread a popular perception. This is what the public occupy themselves with and further on have as expectations towards organisations having to manage as complex issues. To manage such unpredictable issues, soft skills and procedures that include examining the organisations ability to use them are needed to assess risk, identify issues and act on these issues. If organisations find themselves not able to act on, for example, risk of not understanding language, having trouble of cognitive and emotional empathy or lack of teamwork due to bad workplace culture – these can become SOFT issues that the current regulations do not apply. A SOFT procedure is needed to tackle SOFT issues.

Let's organise these skills with the crisis typologies from Sellnow and Seeger (2013):

This constitutes a new approach in addition to the PLIVO approach, and could help municipalities to assess risk, identify issues and acting on them. Management of unpredictable issues that are difficult to handle often on top of an ongoing crisis do need attention. Statements from crisis

Tab. 2: The SOFT Procedure Illustrates Skills Needed to Tackle Types of Crisis Found in Sellnow and Seeger's Table 1, Not Emphasised or Exemplified in Government Regulations

|   |   | Skills needed to manage issues | Addressing these crisis typologies |
|---|---|---|---|
| S | Social | Collaboration, Communication abilities, Language skills, Workplace Culture | Malevolence and Human Breakdowns |
| O | Opinion based | Language skills, Cognitive or Emotional Empathy | Rumours |
| F | Framed | Framing and Perception | Public Perception |
| T | Transparent | Personal Habits, Time Management, Teamwork and Leadership Traits | Organisational Misdeeds |

management teams indicate that these skills were surprisingly difficult to utilise in the heat of the moment. When municipalities are measured only on indicators and values that are easy to calculate with numbers, occurrences, money or in meters – they tend to be forgotten when searching for issues.

Just the fact that many municipalities face more immigration indicates that crisis communication plans need to be revised to reach the population in different languages. "The crisis management team from the 2020-exercise at Volda University College stated that "there is a need for increased capacity on cultural and language skills, alternative forms of communication and closer cooperation with local media" (see footnote 9).

The skills listed in Table 2 could help manage issues and supplement typologies suggested in the scenarios we found in the regulations.

## Conclusion

Local government and municipalities should focus on a two-way communication and dialogic approach to issue management. The structured principles of DSB´s regulations on preparedness and safety include strategic communication with an issue management philosophy only to a certain degree. Strategic communication skills are vital for rule-based bureaucracies, and this would serve as a vital learnings point when following both the regulations on coordinated approaches to civil preparedness and safety, but also as a basic starting point in assessing risk, identifying possible issues and preparing and acting in crisis. Strategic communication is about open ears and eyes, including of surroundings internally and externally for the organisation and the willingness to adapt tactics from input given by surroundings. This helps meet the expectations and would benefit organisations objectives and at the same time include the public's interest. The case presented represents examples of misinterpreting status of opinion among stakeholders. They are examples of cases where one can find that regulations and guidelines miss out on key factors in helping organisations managing risk, issues and crisis. The SLT model of coordination lack practical and logical implementation, even though it seems like the best way forward in handling interdisciplinary and overarching sectoral cases. The result in both cases are unexpected crisis with

dramatic outcome due to lack of early detection and governmental bodies failing in addressing alternative solutions that could have been available if the detection antennas were up and directed outwards. Being aware of important stakeholders, and perhaps more importantly, detecting potential interest groups in order to open a dialogue, and including them as key stakeholders would reduce the impact of crisis in both cases.

## References

Aarset, M. V. (2016). *Risk, Issues and Crisis Management.* (pp. 677). Haugesund: Terp Forlaget.

Beck, U. (1992). *Risk Society: Towards a New Modernity.* London: Sage.

Berg-Hegelund, L., & Arild, J. (2018). Kutt i psykriatien. *Aftenposten.* Retrieved from https://www.aftenposten.no/meninger/kronikk/i/wEB40P/norsk-psykiatri-er-verre-enn-sitt-rykte-jill-arild-og-linda-berg-heggelund.

Boin, A., Kofman-Bos, C., & Overdijk, W. (2004). Crisis simulations: Exploring tomorrow's vulnerabilities and threats. *Simulation & Gaming, 35*(3), 378–393.

Chase, W. H. (1984). *Issue Management: Origins of the Future.* Stamford, CT: Issue Action Publications.

Coombs, W. T. (2010). *Ongoing Crisis Communication.* Thousand Oaks, CA: Sage.

Coombs, W. T. (2015). *Ongoing Crisis Communication: Planning, Managing, and Responding* (4th ed.). Los Angeles: Sage.

Coombs, W. T. (2019). *Ongoing Crisis Communication: Planning, Managing, and Responding* (5. utgave.; International Student Edition. ed.). Los Angeles: Sage.

DSB. (2014). *Veileder til helhetlig risiko- og sårbarhetsanalyse i kommunen.* Retrieved from: https://www.dsb.no/globalassets/dokumenter/veiledere-handboker-og-informasjonsmateriell/veiledere/veileder_til_forskrift_om_kommunal_beredskapsplikt.pdf. (April, 2020)

DSB. (2018). *Veileder til forskrift om kommunal beredskapsplikt.* Retrieved from https://www.dsb.no/globalassets/dokumenter/

veiledere-handboker-og-informasjonsmateriell/veiledere/veileder_til_forskrift_om_kommunal_beredskapsplikt.pdf. (April, 2020)

Forskrift om kommunal beredskapsplikt, (2011).

Forvaltningsloven. (2019). *Lov om behandlingsmåter i forvaltningssaker.* (LOV-1967-02-10).

Griffin, A. (2014). *Crisis, Issues and Reputation Management.* London: Kogan Page Limited.

Heath, R. L. (2013). Issues Management. In R. L. Heath (Ed.), *Encyclopedia of Public Relations: Vol. 1* (2nd ed., Vol. 1, pp. 495–499). Los Angeles: Sage Reference.

Helsedir. (2018). *Nasjonal helseberedskapsplan/National Health Preparedness Plan.* Retrieved from https://www.regjeringen.no/contentassets/17d1a438f21f4986989a9a1441ae2d79/helseberedskapsplan_010118.pdf. (April, 2020)

Hornmoen, H. (2011). «Pandemisk paranoia»? – En analyse av nyhetsomtalen av «svineinfluensaen» i norske aviser. *Tidsskrift for samfunnsforskning, 52*(01), 33–65.

Lerbinger, O. (1997). *The Crisis Manager Facing Risk and Responsibility.* Mahwah, NJ: Lawrence Erlbaum.

Ndlela, M. N. (2019). *Interessentperspektiv på krisekommunikasjon.* Oslo: Universitetsforlaget.

OECD. (2018). *Getting skills right: Skills for Jobs Indicators.* OECDPublishing. Retrieved from https://read.oecd-ilibrary.org/employment/getting-skills-right-skills-for-jobs-indicators_9789264277878-en#page52. (April, 2020)

Peter L., Per, L., & Rykkja, L. H. (2014). Etter 22. juli. Justis- og beredskapsdepartementets ansvar for samfunnssikkerhet. In Anne Lise Fimreite, Peter Langlo, Per Lægreid, & L. H. Rykkja (Eds.), *Organisering, samfunnsikkerhet og krisehåndtering* (Vol. 2, pp. 60–76). Oslo: Universitetsforlaget.

Røvik, K. A. (2011). Analyse av kommunikatorenes innmarsj i offentlig sektor. In S. I. Angell, H. Byrkjeflot, & A. Wæraas (Eds.), *Substans og framtreden: omdømmehåndtering i offentlig sektor* (pp. 71–83). Oslo: Universitetsforlaget.

Rykkja, L. H. (2014a). Fylkesmannen som samordningsinstans. In Anne Lise Fimreite, Peter Langlo, Per Lægreid, & L. H. Rykkja

(Eds.), *Organisering, samfunnsikkerhet og krisehåndtering*. Oslo: Universitetsforlaget.

Rykkja, L. H. (2014b). Øvelser som kriseforebygging. In P. L. A. L. Fimreite, P. Lægreid, L. H. Rykkja (Ed.), *Organisering, samfunnsikkerhet og krisehåndtering* (2 ed., pp. 144–158). Oslo: Universitetsforlaget.

Seeger, M. W., Sellnow, T. L. & Ulmer, R. R. (2003). *Communication and Organizational Crisis*. Westport, CT: Praeger.

Sellnow, T. L., & Seeger, M. W. (2013). *Theorizing Crisis Communication*: United States: Wiley-Blackwell.

Sivilbeskyttelsesloven. (2010). *Lov om kommunal beredskapsplikt, sivile beskyttelsestiltak og Sivilforsvaret*. (LOV-2010-06-25-45). Retrieved from https://lovdata.no/lov/2010-06-25-45/§1.

Timothy, L. S. A. M. W. S. (2013). *Theorizing Crisis Communication*: United States: Wiley-Blackwell.

Tomasgård, A.-M. (2020, 17.1. 2020). Uro for fleire kutt i psykiatrien. *Sunnmørsposten*. Retrieved from https://www.smp.no/nyheter/2020/01/17/Uro-for-fleire-kutt-i-psykiatrien-20855706.ece?rs9547261582232014670&t=1.

Windahl, S. (2009). *Using Communication Theory: An Introduction to Planned Communication* (2nd ed.). London: Sage.

Svein Brurås

# Crisis Reporting and the Ethics of News Media

**Abstract** The crisis management should not attempt to obstruct, instruct or control news reporters. News media have a legitimate right to cover the crisis, grounded in the public's right to know. However, news media have their own professional norms, guidelines and rules of conduct, which are crucial to a responsible journalism on crises. Independent news media do not regard the brand and reputation of the stricken business, but they certainly have obligations to provide a true and accurate account of the crisis – and to protect victims and affected individuals from further damage as a consequence of insensible publication. The chapter discusses some ethical principles and current challenges in crisis journalism, based on Scandinavian journalism ideology and practice.

**Keywords:** journalism, media ethics, news production, crisis journalism.

A passenger ship is in serious trouble in stormy weather off the coast. A large company with hundreds of employees goes bankrupt. An explosion hits a construction site, there are several casualties. When the crisis strikes, it will immediately catch the news media's attention. Within a short time, journalists will arrive at the doorstep of those who are affected. The news media want to observe and take pictures, and they demand to speak with leaders and employees. For those who shall manage and deal with the crisis, the media's interest can be both disruptive and destructive. Not only do they have to handle nagging and demanding journalists just when they are in a stressful and confusing situation. In addition, they lose control over the information that reaches the public. The media might tell another story than the business management would prefer.

Accidents, catastrophes and crises are "good news" for the media – not in a cynical sense meaning that they enjoy it, but as a gripping narrative and a poignant story. The crisis possesses certain characteristics that fit with the criteria of a good news story. It breaks with what is normal and expected, and it has elements of surprise, drama and sensation. It feels relevant to the public because it disturbs their sense of safety. It is

unpredictable and dynamic, it is in progress right now and it entails an excitement: how will it end? For all those reasons, it arouses the media's interest.

However, when the news media are challenged to state the reason for their strong interest in the crisis, they do not emphasize the appealing story or the commercial potential. Instead, they point out the public's right to know, and the role of media as a provider of true and independent information. According to the press itself, this is the main motivation for covering the crisis.

In this chapter, we will argue that the news media's right to "interfere" is justified by the public's right to know. Reporters have a legitimate right to turn up at the scene of a crisis and to ask questions. They have a right to publish bad news as well as good news. But the reporter's right to know and to report certainly has its limitations, legally and ethically. Such limitations may be grounded in a number of considerations: security, rescue work, danger of increased risk, spoiling the investigation and privacy of affected individuals – and may be secrecy for other reasons. Media exposure will, in some cases, cause harm and damages. The main question is at what point such damages outweigh the benefit of openness, transparency and the public's right to know.

The Scandinavian codes of media ethics will be important references in the chapter. Media scholars and analysts have characterized Scandinavian news media as "remarkably responsible media" (Bertrand 2003: xi, see also Lidberg (2011) and Kirchner (2012), and codes of ethics represent accumulated knowledge from journalism practice and from media research over years.

## 1. The Public's Right to Know – and the Media's Right to Report

*"What are you doing here? Please leave us alone. Don't interfere and mess up the situation, we will inform you in due time."*

When approaching a crisis situation, reporters are frequently met with questions and statements like this. And why exactly should news reporters put their noses into other people's misfortune? Well, the reason is that we, the public, need to know about dramatic incidents in our society.

When a business or an institution is hit by a crisis, the management may wish the news media to stay away, or at least to wait until the institution itself is ready to present information. News media, however, will neither wait nor leave it to the management to inform the public. They will publish immediately; they will make use of any source they can find – and they approach the incident with a critical eye. They insist that they perform a public service, which they have a full right and even a duty to carry out. In the very first chapter of the Norwegian Code of Ethics, it says, "*It is the right of the press to carry information on what goes on in society and to uncover and disclose matters which ought to be subjected to criticism.*"[1]

The public has a right to know. Sometimes we need to know for safety reasons. We have a legitimate claim to learn about incidents that may threaten our safety, either it is about toxic waste from a factory, a fire or explosion, bad food in a restaurant or inadequate routines at the hospital.

Other times we need to know for political reasons. In a democracy, the citizens are the highest authority. In order to exercise their role as citizens, for instance by influencing legislation on potential harmful business, the people need to know what is going on in society, not least about dangers, risks and accidents.

The "Right to Know" is not an invention made by the news media in order to serve their own purpose. It is a concept that follows from the general freedom of information that is established and protected by the international declarations of human rights. Without the right to seek and receive information, freedom of expression becomes illusory. Freedom of information is a prerequisite for the people to act as citizens and to participate in democracy and in public debate.

In the European Convention on Human Rights, the public's right to know is explicitly connected to the freedom of speech. The Convention's Article 10 states that everyone has the right to freedom of expression, and this right "*shall include freedom to hold opinions and to receive*

---

1   Code of Ethics of the Norwegian Press, paragraph 1.4.

*and impart information."* Without knowledge on important matters in society, the freedom of speech on social matters becomes illusive.

However – the phrase "the public's right to know" is a rather imprecise and cloudy formulation. Right to know what? This "right" is obviously not without limitations. The public is not entitled to know everything. One limit must be drawn towards privacy and personal information. Another limit must be drawn toward information that, for different weighty reasons, is confidential and excluded from the public's right to know.

The public's legitimate rights must not be confused with the public's curiosity. The public has the right to know about matters of social importance. We are entitled to know about matters concerning our common welfare and security. We have the right to know how politicians and leaders in society carry out their job, how public authorities take care of their tasks and assignments and how private enterprises and organizations behave in our common society. We are entitled to know if a company pollutes the environment; if a sausage factory produces poor products, if a cleaning business exploits the workers or if a nonprofit charity deceives its donators and misuses the funds.

Issues that occur in the private sphere may sometimes be of public interest. Domestic violence is one example. Another example may be when a cabinet minister falls seriously ill. But none of us has a right to know about a pop star's private life or the health condition of the mayor's husband, even if some would think it is interesting. The "right to know" applies to issues of public interest – and it is the journalists, the newsroom and finally the editor who decides what is of public interest and where to draw the line.

So, when reporters and photographers arrive at the scene, demanding information and asking unpleasant questions, they do it on the basis of "the public's right to know" and in accordance with news media's task and mission in society. The press contributes to the citizen's knowledge and understanding of the world, and is therefore entitled to dig up stories and inform about negative and positive events. News media are in the right to publish fortunate as well as disturbing stories, and shall not accept any command of silence from anybody, even not from the directors and managers of the business in question. The loyalty lies with the readers, listeners and viewers.

The possibility that a story may harm the exposed organization or company is subordinate. The mission of providing facts and enlightenment to the public is superior.

Off course, not all the content in news media applies to the concept of "the public's right to know." Every day, media pours out stories, which do not qualify as "important" or of major social or political significance. As we all know, media content includes pure entertainment, plain humor, simple melodrama and sheer nonsense. Such stories cannot be defended by the public's right to know, and if the story bumps against the ethical principle of avoiding harm, it may quickly imply no publishing at all.

## 2. Aspects of Truth-Telling

When a crisis is about to be covered by news media, the ethical demand for truth and accuracy may be challenged in a certain way. Because the public's attention is catched by the drama, the uncertainty and the risk, it is tempting for the journalist exaggerate just these aspects. The more dramatic, the more stirring. The more exciting, the more clicks. The newsroom sharpens the news angle and focuses hard on "worst case," while a sober and comprehensive understanding of the situation gets lost and disappears in the story.

Now, a good journalist is in fact *expected* to sharpen the story, that is, to find the sensational aspects and the stirring angle. This is a part of the professional skills of a journalist. However, the good journalist will not let these requirements affect the level of precision and accuracy. The good journalist will make sure that the public gets a realistic and adequate picture of the situation.

There is a strong obligation to truth in journalism. If we look into the ethical codes of journalists in different countries, we will always find a reference to the duty of truth telling. The Norwegian Code of Media Ethics urges, *"Be critical in the choice of sources, and make sure that the information provided is correct."*

The obligation to truth and accuracy requires more than only to abstain from lying. Here we shall not go into invented stories and fake news although it is an increasing problem. It is more related to social media than to professional news media. What we *do* have among the

professionals is journalists who publish *inaccurate* information, who are unpunctual and slumsy, who create angles and titles that compromise the reality, and who leave out important information because it does not fit in with the angle.

The obligation to truth in media ethics is broken when

- journalists sharpen and dramatize stories to such a degree that they no longer give a correct representation of reality;
- journalists pass on rumors, and fail to check and verify the information;
- journalists misunderstand a situation or a circumstance;
- journalists – because of lack of knowledge – publish wrong information;
- journalists allow themselves to be *used* by sources to present an issue in a certain way.

We should add that in journalism, truth is a rather complicated concept. The different actors and parties will in some cases have different perceptions of what is the truth. The comprehension of truth depends on your position and your perspective. News media must recognize that it not always possible to achieve the final and objective truth. When *verification* is not possible, journalists must go for the second best, which is *balance*. More sources are needed and different positions must be expressed, in order to give a broad and adequate picture of the situation.

## The Core of Journalism

What is the core of journalism? Bill Kovach and Tom Rosenstiel (2007) answer: "*Its essence is a discipline of verification.*" Journalism is about learning and reporting the facts of the present time. The craft of journalism has many components, and its quality requirements can be defined in many different ways, but its professional ethics and work methods are developed and designed to collect and disseminate reliable information. In his widespread textbook on news reporting, Melvin Mencher states that reporters are required to "*verify all information when observation is no possible.*" In a more recent textbook on news journalism, Tony Harcup emphasizes the importance of "*a questioning attitude*" throughout the journalist's work (Harcup 2009: 76). The distinguished journalist Nick Davies writes that "*journalism without checking is like a human body without an immune system*" (Davies 2008: 51). And the world famous

Norwegian journalist, Åsne Seierstad, says that *"the journalist's primary tool is research. Talking to people. Inquiring. Listening. Making notes. Reading reports (...)* (Seierstad 2013).

In the Code of Ethics of the Norwegian Press, it reads, *"Be critical in the choice of sources and make sure that the information provided is correct."* Every year, several newsrooms are convicted by the Press Council for breaches of this particular paragraph. In the Swedish Code of Ethics, it is stated quite similarly: *"Be critical of news sources. Check facts as carefully as possible in light of the circumstances, even if they have been published earlier."* And in Denmark: *"As far as possible it should be verified whether the information given or reproduced is correct."* And finally, the code of the US Society of Professional Journalists states in the first headline of the very first chapter: *"Test the accuracy of information from all sources (...)."* All quotations from the codes of ethics apply to online news to the same degree as news on traditional platforms.

The news gathering and the source groundwork has been the object of critical attention in several studies. News media have as we know gone through substantive changes with regard to technological and economical terms, followed by demand for increased productivity and effectivity in the newsrooms. It has been proven that the independent editorial research and fact-checking has been weakened. Online newsrooms are characterized by speed, rapid publishing and a high production pressure. According to the journalists themselves, a consequence is fewer sources than desirable, thus impairing the quality of the editorial product.

Morever, the news is to a large extent influenced by professional sources, while the content is characterized by ready-made press material and of the media quoting each other. Content analyses have confirmed that the rolling and frenetic 24-hour news coverage impoverishes the quality of the news. The British press researcher, Martin Conboy, states that *"(...) there is evidence that journalists are becoming more re-processors and recyclers than generators of stories."* The German press researcher, Thorsten Quandt, states that *"there is simply not enough time for a lot of research, cross-checking, and original writing."* For that matter, the assertion that the high speed of online news dissemination affects the content has been thoroughly verified and documented in the research.

## 3. Immediacy vs Verification

Speed has always been important in news journalism. News are the heartbeats of the day, and every newsworthy incident must be brought to the public as soon as the technology allows. Since news journalism was "invented" more than 150 years ago, there has been a fierce competition between the news providers about being first with the news.

This is even more so in the age of digital journalism. The "deadline" that used to come up once a day, does not exist in online news. Today, news is published 24/7. Ideally, important news should be passed on at the moment they happen. For planned events, this is off course possible. Live coverage is the ultimate news reporting. When "breaking news" occurs, the leading news media try get as close as they can, and they go live as soon as possible. For online news in general, speed is vital. Immediacy is one of the so-called affordances that separate online news from traditional news. An affordance is a potential, a possibility, and it is a property which provides a possibility.

*"Immediacy is the dominant paradigm of online journalism,"* writes David Domingo. It implies the continually 24/7 publication, real time reporting and continuous updating. It also implies that online news texts, in principle at least, are "unfinished" by the time they are published. A short news story may be preliminary and highly incomplete. The staff of the online newspaper will quickly publish whatever information they have, even if it is not that much; later on they publish more, and there are updates and additional information. Online news can be changed and updated, and they can be influenced through interactivity. As opposed to static traditional news published at regular times, online news has been characterized by several researchers as "liquid" or "fluid" (Deuze 2008; Karlsson and Strömbäck 2010; Saltzis 2012). They are in a way moving, changing.

So there is an unfortunate concurrence: Exactly when the situation is most uncertain and demanding for the crisis management, just when they need some time to gain control, get the facts clear and consider the situation, that is exactly when the media demand information and update *immediately*.

Social media increases the time pressure even more. When an incident occurs, it will quickly turn up Twitter and other platforms, and it will

promptly be shared and spread. The professional media cannot allow themselves to fall too far behind. While rumors are running in social media, people go to the professional news sites for confirmation, and they must find *something* there.

How does this demand for *immediacy* go along with the character of journalism as a *truthseeking enterprise*, as a provider of trustworthy and accurate information about reality?

For news media, the demand for immediacy and the demand for verification pull in opposite directions. The demand for immediacy is a threat to the principle of fact-checking. The two demands may even be mutually exclusive. However, in journalistic practice, a trade-off takes place. Increasing the one will decrease the other. The newsroom must decide what is *sufficient* research, what is sufficient evidence and what is a sufficient number of sources, weighed against the need for rapid publication. In some way, they must attend to speed as well as thoroughness.

*Immediacy* is a professional criterion in news journalism. It is considered as an important journalistic virtue to publish the news as soon as possible, preferable faster than the competitors. But it is also regarded as commercially important, because readers and users will be attracted to a news site that they know is updated with the latest news.

Likewise, *verification* is a professional value of great importance to the profession. The press has been proud to announce that they provide accurate and true factual information. Obviously this is of crucial importance to the society, to the people who ground their actions, their lives, their fear, their political attitudes and on the information provided by the media.

So which of them wins? Immediacy or verification? Well, it will be a crushing defeat for quality journalism if the latter should lose. But speed is still important. Journalists will not wait until the crisis management is ready to speak.

## 4. Sources and the Quality of Journalism (or: Why News Media Will Pick Their Own Sources)

A solid range of relevant sources has been considered as an important hallmark of quality journalism. To give a proper service to the public,

the news media should provide correct and trustworthy information based on a diversity of credible sources. This is closely connected to the emphasis journalists, and editors pay to their *independence* and to *editorial autonomy*. Information should not be forwarded automatically and unedited from public relation departments, neither should it be based on cut-and-paste from other media sources. Instead, it should be the object of editorial scrutiny and control. Journalism is characterized by a free selection of sources; an investigative approach; a critical attitude toward the sources and a diversity of sources. The more sources, the better journalism – provided that the sources are relevant, credible and competent.

## Sources in Crisis Journalism

When a crisis occurs and catches the attention of the news media, the reporters start looking for sources. What kind of sources depends of the type of situation, but certain patterns are common.

- With all kinds of accidents or catastrophes, the police will be among the first to be contacted. The police will quickly give a few basic facts of the incident and their operation.
- Rescue Coordination Centers are an important source. Dealing with media enquiries are one of their tasks.
- Reporters will quickly search for the leaders of the organization in question – the CEO and other high-ranking leaders. However, they will regularly make do with communication staff members.
- Reporters also approach staff of lower rank and employees who are close to the issue. They are valuable sources with first-hand knowledge, but may be reluctant to speak. Whether they have any professional secrecy or have been instructed not to speak is not something the press takes into account.
- Former employees.
- Victims. People who in one way or another was hit or affected by the incident.
- Witnesses. Neighbors. Anyone that might have heard or seen something. Have they noticed anything of interest before?
- Social media. What has the organization and its leaders and employees been posting lately? Can we think of any relevant hashtag worth checking?

- Written sources. Documents, reports. Correspondance with local authorities. Reporters have the right to look into that. Have the business had any kind of inspections or supervision lately?
- Databases. Financial statements and reports.
- Observation. Reporters and photographers appear immediately at the site, they observe the scene and they report what they see.

So the crisis management who believes that they are the only one who should give information about the crisis – well, news media does not accept that. For journalists, it is important to have a broad supply sources, with different competence, experience and points of view.

Reporters and photographers can sometimes be quite insistent and persistent when they approach potential sources. They are from time to time criticized for their behavior, and accused of being aggressive, insensible and in lack of empathy. However, their professional ethics comprehends not only publication, but also the research and news gathering process. The codes of media ethics give sources certain rights and protection.

## Conduct at the Scene

The site of an accident is usually blocked by the police. We all know the colored ribbons that mark the no-go-zone. Everyone must comply with police directives, journalists included. Reporters who can identify themselves as members of the press are usually allowed to get closer to the scene, but still with restrictions. The reason for such limitations is primarily to avoid any disturbance of the rescue work. Other reasons may be the risk of corrupting evidence and cause trouble for the investigation, or it might be dangerous to stay at the scene, for example after a landslide or a fire. What the police cannot do is to turn away reporters out of considerations for the victims. Such considerations should the press make for themselves.

And they do, at least normally. *"Always show the greatest possible consideration for victims of crime and accidents,"* says the Swedish Code of Media Ethics. This will imply to abstain from shooting photos of injured individuals without their explicit consent, and to show considerations toward people in grief or shock. Traumatic stress may imply that the person is not in control of the situation, and should be protected from

giving statements that he or she may regret later. It is not always obvious that a person is in shock, but it is the responsibility of the journalist to be observant to the possibility.

On the site of an accident, it is not unusual to witness strong emotions expressed from those affected. There is crying, fear, confusion, anger, outbursts and suffering. It is good journalistic practice not to expose private emotions without explicit consent, in a situation where people are not able to control their feelings.

The health status of survivors may in some cases indicate that they should be protected from the press. And we must accept that health professionals are best suited to make such decisions. However, if such conditions are not present, healthcare professionals have no authority to interfere between journalists and sources in order to prevent an interview. Victims, even when they are injured, must be allowed to talk to journalists if they want.

Sometimes the press is asked to leave the scene for other reasons – because some people don't want them there. The management of the business or the owner of the property may want to hide something from the news media, or they don't want the press to get in touch with eyewitnesses. News media will not accept this. Normally, the owner of a private property has the right to send off people from the property, but when an incident of public interest occurs, reporters and photographers have the right to be present and observe within the limits stated above. If they are asked to move away, they will ask for legitimate reasons.

Conclusion: Journalists should not be turned away and refused admittance to the site of the crisis. Instead, they should be given proper working conditions. Journalists have the right to follow the rescue work closely as long as they do not disturb the rescue operation or the investigation, and they have the right to talk to those affected and to eyewitnesses.

## Other Source Ethical Issues

*Checkbook journalism* is a controversial issue. Payment to sources is a phenomenon we know best from celebrity journalism, but it also occurs in crime journalism and in journalism on accidents and catastrophes. Some media outlets offer money to criminals, victims, their relatives,

eyewitnesses or others who possess vital information, in order to get exclusive information and have their story. But money can influence what they tell. When information is priced and become a commodity on sale to the newsroom with the highest bid, the source may be tempted to add some extra to the story, to please the media and may be to earn a little more.

Just when a political party in Norway was about to take place in the coalition government, a scandal and a crisis hit the party, and above all the party leader. She was appointed as the government's new minister of culture, but now she suddenly was accused of sexual harassment of a young party fellow ten years earlier.[2] The story was first published in a conservative online news outlet called "Resett," who offered the allegedly offended young man 400.000 kroner (50.000 pounds) to step forward and tell his story to the magazine. The journalistic method was condemned by the Norwegian Press Association.[3]

*Hidden identity, hidden camera and hidden microphone* are methods that reporters should employ only in exceptional cases, and with great care. The general rule is that reporters work in openness. They introduce themselves, and do not try to hide their role and intentions. Everyone shall know when they speak to a journalist – and thereby to the public. But in some cases, the newsroom got a tip or has a suspicion on a matter of great importance, which is impossible to prove and expose with ordinary journalistic methods. Hidden methods are ethically acceptable if they are *"the only possible way to uncover cases of essential importance to society."*[4]

*Protection of sources* is a crucial part of media ethics. In general, it is a part of good journalism to reveal the sources and tell the public about the origin of information. Then the public can decide for themselves how trustworthy the information is. However, in some cases, it is necessary to promise anonymity to a source. Sometimes, an informant takes a risk by talking to a journalist. The source can for instance lose his job if he tells about blameworthy conditions in his company, or he can be exposed

---

2  https://www.newsinenglish.no/2018/01/17/grande-confronts-harassment-rumours/.
3  https://www.vg.no/nyheter/innenriks/i/Rxy895/presseforbundet-om-resett-massivt-brudd-paa-presseetikken.
4  Code of Ethics of the Norwegian Press, paragraph 3.10.

to threats and revenge if he reveals secrets from criminal circles. But this kind of information can be of huge importance to society. That's why the press in some situations promises confidentiality and source protection. This is a promise that must be fulfilled at any cost. Even if the police or the judge asks for information, the reporter shall not reveal the identity of the source.

## 5 Chasing the Individual

An accident with casualties is not a private matter. It is a public matter that the news media should report. An accident has *elements* of private nature, which are visible and striking at the scene, but which should not be reported neither in text, audio and photo.

The public is entitled to know the facts about what has happened, the reasons why it could happen and whether the rescue operation works well or not. The public has a right to get acquainted with circumstances that could endanger our safety, and they have the right to know about risks in our surroundings. Stories about accidents have a preventive effect; they will cause people to behave more carefully and to be aware of risks. The public also needs to know if authorities and governmental agencies do their job, and whether the accident could be avoided in any way.

What we *do not have* a legitimate right to know about is private reactions, emotional outbursts and personal matters of the involved.

### Exposing Feelings and Emotions

A media ethical minefield is "the pursuit for emotions." From television news, we sometimes get the impression that the most important thing is not what happened, but what the involved human beings *feel* about what happened. The attitude among TV reporters is, it seems, that "good television" is tears, anger, despair and personal feelings. Narratives that emphasize such elements will touch and move the viewers; they provide drama, proximity and empathy.

However, such narratives may draw close to the border of privacy. Utilizing a human being as a measure to achieve a dramatic effect, without the person's consent, is offensive and ethically irresponsible – not least when the person is in imbalance and does not control his feelings and emotional expressions.

We do not say that feelings do not belong in the news, because they do. The news should mirror life, they should reflect mourning and happiness and people should cry and laugh, be furious and joyful and be sad and cheerful in the news. The prerequisite must be that they are in control of their feelings and are aware that their emotional expressions will be exposed in media. There must be what we call "informed consent." This means not only a tacit approval, but it means that the person really understands what he or she agrees to. And it is the responsibility of the journalist to make sure that such "informed consent" exists.

When journalists cover an accident, they try to get in touch with people that have been involved. First-hand sources, the survivors, are important sources. They can give a detailed account of what happened just before the casualty and what led up to it; they can impart the dread and the fear they just have been through, and they can tell how the rescue operation worked out from their point of view. Survivors as well as their relatives can convey the emotions and the fright, which are a part of the incident.

However, journalists must be aware of the border toward privacy. The media ethicist Lee Wilkins underlines that privacy is about two things – human dignity and control.[5] The Norwegian Code of Media Ethics addresses the issue like this: *"Show consideration for people who cannot be expected to be aware of the effect that their statements may have. Never abuse the emotions or feeling of other people, their ignorance or their lack of judgment."*[6]

Those who are affected by an accident – survivors or relatives – are concerned with how the event is covered in the media. But we know that their expectations vary a lot. Some will respond negatively to any approach from the media – some of them *strongly* negative, they just want the press to disappear and leave them alone. The news coverage becomes another strain and stress factor in addition to the shock and trauma. Others respond just the opposite. They apprehend the media coverage in a positive way, as a recognition from society that the incident was as serious, dramatic and important as they have experienced it themselves (Brurås 2014: 277).

---

5   Wilkins in Friend and Singer 2007: 84.
6   Code of Ethics of the Norwegian Press, paragraph 3.9.

A common feature among survivors and their relatives is that they are occupied with how the news media describes and depicts the accident. They study intensively the media texts, and they get upset if they find a minor fault or an inaccurate detail.

## 6 Conclusion

*"Tell it early, tell it all and tell it yourself"* is an old advice to the crisis management.[7] Otherwise, the news media will tell it, sooner or later, and the affected business will stand even more on the defensive. Transparency and an open and comprehensive communication may, in the short run, seem harmful in the eyes of the management, because of the negative impact it may have on the business's reputation and brand. The news media, however, are not obliged to regard the reputation of any business or institution. On the contrary, they are obliged to report every piece of information, which they consider as important. And in a crisis situation, the bar is low. The public´s right to know will legitimize possible harmful consequences of a story. However, professional journalism is also responsible journalism. It is news media`s responsibility to avoid *unnecessary* harm. This requires a conscientious weighing where the obligation to inform and the loyalty to the public is placed in one weight bowl, and the harmful effects the story might cause to the affected parties and involved individuals are placed in the other weight bowl. News media`s vital role in a democracy by providing independent information and critical comments on current affairs will weigh heavily in such considerations.

## References

Bertrand, Claude-Jean (2003): *An Arsenal for Democracy. Media Accountability Systems.* Cresskill, NJ: Hampton Press.

Brataas, Kjell (2018): *Crisis Communication. Case Studies and Lessons Learned from International Disasters.* New York: Routledge.

---

7 The phrase is collected from the book "*Truth to Tell: Tell It Early, Tell It All, Tell It Yourself: Notes from My White House Education*" (1999), written by the former PR-advisor to President Bill Clinton, Lanny J. Davis.

Brurås, Svein (2014): *Etikk for journalister. (Ethics for Journalists)*. Bergen: Fagbokforlaget.

Brurås, Svein (2016): Normative Features of a Successful Press Council. *Journal of Media Ethics*, 31 (3), 162–173.

Conboy, Martin (2013): *Journalism Studies. The Basics*. London: Routledge.

Davies, Nick (2008): *Flat Earth News*. London: Vintage.

Deuze, Mark (2008): The Changing Context of News Work: Liquid Journalism and Monitoral Citizenship. *International Journal of Communication*, 2 (2008), 848–865.

Domingo, David (2008): "When Immediacy Rules: Online Journalism Models in Four Catalan Online Newsrooms", in Paterson, Chris and David Domingo: *Making Online News. The Ethnography of New Media Production*, pp 77–97. New York: Peter Lang.

Friend, Cecilia and Singer, Jane B. (2007): *Online Journalism Ethics. Traditions and Transitions*. New York: M. E. Sharpe.

Harcup, Tony (2009): *Journalism. Principles and Practice*. London: Sage Publications.

Hornmoen, Harald and Backholm, Klas (2018): *Social Media Use in Crisis and Risk Communication: Emergencies, Concerns and Awareness*. Bingley, UK: Emerald Publishing Limited.

Karlsson, M and Strömbäck, J (2010): Freezing the flow of online news. Exploring approaches to the study of the liquidity of online news. *Journalism Studies*, 11 (1), 2–19.

Kirchner, Lauren (2012): Self-Regulation Done Right. How Scandinavia's Press Councils Keep the Media Acountable. *Columbia Journalism Review*. Published online April 24, 2012. Retrieved from http://www.cjr.org/the_news_frontier/selfregulation_done_right.php?page=all.

Kovach, Bill and Rosenstiel, Tom (2007): *The Elements of Journalism*. New York: Three Rivers Press.

Lidberg, Johan (2011): A One-Stop Shop for Grievances: Norway's Self-Regulation as a Way to Rebuild Trust in Australian Journalism. *Australian Journalism Review*, 33 (2), 129–143.

Mencher, Melvin (1977/1991): *News Reporting and Writing*. Dubuque: Wm. C. Brown Publishers.

Quandt, Torsten (2008): "News Tuning and Content Management: An Observation Study of Old and New Routines in German Online Newsrooms", in Paterson, Chris and David Domingo: *Making Online News. The Ethnography of New Media Production*, pp. 77–97. New York: Peter Lang.

Saltzis, Kostas (2012): *Breaking News Online. How News Stories Are Updated and Maintained Around-the-Clock*. Journalism Practice 6 (5–6), 702–710.

Seierstad, Åsne (2013): *Scener fra virkeligheten*. Bergens Tidende 21.11.2013 s 45.

Idar Flo

# Framing of the Child Welfare Services in the «Naustdal-Case»

**Abstract** In November 2015, the Norwegian Child Welfare Service (CWS) retrieved five children from a Norwegian-Romanian family and placed them in three different foster homes. The parents in the so-called Naustdal case were charged with family violence. The case led to fierce criticism and strong reactions against the CWS both in Norway and abroad. CWS was thus in a situation where there was considerable uncertainty as to whether the institution functioned properly within the applicable legislation, and questions were also asked whether the legislation took sufficient account of parents. CWS had to deal with a potential crisis because of a case that threatened to undermine trust in the institution. In order to find out how the CWS's risk communication is expressed in the media, we have used framing theory to examine how the CWS was presented in this specific case. The focus has been on how the CWS and other sources were used in the public service broadcaster in Norway, NRK (Norwegian Broadcasting Corporation). It concludes that NRK's presentation of the Naustdal case was fairly balanced in the sense that through the selection and use of sources, none of the interpretation frames was dominant.

**Keywords:** Norwegian Child Welfare Service, framing theory, sources, media, citizens' confidence in institutions

## 1) Introduction

The Nordic countries have been characterized by a high degree of trust between citizens, the authorities and to the welfare services provided.[1] This confidence seems now to be under pressure, with some of the "Welfare State's professions" being subjected to sharp criticism. In social media and other parts of the public, it is also claimed by some that the so-called mainstream media should be much more critical in its coverage of how some of these welfare professions are

---

1   The Research Council of Norway (NFR): The Research Program for Welfare, Labour and Migration 2009–2018.

practiced.[2] This chapter will take a closer look at how the media covers the child welfare services (CWS), which is one of these professions where surveys show that trust is relatively low.

In order to provide good services, the CWS is dependent on the trust of the population. Confidence forms the basis for open communication and a higher degree of cooperation. On the other hand, low confidence can prevent parents from seeking help, which may result in children and families not receiving necessary help from the CWS. For the CWS to be able to carry out its statutory tasks, it is therefore crucial that the institution can deal with situations where there is a risk that confidence will be weakened.

Confidence can be based on reason and knowledge of the CWS responsibilities and methods, but it can also be based on emotions because of what you can hear about the service from relatives and acquaintances who have been in contact with the CSW. Familiarity and knowledge can also be gained through the media, and this contributes to the notions of CWS being formed and the degree to which one has confidence in this institution. The communication strategy to the Norwegian Directorate for Children, Youth and Family Affairs ("Bufetat") also emphasizes that the media is very important when it comes to the public's trust in CWS. In the brochure "When the journalist calls - advice for CWS employees," Bufetat writes, "The media is the most important channel for influencing people's attitudes to CWS '(...)' In order to create an understanding of child welfare, one must obtain facts and build trust. This is done, among other things, through media outlets."[3] The brochure also gives advice on how to respond if you cannot comment on a specific case by emphasizing that "The duty of confidentiality must also safeguard the children's interests in the short and long term." In cases where CWS is considering

---

2   See https://www.bufdir.no/Global/Befolkningenes_holdninger_til_barnevernet.pdf. See also http://www.medienorge.uib.no/files/Eksterne_pub/mecin_delrapport_7_juni_2017.pdf and https://press.nordicopenaccess.no/index.php/noasp/catalog/view/16/56/184-1.
3   Ministry of Children and Families 2012: «Barnevernet – en hjelper: Kommunikasjonsstrategi 2013 – 2016». It is Bufetat who is responsible for the Child Welfare Service at the national level.

submitting a case to the county board, it is advised to say, " In general I can say that we only promote cases of takeover of care if we consider that there is serious neglect and the child cannot stay at home. We look forward to getting the court's assessment of this."

The CWS has a statutory duty to intervene and must in serious cases take over the care of children where the conditions are present. From the media's perspective, taking over care is a dramatic conflict between "the little citizens" against a central public institution, making media coverage of such a case likely. Thus, if the media portrays CWS actions in a negative way, the institution can quickly end up in what Løvik defines as a crisis that is "a situation that threatens or may threaten the core business and/or credibility (reputation) of a business or organization (Løvik 2015:20)." From a CWS perspective, it will therefore be necessary to make a risk assessment, considering how likely it is that such a crisis could occur and what consequences it could have (Løvik 2015:24–25). Because such an event meets several news criteria, the likelihood of the case being discussed in the media is high, and for CWS, the trust in the institution may be at stake. Therefore, it is very important for the public's confidence in the institution that the intervention is perceived as legitimate, but, as Veland claims, actions can be legal "(...) that is, legal, but without being perceived as legitimate, that is, valid and correct (Veland 2004:199)." Confidence can therefore also be seen as a yardstick on whether the CWS' mission is in accordance with ordinary people's perception of what is right and wrong. An important factor that the CWS must always take into account in its risk communication is the statutory duty of confidentiality, which makes it difficult for the institution to explain and comment on their own decisions in specific cases.

Studies show that trust in CWS is relatively low, especially among some immigrant groups. Several researchers have pointed out that this may be due to cultural differences regarding the view of the family's role and upbringing of children, and the extent to which authorities have a legitimate right to intervene in a family.[4]

---

4  https://www.bufdir.no/Aktuelt/Tre_av_ti_personer_med_innvandrerbakgrunn_har_liten_tillit_til_barnevernet/.

Several cases, in which the CWS has taken over the care of the children from parents with a foreign background, have led to demonstrations outside Norwegian embassies in several countries. It has been claimed that "the Norwegian state steals children," and several foreign politicians have also reacted strongly.[5] The Foreign Ministry has stated that such cases threaten to weaken Norway's reputation.[6]

In order to find out how the CWS's risk communication is expressed in the media, we shall therefore take a closer look at how the CWS is presented in a specific case where the father of the children is foreign. The chapter will therefore focus on how the CWS and other sources were used in the public service broadcaster in Norway, NRK (Norwegian Broadcasting Corporation).[7]

In November 2015, the CWS retrieved five children from a Norwegian-Romanian family and placed them in three different foster homes. The parents in the so-called Naustdal case were charged with family violence, but got the children back in June 2016 after fierce criticism and strong reactions against the CSW both in Norway and abroad.[8] The family moved to Romania in August 2016 where the parents in an interview on Romanian TV admitted that they had slapped their children. The parents are Pentecostals, and several of their supporters claim that fear of Christian indoctrination was the real cause of the CWS taking over the care of the children (VG August 10, 2016). The case was later appealed to the European Court of Human Rights.

---

5   On February 9, 2015, VG wrote, "Czech President compares Norwegian child welfare with Nazi program." The newspaper quoted President Milos Zeman from an interview he had with the Czech media Blesk: "The boys are in foster families, similar to Lebensborn. Their mother is allowed to meet them for 15 minutes twice a year and she is not allowed to speak Czech to them." The case was about the CWS who took over the care of the two sons of the Czech woman Eva Michalakova who lived in Norway.
6   "Norwegian CWS seen through international eyes." Seminar October 22, 2017, Literature House, Oslo.
7   https://www.nrk.no/about/a-gigantic-small-broadcaster-1.3698462.
8   In 2010, the Children Act stated that children should not be subjected to any form of violence, nor for example light spank, although it is alleged as part of their upbringing.

## 2) Theoretical Framework

We are not only concerned with the scope, but also how the media reports on cases, and how certain aspects of an event are highlighted above others. A news article has many elements like headlines, photo etc., and each element adds meaning that the reader must interpret. We will therefore look for elements in NRK's articles on this matter that can give the audience a notion about different aspects of the CWS. Within so-called *framing theory*, it is emphasized that cases are presented within certain interpretive frameworks, and that the public may have a tendency to interpret these matters within such interpretative frameworks. In this chapter, we will take a closer look at framing theory, and how this can be used as a basis for an analysis of the Naustdal-case. Todd Gitlin has provided the following definition of framing: "Frames make the world beyond direct experience look natural. (...) Frames bring order to events by making them something that can be told about; they have power because they make the world make sense (Gitlin 2003:27–28)." Robert Entman has argued that all interpretive frameworks help to 1) define and refine the problem, 2) identify the root cause of the problem, 3) provide a basis for moral assessments, and 4) suggest solutions and measures. Entman has summarized the framing concept as «selecting and highlighting some facets of events or issues, and making connections among them so as to promote a particular interpretation, evaluation, and/or solution (Entman 2003:5)."

It is beyond the scope of this chapter to study all the elements of a text equally thoroughly, and we have chosen to focus on the use of sources. To what extent the CWS (and others) are used as sources and explained their point of view in the case will greatly affect this case's interpretation framework, and will therefore be the central element in the analysis.

## 3) About the Material

From December 2015 and for more than a year ahead, the CWS in the small municipality of Naustdal was at the center of a controversial case that created major headlines in both Norwegian and foreign media. We will examine how the CWS's handling of the case was covered by the NRK, and whether it was framed in a way that could weaken confidence in the CWS.

NRK's first news report on the case came on December 22, 2015, where it was referred to a case in an unnamed municipality in the county of Sogn and Fjordane under the heading "CWS case creates storm from Christian environment." The last article in the material came on September 20, 2017, and stated that the County Governor had discovered a breach of the duty of confidentiality of the CWS in Naustdal. During this period, NRK had 40 news articles referring to the case between the CWS and the Norwegian-Romanian couple. The material can be divided into the following phases:

Phase 1 (from 22.12.2015): NRK writes about a controversial case where the CWS have taken care of five children from a family in an unidentified municipality in Sogn og Fjordane county. The foreign origin of the children's father is not stated, but is referred to only as "the father's homeland." Foreign Pentecostal churches organize demonstrations against Norwegian CWS.

Phase 2 (from 28.1.2016): We are told that the case concerns a Norwegian-Romanian family in Naustdal municipality. The municipal director in Naustdal, experts and relatives of the family comment on the matter.

Phase 3 (from 6.4.2016): Fjordane District Court has decided that the Norwegian-Romanian couple will get back the youngest of their five children.

Phase 4 (from 22.4.2016): NRK writes several articles on the organization and use of resources of the CWS in Sogn og Fjordane, partly related to the Naustdal-case.

Phase 5 (from 3.6.2016): The CWS in Naustdal signs an agreement on the return of the children to the parents and cooperation on assistance measures for the family.

Phase 6 (from 10.8.2016): Prosecution charges for upbringing violence against the Norwegian-Romanian couple are taken. The family moves to Romania and the CWS in Naustdal is investigated by the County Governor.

Phase 7: (from 3.1.2017–20.9.2017): The parents do not attend the trial. The lawyer of the family appeals the case to the European Court of Human Rights (ECHR).

Many researches are from a perspective of power concerned with the extent to which different groups in society are represented in the media. This

leads to quantitative surveys where the number of sources is mapped to determine whether, for example, women or men are the most represented, or whether an "elite" in politics and business dominates the media image. Although many of the sources in our case in many ways can be categorized as belonging to an "elite," we are concerned with far more than doing a quantitative survey of which groups are represented. We want to find out to what extent the sources through their statements can influence the interpretation framework in this specific case. All the sources will first be categorized before we analyze what meaningful function they have in the text, and further analyzed to find what kind of interpretative framework the different sources support through their statements and presence in the text. Although several articles also refer to written ones, only the oral sources will be systematically analyzed. The oral sources are categorized as follows:

## Category 1a: Those Directly Affected

In journalism, it is common to investigate any type of cases by interviewing those directly affected by an incident. In our case, it is primarily the parents of the five children for whom the CSW took care.

## Category 1b: Spokespersons for Those Who Are Directly Affected

In this case, there are close relatives who speak on behalf of the parents on several occasions, primarily the sister of the mother and their parents. Eventually, the Norwegian-Romanian couple are being prosecuted, and their lawyers are used as sources. These are also categorized as spokespersons for those who are directly affected.

## Category 1c: Peripheral Supporters for Those Who Are Directly Affected

In addition, there is a group of sources that are difficult to define and categorize. These are people who express support for the Norwegian-Romanian couple, but who are not their lawyers or relatives. It is a source belonging to the couple's parish in Romania, a Norwegian newspaper editor and a Romanian senator.

## Category 2: Those Who Are Responsible

In this case, there is a clear line of conflict between the parents and the local CWS, i.e., those responsible for the decision to deprive custody. It is a municipal task to make sure that we have a CWS that meets this statutory requirement. Those responsible at the municipal administrative and political level can be placed in the same category if they speak on behalf of the local CWS. This is nonetheless problematic, because child welfare is a profession that cannot easily be put in the same category as a counselor or mayor, and which it is desirable to distinguish as a separate category.

The CWS is both a profession, but also an administrative body that has a local, regional and national levels. Sources representing this administrative body at regional and state level will be registered as a separate subcategory. These will be categorized on the basis of their position, although there may be reason to believe that some of these sources have an educational background that could have defined them as expert sources (see below). This category is therefore divided into 2a) Local (in Naustdal), 2b) Regional, 2c) National, and 2d) CWS in other municipalities.

## Category 3: Expert Sources

In order to examine issues from different sides are so-called experts are often used as sources, and these are often presented with professional title, educational background or similar information. In lexicon, an expert is loosely defined as "a particularly skilled or expert person." In our case, there may be experts who comment on the specific Naustdal-case, or CWS on a more general level. Sources who are highly educated in a subject area relevant to the case will be defined experts. There may be psychologists who specialize in children, academics who educate child welfare educators, lawyers who have long experience in child welfare matters, etc. In other words, there can be a wide range of professions within this category, and in addition, one must also consider whether other sources can also be defined as experts. In our case, the editor in a Christian daily newspaper is defined as an expert, since the issue of Christian upbringing is a central issue in this matter.

Some may claim that those who have been placed in foster homes themselves, or who have had work or trust positions within relevant interest

organizations can also be called "experts." If we categorize such sources together with professional experts, the boundaries of what can be defined as "expert source" are unclear. They are therefore categorized as 3b) Expert Interest Organization.

What can make this even more complicated is the role the media assigns to a source in the news matter. For example, a source may be presented and referred to as an "expert" in the case, even if he/she is not a "particularly skilled or expert person." In such cases, we will not categorize the person as an expert, since as far as possible objective criteria must be used. It should nevertheless be added that to the extent that a source is presented, rightly or wrongly, as an expert, it will of course mean something to the interpretation of the text.

## Category 4: Prosecuting Power

As this case is rapidly developing into a criminal case, representatives of the prosecution will form a separate category.

## Category 5: Other Sources

This is a category for sources that fall outside the other categories.

Figure 1 shows that 40 different oral sources have been recorded in coverage of the Naustdal case, which have been cited 88 times distributed in 40 news articles. Those directly affected by the CWS decision are sourced only once. It is in the form of a letter to Naustdal municipality that NRK refers on August 12, 2016.[9] There are advocates for those who are directly affected and who are most represented in this category. It is primarily close relatives (the mother's parents and sister), and lawyers. In addition, there are other more peripheral sources that in some form express support for the couple.

The local CWS is not used as a source. The municipal director in Naustdal has the administrative responsibility for the CWS in the municipality, and he is by far the most used source in this category. The county governor has the supervisory authority for the municipal CWS, and is used as a source at regional level. At the national level, the political leadership

---

9 This is a written source, but is registered because it is an important exception.

**Fig. 1:** Oral sources in the "Naustdal case," NRK.no 12.22.2015–09.20.2017

| Category | Sources | Number of articles used as source | |
|---|---|---|---|
| 1a Those directly affected | 1 | 1 | 1 % |
| 1b Spokespersons for those direct directly affected Talsperson ramma | 5 | 17 | 19,5 % |
| 1c Peripheral Supporters | 6 | 6 | 7 % |
| 2a Responsible at local level | 2 | 28 | 31 % |
| 2b Responsible at regional level | 4 | 6 | 7 % |
| 2c Responsible at national level | 4 | 8 | 9 % |
| 2d Responsible for the CWS in other municipalities. | 5 | 5 | 5,5 % |
| 3a Expert | 6 | 8 | 9 % |
| 3b Expert, NGOs | 3 | 3 | 3,5 % |
| 4 Prosecuting authorities | 1 | 1 | 1 % |
| 5 Other | 3 | 5 | 5,5 % |
| Sum | 40 | 88 | 99 % |

in the Ministry is sources, as well as the leadership of the Norwegian delegation to the Council of Europe. The case has also been investigated by using sources responsible for CWS in other parts of the county.

Among the expert sources, we find psychologists and lawyers, and NRK have also used sources representing various interest organizations for children in care (barnevernsbarn). The prosecutor is the source only on one occasion, and that's when the couple did not attend the trial. In addition, NRK has received comments on the demonstrations against CWS from the ambassador's council in the USA. Vebjørn Selbekk, editor of the Christian newspaper Dagen, has been used as a source on three occasions. Figure 1 shows that it is the category of those responsible that has been used most often as a source, but does that also mean that the explanation from the CWS dominates the interpretation framework?

## 4) What Do the Sources Say?

In order to assess which framing the various sources support, we should interpret it within the context in which the legal basis for the decision became gradually known and concretized through NRK's reports. In the

first report NRK wrote, "Parents are charged with violence against the children" on December 22, 2015. In an interview, February 16, 2016, the grandparents say that a couple of the children should have been hit on the back once or twice. In an interview on April 21, 2016, the aunt says that "the parents tell that it is not a part of their upbringing to give a slap on the buttocks, but it has happened in particularly busy situations." On May 20, 2016, NRK wrote, "The police have not found any signs of abuse on the children, but their parents have admitted to have slapped them in heated situations." On June 3rd, 2016, NRK wrote: "In an interview on Romanian TV, the couple has admitted that they have slapped the children on the back and pulled them in the ears - even though they knew such upbringing methods were illegal in Norway ("Norsk-rumensk foreldrepar får tilbake barna" NRK. no 3rd June 2016)."

On August 10, 2016, the mother's defender, Ingrid Breistein, was interviewed when it became known that the couple had been indicted for upbringing violence: "My client has admitted slight slaps in the upbringing of the children ever since the first police interrogation. And she maintains at it. So she acknowledges partial criminal charges, in accordance with the indictment." The following day NRK writes about the indictment: "The police say parents over a period of five years should have slapped the children on several occasions and over several parts of the body. They also say that the parents should pinch the children in the ear or upper arm until the children were taken out of their home in November last year." The day after, NRK reported that the family had gone to Romania. When the trial should have started on January 3, 2017, NRK writes that: "The charges say that parents from summer 2010 to November 2015 on several occasions should have slapped the children on their buttocks, over the neck area and against the arms, several times also against the head, and pinched them in their ears or upper arms. This should also have happened while others were watching."

## What Do Those Who Are Afflicted Say?

The parents of the five children never spoke directly to NRK, but on one occasion, a letter they had sent to Naustdal municipality was referred. It was August 12, 2016 in the article "Naustdal Parents Moves from Child Welfare" where it was stated that the family was now in Romania. The

parents make strong charges against child welfare, which they claim "traumatized their children." The NRK cites from the letter in which the parents have experienced CWS as "unprofessional, non-empathetic, inhuman and incapable of seeing the value of family and the important bonds between parents and children."

In this case, there are close relatives who on several occasions make statements on behalf of the parents, primarily the sister of the mother and their parents. When a lawsuit is eventually brought against the Norwegian-Romanian couple, their defenders are used as sources. On April 21, 2016, Ingrid Baunedal, who is the sister of the Norwegian-born mother, met the councilor in Naustdal for a debate on NRK TV. During the debate, which NRK.no referred, Baunedal claimed that "the child welfare service has misinterpreted the family, parents and children," and that there was "a clear need for change in the legislation governing child welfare, the justice system and everything around CWS" (...). "I know there have been pats in stressful situations. It has not been part of their upbringing." Baunedal's assertion that the parents' Christian faith has been a key justification for both CWS and police actions was also cited.

These opinions are also shared by others, including the children's grandparents. In an interview on February 16, 2016, the grandfather says,: "We perceive it as they have involved the Christian faith in the case. It is strange in a Christian democratic country that Christian upbringing should be banned. It is completely incomprehensible to us." The interview shows that grandparents have a different view than CWS of what can be defined as violence against children: "We do not know of any violence at all. It is strange that they call it violence, which ordinary people do not call violence. It is perhaps the case that most people may have experienced a particularly stressful situation, that they will have a pat on the outside. It does no harm at, the grandmother says."[10] The grandfather believes

---

10 When NRK visited their Pentecostal church in Bucharest, the brother of the Romanian father also expressed similar attitudes. He believed that children must be disciplined and that the Scandinavian way of raising children is "to take it too far the other way." The pastor of the congregation believed that the CWS had destroyed a family just because of some slapping (NRK.no 18. januar 2017. «Ber Gud om hjelp i kampen mot barnevernet»). When the leader

that the CWS has exposed the children and parents to an abuse, and should have acted in a completely different way: "If they believe that the parents have not done their job, then they must give them help, facilitate and prevent, and not just kidnap the children."

The grandparents were also interviewed on August 15, 2016, right after the indictment was filed, and the Norwegian-Romanian couple and their children had traveled to Romania. The same serious allegations that the parents had written in the letter to Naustdal municipality were repeated, including that the CWS had broken a cooperation agreement that was signed with the parents after they had returned the children home. "The long-lasting harassment from the CWS made it impossible to function as a family. The whole thing is terribly sad, the Grandfather says." He leaves no doubt that the CWS have made great mistakes in this matter: "The court ruling that gave the children back to the family shows that the children should never be taken out of the family. And when the parents finally get their kids back, the CWS will not let them be at peace."

The father's lawyer, Ragnhild Torgersen, supports the claim that the CWS had been "very invading" and did not comply with the agreement, but rejects that the couple moved to Romania to avoid criminal prosecution in Norway. At the same time, she trivializes what the couple is accused of: "The parents have acknowledged criminal charges for parts of what has been alleged against them. We must be aware that what they are accused of did not cause any bruises or pain to the children. That is very important for how serious a charge is, she says (NRK.no 21. august 2016)."

The lawyers of the defendants have been interviewed in several articles claiming that CWS should never have taken over the care. On June 7, 2016, NRK writes, "On Friday, it was announced that Naustdal Municipality is entering into a cooperation agreement to return all the

---

of "Christian Coalition," Finn Jarle Sæle, gave the family an award in May 2017, he justified the award by claiming that giving the children a pat was not violence as alleged by "utopians in the public total care community" (NRK. no 16. mai 2017 « - Familien måtte gjere som mor til Jesus gjorde»).

children to the family. NRK finds that it was in connection with the main treatment in the county board for child welfare cases that Naustdal signed this agreement. On Friday, the municipal director Øyvind Bang-Olsen was referring to the duty of confidentiality, and did not want to say anything about why they had come to this solution." The family attorneys believe that the process surrounding this agreement indicates that there was no legal basis for depriving the family of childcare: "The terms for the Naustdal municipality to take care of the five children in Naustdalsaka were not present for any of the children, says Ragnhild Torgersen.

There are several who believe that there is something wrong in the case processing of the local CWS, also among those who are categorized as peripheral supporters of those who are affected. Karna-Lise Bloch is a work colleague of the accused mother. The preamble to an article on May 20, 2016, states: "The mother, who is deprived of four children in Naustdal, went to the same class and delivered assignments together with the (current) head of CWS in the municipality. Naustdal municipality rejects incapacity." Bloch went to the same class and "fears the mother has been extra hard treated for fear of being blamed for treating her student friends too mildly." Inger Baunedal also supports this claim and think it is incomprehensible that the CWS manager should be competent in the matter (NRK.no 20. mai 2016 «Mor og barnevernsleiar gjekk i same klasse»).

In short, those who were deprived of the care of their children and their close and less spokesmen believe that child welfare has failed. This framing is supported by rejecting or belittling the claim that violence has been used against the children, and claims that their Christian upbringing is the real reason for the CWS decision. They also think that there may have been errors in the case processing and that the CWS have harassed the family. Let's see what the expert sources say about these allegations.

## What Do the Expert Sources Say?

When the case was first referred in December 2015, NRK emphasized that the case had led to major protests abroad. Major English-speaking Christian media had claimed that the parents had done nothing wrong,

but that Christian upbringing was the real reason why they were deprived of their children. The editor of the Christian daily *Dagen*, Vebjørn Selbekk, was asked to comment on the matter. Selbekk was presented as one who had "gone deep into the matter," and he stated that "both the case and Norway are generally portrayed in a way as a country where parents are deprived of their children if they want to give their children a Christian upbringing. That's not right" (NRK.no 22 Desember 2015 "Barnevernsak skaper storm frå kristne miljø"). Selbekk later reiterated these claims when there were a series of demonstrations against Norwegian child welfare in April 2016, and believed that Norway was exposed to a demonization campaign (NRK.no 16th. April 2016 "Norske myndigheter: - Mange ubegrunnede påstander").

Selbekk did not believe that the CWS had done anything wrong, but for other experts the matter was completely different. In "Psychologist Specialist Slaughters the Child Welfare Service" on February 18, 2016, psychologist specialist Einar C. Salvesen is presented as one of several professionals who have signed a petition with "sharp criticism of Norwegian child welfare service." Salvesen is portrayed as an expert who, for several years, has been "a judge and expert in these kinds of cases" and has thoroughly studied the case where he had had "access to the case document and met the parents."

Salvesen says indirectly that violence has probably been used against the children, but that child welfare should rather help the family through guidance rather than take the kids from the parents. "It is about how to go into families where this is part of the culture for one of the parties," Salvesen said, adding, It was well facilitated for cooperation on the part of the parents. There was also a very good ability to care that could be utilized. In addition, there were some things the family should receive guidance about. It is worth noting that Salvesen probably refers to the Romanian father when he says that this [that violence has probably been used] is "one part of the culture of the one party." Still, he believes that the CWS has made serious mistakes: "It is a tragedy for the children. This case is so sore and heartbreaking that it is almost impossible to endure. I have no doubt that CWS has made a mistake in this matter," Salvesen, says. "At that time, the five children were placed in three different foster homes. Three days earlier, the child psychologist Willy-Tore Mørch had

commented on the matter, claiming that splitting the siblings would have very negative consequences for the children (NRK.no 15th. February 2016 "Professor kritisk til at barnevernet splittar søskenflokk")." In response, Øystein Sævik in The Office for Children, Youth and Family Affairs (Bufetat) pointed out that it is often difficult to find foster homes that could accommodate more than two siblings. Professor of Law, Jan Fridthjof Bernt, was used as an expert source on the question of whether the CWS leader was incompetent or not. Bernt believed that according to the law, the child welfare leader was not incompetent and you had to be "almost like a brother or sister" in order to be known incompetent because of a close relationship with one party.

The question of impartiality was also put in the context of the size of the municipality. This happened at a time when the so-called municipal reform was a major political issue nationally, where the government wanted to reduce the number of municipalities. In May and June this year, there was a referendum in many municipalities where residents were asked if they wanted to merge with neighboring municipalities. Supporters of larger municipalities argued that the quality of municipal services could be improved if organized in larger units, and several pointed out that this was particularly the case for the CWS. On May 25, 2016, senior researcher Dag Ellingsen was interviewed. In the preamble, he is quoted as saying that "the municipalities must have at least 15,000 inhabitants in order to have their own child welfare service office." NRK then states that "in Naustdal, where a Christian couple is deprived of five children, there are less than 3,000 inhabitants." Ellingsen does not comment on the specific case, but suggests that the CWS may have made mistakes due to lack of expertise in such cases: "For example, care transfers are rarely done in small municipalities, perhaps every five years. Then you have no routine and experience to deal with this type of difficult process."

The issue of competence was also linked to the use of resources, where NRK compared how much the CWS in the different municipalities in Sogn and Fjordane spent per child in the period 2013–2015. The statistics showed that Naustdal was among the municipalities that spent the least per year (about NOK 30,000) which was far below the average (NOK 47,000) in the county. The head of the National Organization for Youth

in Care (LFB) claimed that "this may indicate that many do not receive the help they need." Although these statistics can be interpreted in different ways, for example that Naustdal uses its resources efficiently, NRK follows up LFB's interpretation in its leading question to the municipal director in Naustdal: "Does not this show that Naustdal does not prioritize the CWS?" He replies that the figures should be seen in a broader context that would give a better impression of Naustdal, and that the municipality now spent significantly more resources on CWS than before. (NRK.no 3. mai 2016. «Pengebruk på barnevernsbarn: - Kan tyde på at nokre barn ikkje får hjelpa dei treng.»)

Several of the expert sources' statements and the context in which this case is presented may fit into the presentation where it is uncertain whether CWS in Naustdal has done the right thing. Some experts even claim that CWS have made serious mistakes. The CWS in Naustdal is thus in a situation where serious allegations are made that they have destroyed a family by depriving the care due to religious prejudice, and that this is due to a lack of professional competence. The CWS risks weakening their confidence, not only in handling this case, but also as the CWS as an institution. How do the CWS meet these accusations and how do they defend their decisions?

## What Do Those Responsible Say?

First, let's take a closer look at how CWS maneuvers within the limits of confidentiality. On February 16, 2016, the municipal director was asked to comment on the allegation that his parents' Christian upbringing had significance for CWS taking away their children: "I cannot comment on the specific case. But on a general basis, I can say that this type of argument will not hold when the County Social Welfare Board or District Court decides this type of case." (NRK.no 16. februar 2016 "Vi legg oss med saka og vaknar med den. Vi får ikkje tankane vekk frå saka").

Two days later, he was confronted by psychologist expert Einar Salvesen's claims that the parents have good caring skills and that the CWS has made a grave error in taking the children from the parents. The municipal director here also refers to the duty of confidentiality, but says that the parents' legal security is safeguarded: "But the municipality

cannot make such a decision alone.[11] This type of decision is to be ratified by the County Social Welfare Board, which is the legal body for child welfare matters. It is also the case that parents have the opportunity to appeal this type of decisions to the District Court" (NRK.no 18. februar 2016 "Psykologspesialist slaktar barnevernet).

In June 2016, an agreement was made to return the children to the parents. Such an incident can be construed as confirmation that it was wrong to deprive the parents of the children, as the lawyers of the parents argued (NRK.no 7. June 2016. "Meiner kommunene uansett ikkje hadde grunnlag for å ta borna"). Bang-Olsen was asked why parents now got the children back. On this occasion, he also referred to the duty of confidentiality, and made a more general comment that the municipality had a responsibility to "pay attention to the best interests of the children." When the family moved to Romania in August 2016, the CWS was accused of breaking the agreement and "invading" the family. Bang-Olsen dismissed the charges, and defended the CWS's actions through a general statement that "it is not uncommon to have assistance measures in the home" (NRK.no 15th. August 2016 "Forstår at familien og barnebarna måtte forlate landet").

Those who are responsible for the CWS at regional and state level also referred to the duty of confidentiality and did not comment specifically on the Naustdal case. Their statements were essentially aimed at explaining the system. In January 2016, County Governor Anne Karin Hamre welcomed a Romanian delegation consisting of a former foreign minister and seven other members of the Romanian parliament. Hamre stated just before the meeting that because of "a lot of incorrect information in what is disseminated in the social media," it was "important for the Norwegian authorities to get as much factual information about Norwegian child welfare service and the legislation we have in this country" (NRK.no 19th January 2016: "Møter rumensk delegasjon om barnevernssak").

---

11 This is the normal stages in child welfare case in Norway, see: https://bufdir.no/en/English_start_page/The_Norwegian_Child_Welfare_Services/stages_in_a_child_welfare_case/.

In May 2016, it became known that 100 lawyers from several countries had signed a letter to Prime Minister Solberg asking her to intervene in the Naustdal case. "We have looked into the facts of the case and are deeply concerned that the takeover of the children was motivated by the Christian faith of the family,", the letter states. In the same article, NRK referred to a statement that the responsible minister, Solveig Horne, had given to the Christian daily «Dagen» in January 2016: "There is no legal basis in the Children Act to take over the care based on religion, but it is forbidden to beat children, the Minister of Children and Equality Horne told the newspaper in January" (NRK.no 22nd May 2016 "100 jurister med brev til Solberg om barnevernssak»).

The municipal director in Naustdal also had to defend in that doubts were raised about the professional competence of the local CWS office in connection with the current case. The claim that the local CWS in Naustdal was too small was rejected by Bang-Olsen, who pointed out that "we compensate that we are a small municipality with interdisciplinary cooperation, good contact with professional authorities and guidance. In addition, we hire expertise externally" (NRK.no 25th May 2016. "Vil ha større barnevernskontor"). Bang-Olsen also added that the CWS in Naustdal considered entering into a collaboration with neighboring municipalities Førde and Gaular (NRK.no 25 mai 2016 "Forskar meiner små barnevernskontor manglar viktig kompetanse").

At the end of August 2016, NRK announced that Naustdal municipality had sent a letter asking the County Governor to make an evaluation of the CWS in the municipality. According to Bang-Olsen, the intention was to give "better answer our residents, and to learn from the way we as a municipality have handled this." Bang-Olsen pointed out that "in a case that is subject to the duty of confidentiality, not everything is possible to say. But an external assessment will answer all those who have asked relevant questions to the municipality." What Bang-Olsen points out is that an external investigation could help inform the public so that the intervention could be perceived as legitimate and so that the case should not weaken the trust in the CWS. This happened a couple of weeks after charges were brought against the Norwegian-Romanian couple, which could indicate that it was right decision by the CWS in Naustdal to intervene in the family.

## 6) Conclusion

Framing are of course not just about the sources that can comment on a case. What the journalist chooses to quote and highlight also plays a significant role. We can see a clear example of this among sources who are close relatives of the couple, who downplay the violence to which the children were exposed by using words like "slaps," in sharp contrast to the serious details that emerged in the indictment. On the other hand, these sources use strong words against the CWS which they accuse of having "kidnapped" the children. Such statements support the framing that CWS has probably done something wrong, and this is supplemented by some experts who characterize the interventions as a "heartbreaking assault." Other expert sources are far more moderate in their statements, and the answers they provide are more focused on the system than on the specific case and support the framing that the CWS *may* have done something wrong.

CWS was thus in a crisis situation where they had to deal with sharp accusations directed against the institution through the media, and where forced to explain and defend why they took the serious step of taking the children from their parents. If we look at how often the municipal director in Naustdal is allowed to comment on the matter, it seems that he has good opportunity to put it into a framing which indicates that the CWS did the right thing. But the duty of confidentiality prevents him from going in to details. Still, the reason why he can be as concrete as to refer to the case as "upbringing violence," is because that the charges against the couple had been publicly known already from late 2015. This framing is later strengthened because NRK referred to concrete serious details when the indictment was submitted in August 2016. In other words, the CWS's vague explanation is "saved" by other sources because the duty of confidentiality largely prevented the CWS from defending itself against the charges. All this leads to the conclusion that NRK's presentation of the Naustdal-case was fairly balanced in the sense that through the selection and use of sources, none of the three frames was dominant.

## References:

Entman, Robert (2003) *Projections and Power: Framing News, Public Opinion and U.S Foreign Policy*, University of Chicago Press, Chicago.

Gitlin, Todd (2003) *The Whole World is Watching: Mass media in the Making & Unmaking of the New Left*, University of California, Berkeley.

Løvik, Kjell (2015) *Krisehåndtering online: Sosiale medier i krisekommunikasjon og beredskapsarbeid*, Cappelen Damm akademisk, Oslo.

Ministry of Children and Families (2012): *Barnevernet – en hjelper: Kommunikasjonsstrategi 2013 – 2016.*

The Research Council of Norway (NFR): *The Research Program for Welfare, Labour and Migration 2009–2018.*

Veland, Jarmund (2004) Barnevernets rammebetingelser og legitimitet (p. 162 – 215) in Havik, Toril (ed) *Barnevernet: Forutsetninger og gjennomføring.* Oslo: Universitetsforlaget

## Online

https://www.bufdir.no/Global/Befolkningens_holdninger_til_barnevernet.pdf. Se også.

http://www.medienorge.uib.no/files/Eksterne_pub/mecin_delrapport_7_juni_2017.pdf.

https://press.nordicopenaccess.no/index.php/noasp/catalog/view/16/56/184-1.

"Norwegian CWS seen through international eyes." Seminar October 22, 2017, Literature House, Oslo. See: https://www.regjeringen.no/no/aktuelt/seminar-om-norsk-barnevern-sett-med-internasjonale-oyne/id2616044/.

Burcu Peksevgen, Erling Sivertsen, Jan Arne Halvorsen

# A New Habitats for Universities in Norway: Crisis in Democracy

> (...) that the perfection of power should tend to render its
> actual exercise unnecessary; that this architectural apparatus
> should be a machine for creating and sustaining a power
> relation independent of the person who exercises it.
> 
> (Discipline and Punish. M. Foucault)

**Abstract** This chapter problematizes the transition to open-plan new habitats for the academic offices in Norway. It argues that although the transition is presented as a democratic process by authorities, it will result in managerialism and an increased authoritarianism in leadership. This chapter summarizes the steps taken by Norwegian authorities and critically analyze them from a theoretical perspective. The contention of this chapter is that the transition to open-plan habitats in universities in Norway creates a rupture in democratic culture and is an example of pseudo-democracy.

**Keywords:** open-plan universities, democracy culture, surveillance, organizational culture

## Introduction

The transition to open-plan new habitats in Norway is a problematic issue and has the potential of engendering crisis among the different sectors of political life. Considering the particular working dynamics of academic life, these problems should not only be seen as space related but also as serious issues related to deeply rooted democratic concerns. Those who support a transition to open space-working environment in universities seem to neglect a fundamental understanding that our perception of space

is multilayered. As Foucault suggested,[1] space is never only about walls; we dream and think with space. Traditionally, there has been a strong relationship between the academic knowledge production and the space that production takes place. In its simplest terms, nature of the academic work, as most of the academics attest needs solitude in a secluded, private space for thinking and writing. Pseudo-privacy, which means interruption by phone calls, e-mails, text messages, and on-line virtual meetings, kills the knowledge work and demotivate the knowledge workers (Baldry and Barnes, 2012).

"What happened when we first moved to open plan, the principal and other people used to come round at a certain time on a Friday and take note of how many people were not at their desk. This used to happen fairly regularly. They seem to have moved away from that now, but it is not uncommon for somebody in senior management to come round and note if a lot of staff are not there – they may be teaching or may be at home working." This is how one of the respondents in Baldry and Barnes's (2012) study has explained the changes that came with the open-space working environment and his concerns about increasing surveillance. It is obvious that intrusion of privacy and destruction of solitude are not the only concerns of academics. Transition to open-plan habitats in academia also triggers deeply rooted fears of authoritarian surveillance. Surveillance of the academics and disciplining the academic work have been a primeval fear among the academicians throughout the modern times. A panopticon-like authoritarian control (Foucault, 1995: 195–230) has always been seen against the very sole of academia, and it will always be a reminder of a world most drearily depicted by George Orwell in 1984: "There was of course no way of knowing whether you were being watched at any given moment... You had to live—did live, from habit that became instinct—in the assumption that every sound you

---

1 (...) we do not live in a homogeneous and empty space, but on the contrary in a space thoroughly imbued with quantities and perhaps thoroughly fantasmatic as well. The space of our primary perception, the space of our dreams and that of our passions hold within themselves qualities that seem intrinsic: there is a light, ethereal, transparent space, or again a dark, rough, encumbered space... (Foucault, 1967:3).

made was overheard, and, except in darkness, every movement scrutinized" (Orwell, 2004: 4,5). It should also be underlined that considering the Norway's reputation related to democratic processes, the rupture the transition created should not pass unrecognized. Below, we will first present the conflict that the transition created then attempt to problematize the transition as a pseudo-democratic process.

## Steps of Transition in Norway

Open-plan offices were designed in the 1950s and reached their height of popularity in the early 1970s, when many companies converted to these types of designs. Original claims by the designers of open offices were that they created flexible space, allowing layout to be more sensitive to changes in organizational size and structure. Workstations can be easily reconfigured at minimal cost and meet changing needs. It was also believed that the absence of internal physical barriers would facilitate communication between individuals, groups, and even whole departments, which consequently, would improve morale and productivity (Brennan, Chugh, & Kline, 2002). There are several types of office designs ranging from traditional private offices to open offices. A "cell office" is a personal room surrounded by four walls with a window. Private meetings and most work activities are facilitated in the room. The "shared room office" is designed 2–3 persons sharing the office, which is surrounded by four walls, has a window/windows and most activities are facilitated in the shared room. While in "open plan landscape" – employee has a personal workstation in a common workspace, no access to own window, telephone communication and meetings in specific rooms and most of the activities are facilitated in common shared spaces. The last design is "flex office" where there is no personal workstation, and this type depends on advanced information technology, which makes the employees independent to choose when and where to work from. Employee's personal belongings and work materials are in a pedestal-on-wheels or personal cabinet. There is access to "back-up spaces" for meetings and phone calls and all work activities are facilitated in the common shared spaces.

The open offices as explained here have existed for a long time in Norway and the other Scandinavian countries, but this kind of habitats

did not create any conflict until the last years. The conflicts emerged as we will show below when the public sector of Scandinavian countries including the universities and colleges started to design open office plans in all new buildings.

## The Conflict Related to the Area Norm and the Implementation of Open-Office Landscapes in Norwegian Universities and Colleges

There are several lines of conflict. Firstly, the Norwegian Government, Norwegian Directorate of Public Construction and Property, and the university leaders arguing for the minimization of space because of environmental concerns. Secondly, unions are insistent that the best work environment for teachers researchers and students is the cell office. Thirdly, ongoing research in Sweden shows that open-plan offices create conflicts and absence, and reduce health. With breaking down the walls and replacing cell offices with open-plan office landscapes, the working condition in Norway is in a major process of change. Those who support open landscapes argue that they can be economically more feasible because they save square meters. It is also suggested that open landscapes lead to better communication and more collaboration in work environment. Open-office landscapes come in variety of size and forms, such as from small four people to large twenty-four people sit in the same room. Many companies also practice so-called activity-based jobs, where the employees do not have a fixed place, and they sit where it is most appropriate related to the task and with whom they will perform that task. The area standard itself, 23 square meters per employee in public buildings and the considerations of the Norwegian Directorate of Public Construction and Property, which leads the development of state-owned new buildings, have led to protests and conflicts, because co-determination and democracy in the workplaces have been challenged. Statsbygg is the Norwegian government's key advisor in construction and property affairs, building commissioner, property manager, and property developer. The open-office landscape missionaries often describe themselves as forward-looking, while the opponents are described as back leaning.

In the so-called area norm from 2015, the Government (Ministry of Local Government and Modernization in 2015) decided that offices in future state-building projects should not exceed 23 square meters of gross area per employee. In practice, this meant that more employees had to work in the same room, but it took a few years before the area norm's consequences led to protests and conflicts. Small offices and open landscapes in all new buildings in the public sector became a conflict between employers and employees. It became a job war in which employers and staff at universities and colleges are constantly in conflict. The most heated conflict is in those universities where new large buildings will be erected. This applies to Norwegian University of Science and Technology (NTNU), the Norwegian University of Life Sciences (NMBU), the University College of Western Norway (HVL), and the University College of Volda (HVO). However, the new government quarter, linked to the Brevik incidence in 2011, is also one of the projects that have created protests and conflicts. These protests have been increasingly covered by the media, and experiences made in other countries have been covered and commented on by publications such as *Khrono, Universitetsavisa, Uniforum og På Høyden* with the university sector as a target group (Njåstad & Bergstrøm 2017).

A study undertaken in Scotland and Australia done by Baldry and Barnes (2012) nearly ten years ago is interesting because the study focuses on open-plan (OP) in universities. They argue that open-plan academic offices are undermining both scholarship and professional identity despite the rhetoric of synergy and cost reduction. The OP-organized universities are in conflict with professional autonomy and internalized "craft-control" of research and teaching (Baldry & Barnes 2012:243). This we consider to be the case also in the universities of Nordic countries. Thus, the findings and argument apply to the situation discussed in this chapter.

The early phase of protests and conflicts has drawn attention to the unfortunate effects that the land standard will have for universities and colleges. They have repeatedly protested that they could not meet with the leaders of their own institutions. When their protests were heard, they did not become a part of the decision-making process. In other words, they did not have codetermination and co-influence. Gradually,

the trade unions have also got involved with the conflicts, such as the the Norwegian Association of Researchers (NAR), the Academic Union, Parat, NTL. In the same way, news media began to pay attention to the conflict and protests. The Norwegian Broadcasting (NRK) program *Brennpunkt* has put the conflict at the forefront of the program: *Kontoret* (The Office) (NRK 25.4.2018). In this conflict, the Government and Gov Statsbygg allied with locale employers became missionaries for the open-office landscaping. They argue that open-office will benefit students and increase employee's research and creativity. Employees on the other hand fight for their own offices and claim that research shows that open-office landscapes do not work for many tasks (Bergstrøm 2017). They also claim that work at the university is demanding, requires concentration and private office space. Otherwise, they argue that research and the supervision of students will be injured.

As more and more universities are going to need new buildings, the conflict spreads across the whole country and more and more people find that the management who is to be construction managers ally with Statsbygg and not with the employees at their own institution. Many find that the management hears the employees' protests, but they do not listen to it and make some moves that can force the authorities to retreat in this special requirement. Although open-plan offices are more trendy right now, it is not certain that it will continue like this. Digital development means that we can work almost everywhere, so that static jobs are likely to be fewer. The consulting company Cushman & Wakefield (2018) has published a report with six trends they believe can affect future jobs:

**Smart Buildings:** Many workplaces are empty for various reasons during the working day. In the future, you may be able to see via an app on the phone where there are available seats, how the indoor climate is, and a lot of other information. This allows the office space to be optimally utilized.

**Well-Being:** A hectic working life with few fixed points of reference requires employers to make even better arrangements for employees' health and well-being. There may be access to exercise options and healthy food, green plants, good indoor climate, and the absence of noise and disturbances.

**Urban Environments:** It is a global trend for companies to enter the city centers. Better public transport opportunities, opportunities to take advantage of what the city offers and social gatherings after work are among the reasons.

**Social Responsibility:** Most of the so-called millennials, people born between 1980 and 2000, are concerned with corporate social and environmental work, which determines where they want to work.

**Coworking:** Both in Norway and the rest of the world a new trend, *co-working* spaces (common office space where one can rent a place without being employed) are emerging.

**Freelancers:** Few of today's young people have ambition to work in the same company for a long time. Increased workplace migration means that companies must facilitate workplaces for temporary employees.

Although the debate over open-office landscape seems to be very complicated in reality it is about money. Involvement of unions and taking the conflict in their agenda can be proposed as a major step for the solution. A meeting at the "Arendalsuka," a lobby week in the city of the Arendal, where large and small from business sector, public sector, and the Norwegian parliament meet, listen, and negotiate with each other can provide a platform for constructing an agreement. The protests and conflicts related to the issues of tomorrow's workplace for an increasing number of public sector workers have also forced issues of co-determination and democracy in the workplace on the agenda. The Norwegian Association of Researchers (NAR) has even engaged several researchers Enehaug & Nordrik (2018) at the Labour Research Institute at Oslo Met to create a Co-determination Barometer for Norway. In the memorandum, based on the Co-determination Barometer and other research-based knowledge, they concluded that three working conditions are important for companies' working environment and productivity: conflicts, conflict management, and integrity. Participation and co-determination are shown to have a significant positive impact, so that conflicts and crises occur less frequently and are better handled, and that the individual's integrity is safeguarded. We also want to add that with participation and co-determination democracy at workplaces is taken care of, developed and strengthened rather than discontinued.

The protests, the conflicts and the debate have created a crisis in the relations between management and employees nationally through trade unions such as NTL, the Norwegian Association of Researchers (NAR). The crisis is also regional, where some universities and colleges are located. The relationship between unions and management has been significantly aggravated because the opinion of the unions are not heard and paid enough attention. The party cooperation that is rooted in the Basic Agreement for Civil Service squeaks in the joints when new buildings are to be planned, projected, and built, because the union representatives in the unions are not listened to.

## Creative Free Actors in Open Spaces or Isolated Change-Resistant Prisoners in Cells?

The hot conflict in academia and the broader public sphere about the processes, criteria of design, and participant workplace democracy in Norway as previously described, is interesting from a communication-theoretical point of view. This is a case where the multifaceted overarching policies and goals of the government on the conditions and quality of higher education and research, (and its realizing directorate on university property development; «Statsbygg»), clashes with the daily social and practical lifeworld concerns and needs of students and academics (Woltmann, 2019).

It concerns the interplay between individuals and organizations and serves as an indicator of the actual deliberative conditions at some of the most important social-political institutions of modern democratic societies, university research and education. It can thus be viewed through the lenses of critical communication theory as a battleground where the aftermath paradoxes and discrepancies of a steadily increasing managerialism in higher education plays out. It can be seen as the spasms of an ailing management ideology, New Public Management (Tjora, 2019). It constitutes the battleground where NPM is pitted against the inherent practical lifeworld demands of an informed and actively involved academic community (Alvesson, 2014).

The conflict highlights the possibility of unwanted fallout results of bad governance: badly designed and badly performed communication processes. These might in turn result in alienation, withdrawal and internal

exile, loss of trust, and legitimization (Habermas, 1997). The outcome might thus prove detrimental to both scholarship, professional self-esteem and identity.

The open space conflict can serve as a mirror of the self-image that our society should have of itself, of our basic values and the ways we can cooperate in creating good institutions and good conditions for personal, intellectual, and societal growth at large (Rorty, 2006).

"Knowledge for a better world" says the credo of NTNU, yct the universities themselves, the very home of free, critical, evidence-based reflection, and scientific research became the battleground. In thinking about these matters, it may help to remind ourselves of the guiding words from one of the greatest minds of the 20th century, Bertrand Russell: "When you are studying any matter or considering any philosophy, ask yourself only what are the facts and what is the truth that the facts bear out. Never let yourself be diverted either by what you wish to believe, or by what you think would have beneficent social effects if it were believed" (Russel, 2012).

Then, what do the facts bear out? As is common in many types of conflict, there are conflicting interests and views, different framing strategies, and representations of the basic facts of the matter. What does the empirical evidence base tell us about the differences and consequences of the design layout of the workspaces: large open landscapes with A(ctivity) B(ased) W(orkspaces) ABW or cell offices? What are the pros and cons? What are the experiences with ABW and open space landscapes? In short: Does "Activity-Based Workspaces work"?

Views differ, as noted about, yet one of the most comprehensible meta-studies done by organizational psychologist Matthew Davis, reviewing more than a hundred studies about office environments concluded that ABW did not work. "Though open offices often fostered a symbolic sense of organizational mission, making employees feel like part of a more laid-back, innovative enterprise, they damage workers' attention spans, productivity, creative thinking, and satisfaction. Compared with standard offices, *employees experienced more uncontrolled interactions, higher levels of stress, and lower levels of concentration and motivation*" (Davis, M. C., Leach, D., & Clegg, C., 2011). A recent Norwegian study also confirms with the Davis's research that as compared with standard

offices, open offices decrease attention spans, creativity, and productivity (Gjerland, E. Søiland & F. Thuen 2019).

The Norwegian minister of «Næringsliv» Monica Mærland declares in the Parliament debate that there is no clear conclusion on the open space ABW matter, but open spaces are favored anyhow. Her answer was based on one report from Statsbygg, the governmental real estate body, given the task of designing and managing the building processes. Her assertion is contradicted by Professor Knut Inge Fostervold, perhaps one of the most central workplace researchers in Norway. He has surveyed the major bulk of the scientific studies on the matter of workplace design and finds that the statement from the minister is false. The overwhelming results are in favor of cell offices combined with flexible room plans. This view is supported by two Harvard scientists: Bernstein and Turban. Contrary to common belief on face-to-face communication in OS ABW they found that: "In two intervention-based field studies of corporate headquarters transitioning to more open office spaces, we empirically examined—using digital data from advanced wearable devices and from electronic communication servers—the effect of open office architectures on employees' face-to-face, email and instant messaging (IM) interaction patterns. Contrary to common belief, the volume of face-to-face interaction decreased significantly (approx. 70 %) in both cases, with an associated increase in electronic interaction. In short, rather than prompting increasingly vibrant face-to-face collaboration, open architecture appeared to trigger a natural human response to socially withdraw from officemates and interact instead over email and IM" (Bernstein &Turban, 2018). Jan Pejtersen and colleagues studied more than 2400 employees in Denmark and found that workers in two-person offices took an average of 50 per cent more sick leave than those in single offices, while those who worked in fully open offices were out an average of sixty-two per cent more (Pejtersen, Feveile Christensen, Burr, 2011). It should also be added that Covid 19 has fundamentally changed the health considerations about ABW, sending architects back to their drawing boards.

What then are the normative implications of the government not responding to contradiction and not properly including the most relevant stakeholders, the university workforce and their organizations? How might we assume that academics react to non-responding interlocutors?

As logicians, argumentation theorist and social epistemologists from Aristotle to Alvin Goldmann have taught us, denying the truth of the premise has grave consequences for the conclusion. To neglect the fundamental role and rules of the logos dimension is bad argumentative practice. Waving the ethos or pathos cards cannot override that. Yet, what if we for the sake of analytical reflection set the various details of the factual question aside for a moment and ask "how could normative based critical theory as told by Habermas, Rawls and Hampshire help us see what is at stake here"? The broad view is that they all tell varieties of a common tale of content and procedure.

The core idea of deliberative democracy is that we through the game of articulating reasons are able to self-govern collectively, to root out in dialogue what reasons we have to hold one proposition true, others false. It matters how we argue, well rather than poorly, transparent rather than opaque. If we hold on to the rather lofty idea of democracy and workplace democracy as the social manifestation of our individual and collective role as truth trackers and citizens, as mutually recognized players in the game of asking for and giving reasons in the public sphere, we see that this participation brings with it a duty to respond to criticism, offer supporting reasons when challenged. If these discursive norms of civility are broken, then we are left only with power play, manipulation and manufacturing of consent. When organizations, small or large, break the basic framework of public reason, then anomalies occur; what bureaucrats often coin as "noise" or "change – resistance."

The rational tradition of weighing pro/con evidence, adversary reasoning, is one of the pillars of the whole scientific enterprise and the democracy. If contrary facts, evidence, and deliberative procedures seemingly has low currency in the departmental "informed" decision-making process, then we must suspect that other undisclosed arguments play a more decisive role; economic constraints dressed in the aforementioned trendy vocabulary: of forward thinking, innovation, startups, global digitalization, deep workplace transformations by high tech and AI etc. This lingo is often packaged as proactive, business friendly communication, strategic acts of communicative influence targeted at the political level, university leaders, consulting firms, and lower rank decision makers. Rather ambiguous references are too often made to Google and

Facebook and their creative work environments with playgrounds and silent Zen rooms.

The deep differences between the goals of big corporations and universities are then conflated. Vocabularies matter, they are tools for different tasks. It is not one size that fits all. The present-day hegemonic lingo of big corporations that is adopted by politicians, university bureaucrats, and administrators is a bad tool for building universities. Vocabularies from one sector invade another and cause grave damage.

Organizational cultures and moral obligations are deeply intertwined. When we are neglected, not taken seriously, or flat out disqualified as participants in the design process of our own workspace, then we are exiled as knowers, as epistemic, rational, and moral agents. We are not seen as capable inhabitants of the space of reasons in which we can exchange information and arguments. When we are not taken seriously as reason mongering creatures, the organization inflicts serious damage on itself, its own culture, and its own members. "To be wronged in one's capacity as a knower is to be wronged in a capacity essential to human value. When one is undermined or otherwise wronged in a capacity essential to human value, one suffers an intrinsic justice. The form that intrinsic injustice takes specifically in cases of testimonial in justice is that the subject is wronged in her capacity as a giver of knowledge. The capacity to give knowledge to others is one side of that many-sided capacity so significant in human beings: namely, the capacity for reason. We are long familiar with the idea, played out by history of philosophy in many variations, that our rationality is what lends humanity is distinctive value. No wonder, then, that being insulted, undermined, or otherwise wronged in one's capacity as a giver of knowledge is something that can cut deep" (Fricker, 2007:44).

## References

Alvesson, M. (2014) *The Triumph of Emptiness*, Oxford: Oxford University Press.

Baldry, C. & Barnes, A. (2012) The open-plan academy: space, control and the undermining of professional identity. *Work, Employment and Society* 26(2), 228–245. Doi: 10.1177/0950017011432917

Bergstrøm, I. (2017) Leste all forsking om åpne landskap, fant bare helseskader og produktivitetstap. *Universitetsavisa* og *På Høyden*: https://www.universitetsavisa.no/politikk/2017/10/10/Leste-all-forskning-om-%C3%A5pne-landskap-fant-bare-helseskader-og-produktivitetstap-69586.ece.

Bernstein, E. S. & Turban, S. (2018) The impact of the 'open' workspace on human collaboration. Phil. Trans. R. Soc. B 373: 20170239. http://dx.doi.org/10.1098/rstb.2017.0239.

Brennan, A, Chugh J., & Kline T. (2002) Traditional versus Open Office Design: A Longitudinal Field Study. *Environment and Behavior*, 34 (3), 279–299. https://doi.org/10.1177/0013916502034003001

Cushman & Wakefield (2018) *Coworking 2018: The flexible workplace evolves*. London: Cushman & Wakefield; Real estate market reports. http://www.cushmanwakefield.co.uk/en-gb/research-and-insight/2018/coworking-2018.

Davis, M. C., Leach, D. J. & Clegg, C. W. (2011) *The physical environment of the office: Contemporary and emerging issues*. In G. P. Hodgkinson & J. K. Ford (Eds.), *International review of industrial and organizational psychology: Vol. 26. International review of industrial and organizational psychology 2011* (p. 193–237). Wiley Blackwell. https://doi.org/10.1002/9781119992592.ch6.

Enehaug, H. & Nordrik, B. (2018) *Medbestemmelse, konflikt og integritet. Medbestemmelsesbarometeret 2017*. Delrapport 3. Oslo: Arbeidsforskningsinstituttet, Oslo Met. http://www.hioa.no/Om-OsloMet/Senter-for-velferds-og-arbeidslivsforskning/AFI/Publikasjoner-AFI/Medbestemmelse-konflikt-og-integritet.

Gjerland, A., Søiland, E. & Thuen, F. (2019). Office concepts: A scoping review. *Building and Environment*, 163, October 2019, https://doi.org/10.1016/j.buildenv.2019.106294

Foucault, M. (1995) *Discipline and Punish the Birth of the Prison* New York: Vintage Books

Foucault, M. (1967) "*Des Espace Autres*," *Of Other Spaces*: *Utopias and Heterotopias*, retrieved from https://web.mit.edu/allanmc/www/foucault1.pdf 01.10.2020

Fricker, M. (2007) *Epistemic Injustice: Power and the Ethics of Knowing*. Oxford: Oxford University Press.

Habermas, J. (1997) *Theorie des Kommunikativen Handelns*, pocket edition SurhkampVerlag.

Halvorsen B. E. (2018) Det hjelper ikke med medvirkning om en ikke har medbestemmelse. Trondheim: Universitetsavisa https://www.universitetsavisa.no/campus/2018/06/14/Det-hjelper-ikke-med-medvirkning-om-en-ikke-har-medbestemmelse-74864.ece.

Kommunal og moderniseringsdepartementet (2015): *Rundskriv om normer for energi og arealbruk i statlige bygg*. Oslo: Statsministerens kontor, Regjeringen https://www.regjeringen.no/no/dokumenter/rundskriv-om-normer-for-energi--og-arealbruk-for-statlige-bygg/id2474498/.

Ministry of Local Government and Modernization (2015), https://www.regjeringen.no/en/dep/kmd/id504/

Njåstad, M. og Bergstrøm, I. (2017): Malmø-ledelsen gjør retrett om åpent landskap og clean desk. *På Høyden* 3.10.2017 https://www.universitetsavisa.no/campus/2017/10/03/Malm%C3%B8-ledelsen-gj%C3%B8r-retrett-om-%C3%A5pent-landskap-og-clean-desk-69352.ece.

NRK (2018): *NRK Brennpunkt: Kontoret*, 25 April 2018 https://tv.nrk.no/serie/brennpunkt/MDDP11000618/25-04-2018. Hovedavtalen i staten 2017–2019 https://www.regjeringen.no/contentassets/1d80f80f0ba24db3ad018c75052e81eb/no/pdfs/h-2387_hovedavtalen-i-staten.pdf.

Orwell, G. (2004) *1984 Nineteen Eighty-Four*, Penguin Modern Classics, London.

Pejtersen, J. H., Feveile, H., Christensen, K. B., Burr, H. (2011) Sickness absence associated with shared and open-plan offices–a national cross sectional questionnaire survey. *Scandinavian Journal of Work Environment and Health*; 37(5): 376–382. doi: 10.5271/sjweh.316.

Rorty, R. (2006) *Take Care of Freedom and Truth Will Take Care of Itself*, Stanford: Stanford University Press.

Russell, B. (2012, 15 August) *Message to Future Generation* [video file] retrieved from: https://www.youtube.com/watch?v=ihaB8AFOhZo.

Tjora, A. (2019) *Universitetskamp*, Oslo: Scandinavian University Press.

Woltmann, A. (2019, 21 June) https://www.arkitektnytt.no/nyheter/best-i-apne-landskap.

Endre Eidsaa Larsen

# Abounaddara and the Concept of Dignified Images

**Abstract** The Syrian Civil War (2011-present) has involved a "struggle for representation" (Tarnowski, 2017). In this multisided conflict, there has been an enormous number of visual images from the conflict zones – not least images of destruction, ruins and dead bodies – constructed in various ways and used for different purposes across the globe. In this context, the anonymous Syrian film collective Abounaddara has been vocal in their demand for "dignified images" of the Syrian people (Elias, 2017). Referring to their films as "emergency cinema" (Boëx, 2012), Abounaddara has called attention to the risk of dehumanization involved in the representation of human beings in times of conflict. Both in their films, posted on social media platforms, and in written statements, the collective has problematized and challenged the dominant aesthetics of the conflict, and emphasized people's legal and ethical rights to control their own image. As a film collective, Abounaddara not only represent a noteworthy initiative in the context of the Syrian conflict, but also raise important ethical concerns in our image-saturated world, related to risk factors in terms of representational and perceptual dehumanization.

This chapter seeks to explore Abounaddara's notions of dignified images in light of an aesthetico-ethical perspective and argues that their films operate with two critical strategies linked to this notion: détournement and fragmentary, incomplete descriptions and portraits of events or people. Both strategies can be seen as defence strategies in response to a perceived risk of dehumanization involved in the sensationalism of mainstream media. The chapter refers to the collective's own statements, while also discussing some of their films. My goal is both to show Abounaddara's work as a specific, historical example of resistance to representational dehumanization, and to suggest ways in which their initiative thematizes a more general problem: Moral responsibility and ethical risk in the making and perception of images of actual people in times of conflict.

**Keywords:** dignity; dignified images; dehumanization; representation; Abounaddara

## Introduction

*Dignity*, and particulary the idea of an *inherent human dignity*, is a contested notion, yet has been a critical concept in the aftermath of the atrocious genocides of the 20th century. Contested, among other things, because of its empirical intangebility; critical, one could argue, because of its signal, promise or claim of an inherent worth in the human being, and of a shared humanity. The concept of dignity implicates an ethical commitment to protect this "shared humanity" from degradation and dehumanization of various kinds, such as racist ideologies and genocides determined to exstinguish whole people of human beings. This ethical commitment was of a particularly pressing concern after the vile atrocities of the Nazis, particularly the infatomable catastrophy of Holocaust (Maplas & Lickiss, 2007).

The Nazis, we are reminded by the Syrian film collective Abounaddara, began by "representing their victims as deprived of dignity, as *subhuman*" (Abounaddara, 2017). Before killing their victims, the Nazis tried to strip them of their humanity in images that were supposed to represent (stand in for) them. One way of achieving this was to compare a specific group of people, Jews, to animals. For instance, in the Nazi propaganda film *Der ewige Jude* (Hippler, 1940), Jews are compared to rats. By way of analogy, the human being is deprived of its individuality and dignity, even of its humanity, linked to "parasitic animals." What role did these images of Jews play in the process of the industrial slaughter of this people and the systematic killing of these human beings? Whatever the answer to this question, it should be obvious that this evident form of representational dehumanization, in some way or another, bear a responsibility vis-a-vis the actual genocide of the Jews.[1]

It is from this historical backdrop that the modern notion of an inherent and *non-hierchical* human dignity, and its role in moral and legal discourses, could be said to find its particular impetus and urgency

---

[1] From Primo Levo's interview with a Nazi officer, we learn, for example, that forms of humiliation and degration of the victims were performed to ease the killer's conscience when killing; the dehumanizing gaze of the killer supposedly made it easier to actually perform the killing (Oliver, 2010, p. 89).

(Malpas & Lickiss, 2007). It is telling that the very first sentence of "The Universal Declaration of Human Rights" of 1948 states that "the recognition of the *inherent dignity* and of the equal and inalienable rights of all members of the human family is the foundation of freedom, justice and peace in the world" (Cahn, 2012:1208). It is from this same historical backdrop that I believe we should understand the Syrian film collective Abounaddara, founded in 2010, when they speak of the importance of *dignified images* in the context of the present conflict in Syria (Abounaddara, 2017; Elias, 2017). With the concept of dignified images, and films made in its ethos, this Syrian film collective has stressed the ethical responsibility of moving images – of different, sometimes obscure origins, and from different sides of the conflict – circulating the globe. Moreover, I would argue, Abounaddara has, through their work on and with this concept, explicitly and urgently communicated *a risk of representational and perceptual dehumanization – of actual Syrians, in particular, and, of actual people, more generally, when they are treated by images*. Dignity is always at risk. Abounaddara work to communicate this risk, as it relates to their critical situation, in aesthetic terms.

In this chapter, based primarily on films by Abounaddara and statements made by their spokesperson, I will explore this notion of dignified images as it relates to the risk of representational and perceptual dehumanization. Acknowledging my own position as a Norwegian film scholar, lacking experience and gravely limited in my knowledge of the complex situation in Syria, I will limit the scope of this essay to the problem of the viewer vis-a-vis the representational forms of Abounaddara's films. From this perspective, Abounaddara's initiative could be seen as a questioning of the conventions of filmic images and forms;[2] a questioning of how these forms represent, mediate, figure and construct an actual reality (the daily life of Syrians); and a questioning of how these forms address a (global) viewer. More specifically, as I hope to make clear, a central dimension of Abounaddara's initiative involves how they *rhetorically address and*

---

2   With "filmic images and forms," I here refer to "film" in a broad way: moving images organised in an audiovisual and spatiotemporal montage lasting for a certain set duration of time (this encompasses, for example, "video" and digital moving images).

*problematize the viewer's perception.* This problematization concerns both the viewer's perception of the actual realities depicted in the films, and the viewer's perception of the depiction itself, of the formal treatment, of the filmic construct. In this context, the notion of dignified images has at least three aspects: the dignity of the represented (the persons referred to or evoked by the images); the dignity of the representation (the images' treatment); and the dignity of the viewer. As such, the question of dignified images, and the risk of representational dehumanization actualized by this concept, involves both a risk for the people depicted (a risk of being dehumanized in undignifying images) and a risk for the viewer (in terms of a potentially dehumanizing perception of the depicted).

The phenomena of representational and perceptual dehumanization – the question of how representations of people can dehumanize the represented, or how representations can allow us to get a dehumanized perception of others – is a great ethical concern in our image-saturated times. With "dehumanization," I mainly refer to processes and structures of seeing, representing or figuring others in ways that remove from them such positive human qualities as "individuality, autonomy, personality, civility, and dignity" (Oliver, 2010:85). In other words, I refer to processes and structures that enable "moral exclusion" of some people. Through such moral exclusion, these processes facilitate a "dehumanizing perception" (86) of others. According to Herbert C. Kelman, a professor in Social Ethics, it is crucial that we perceive every human being as having identity and community – if not, we perceive dehumanizingly. To see someone as having identity means, in this context, to see him or her as being distinguishable from others, and capable of making choices. To do this is of utmost importance in treating the other with dignity. By "excluding a person or persons from our moral community," scholar Sophie Oliver reasons, "it becomes possible to act inhumanly against them, or else to allow harm to be done to them by others."

The documentary *Winter Soldier* (The Winterfilm Collective, 1972) testifies to this risk, showing the connection between dehumanizing images of the "Other" and atrocious acts of violence. In this film, American soldiers, just having served in the war in Vietnam, talk about their dehumanized view of the Vietnamese, they refer to indoctrination during military training, making them able to commit horrendous acts

to the human body. The film mainly consists of intense close-ups of the American soldiers' faces, thereby letting us concentrate on their individuality and their individual facial expressions, while they refer to the dehumanizing and undignified acts, they did and witness in Vietnam. This aesthetic decision has two important, intertwined effects: it preserves the American soldiers' dignity as individuals while countering the rhetoric of dehumanization referred to.

For both Sophie Oliver and the Winterfilm Collective, dehumanization is figured as a problem of *(mis)perception* potentially leading to inhuman acts, where we all have an obligation to resist structures of moral exclusion – an obligation to preserve a regard for the other's dignity.

It is my hope that the reader of this chapter will link the following discussion to other areas of our cultural and political life and to other modes and forms of representational images. Living with social media, global news, short and long films, etc. as a large part of our life world (our visual environment and medial experience of world events), Abounaddara's notion of dignified images speaks to broader, more general concerns and problems related to representational images spreading fast in our global world.

Now, before moving further with Abounaddara's idea of dignified images, and how it can be seen as a form of risk communication, we shall take a look at the more fundamental question of what constitutes dignity.

## On the Notion of Dignity

While historically referring to the "worth" of a social elite (Rosen, 2012), the *dignitas* of an aristocratic identity (Riley, 2010; Hennette-Vauchez, 2011), the modern, egalitarian concept of "dignity" refers to an inherent and irreducible worth in every human being – irrespective of social status. The idea of worth is here linked to the notion of respect; to have dignity is to have an inherent worth demanding respect. *The Oxford Dictionary* defines dignity as "the state or quality of being worthy of respect." This meaning is contained and developed in Immanuel Kant's imposing maxim formulated in *Groundwork of the Metaphysics of Morals* (1785): *Every human being should be treated as an end in himself (or herself), and not merely as a means*. This is a matter of *respect* for other human beings,

acknowledging that they have an irreducible *worth* that is not up for sale, and a *worth* they have in virtue of *what they are*.

History shows us, however, that such an inherent worth has not easily been respected – or even seen as present in all human beings. For a long time "dignity," or "*dignitas*," was a non-egalitarian, hiearchical concept pertaining to a certain group of people, such as the aristocracy, to kings, or to God (Riley, 2010). That is, "dignity" was not considered an innate value in the human being, but rather dependent on a person's social status, such as "matter of rank and honour, of title and office" (N. Tarling, 2007:142). As Frost (2013) observes, humanist thought – either religious or rationality-based – was long operating with the notion of "ranked dignity." Historically, then, the concept of dignity has not been an inclusive one; it has worked to exclude and stigmatize people not deemed "dignified," not deemed worthy of respect.

Animal metaphors, for example, have been a recurring way to treat others in an undignified manner. As Riley (2010) points out, the notion of dignity has, from ancient to modern time, worked to distinguish what separate humans from animals and their supposed "bestiality." This can explain the many animal metaphors used to degrade and stigmatize people perceived as less dignified than others. The horrors of the Nazis, as referred to in the introduction, is a paradigmatic example of the possibly grave consequences of such a "ranked dignity" figured in terms in animal metaphors that dehumanize human beings.

Looking beyond this paradigmatic example, there are innumerable examples of these processes, past and present, where the notion of "ranked dignity" has been implicated in moral catastrophes. Morton Deutsch, for example, has referred to some of the major historical examples of individuals and groups "treated inhumanly by other humans":

> slaves by their masters, natives by colonialists, blacks by whites, Jews by Nazis, women by men, children by adults, the physically disabled by those who are not, homosexuals by heterosexuals, political dissidents by political authorities, and one ethnic or religious group by another. (Oliver, 2010:87)

Today, however, dignity tends to be regarded as a *unifying* – and not divisive – concept. According to Riley & Bos (2019), the modern concept of dignity can be said to "represent a claim about human status that is intended to have an unifying effect on our ethical, legal and political

practices." Today, dignity is not connected to external factors, but refer to each individual's "inviolable status as embodied persons" (Riley, 2010:158). Remy Debes (2017), in his historical discussion of the concept, describes our modern, egalitarian notion of dignity as "the fundamental moral worth or status supposedly belonging to all persons equally." This "democratization" of the concept was firmly established after the Second World War – figuring, as we have seen, in the *Universal Declaration*'s pronouncement of a "human family" – and is operative in the modern concept of *human rights*. As already pointed out, Immanuel Kant is the founding figure of this modern conception of an inherent human dignity.

Kant refers to *dignity* as a human being's unconditional and incomparable "inner worth," a worth that we have an ethical commitment to protect and respect (Kant, 2012:789). This dignity, or unconditional and incomparable worth, is connected to a human being's moral freedom – its autonomous will, his or her freedom of action – that we must respect. Kant clearly distinguish the notion of dignity from that of "price": "In the kingdom of ends everything has either a price or a dignity. Whatever has a price can be replaced by something else as equivalent. Whatever by contrast is exalted above all price and so admits of no equivalent has a dignity» (Kant, 2012:788). The human being has dignity and no price. It has dignity, according to Kant, because it is capable of morality, by acting not merely out of "inclinations," but out of moral choice and freedom. Our *work skill* has a market price, Kant explains, but our "fidelity to promises or benevolence out of basic principles (not out of instinct) have an inner worth" (Ibid). We find a similar connection between human dignity and human *freedom* in the Renaissance thinker Giovanni Pico Della Mirandola, for whom the human being is distinct from animals in the way we "do not simply fulfil a preordained role" (Rosen, 2012:14–15), but are free: Man chooses his or her own destiny. Pico connects our "dignity" as human beings to our *freedom* as creatures able to shape our own destiny. Indeed, it is in Pico, Rosen explains, that we see the roots to the modern concept of dignity that Kant would develop and elaborate: "Dignity' goes from being a matter of the elevated status of a few persons in a particular society to being a feature of human beings in general, closely connected with the capacity for self-determination" (Rosen, 2012:15). This connection between a perceived human freedom, our

self-determination as beings in the world and a proclaimed dignity, is what Kant elaborates on in his moral philosophy – giving us the foundation for Abounaddara's conception of images of dignity, as we soon will return to.

Concluding this brief reflection on the notion of dignity, I would like to allude to its political precariousness, and to its potentiality as a relational concept interconnected with art – art being, in this context, conceived as a critical activity reworking our relations to the world, to other human beings, and to ourselves. Even though dignity has become an important concept in moral and legal contexts, not least human rights discourse, it nonetheless remains to be defended and enforced in different contexts. As N. Tarling (2007) argues, people's dignity and rights are regularly "endorsed but not effectuated" (149). Abounaddara's work is, I would argue, an effort to effectuate the notion of dignity; of communicating the risk of depriving people of dignity, a communication enacted in the representational and perceptual work, operations and initiatives of images. "Dignity is not an idea abstracted from human action," writes Malpas & Lickass (2007), "but has life only in the actual relations between human beings" (5). Reminding us that dignity has to do with the elusive "feeling of and for the human" and its situatedness in the wider world, they further argue that "a sense of human dignity is perhaps most profoundly encountered [...] in poetry and story (both the story of history as well as literature), in art and music, and certainly not only in philosophical or legal analysis (4)." Abounaddara, working with a multisensory and multimodal art of the image, works on exactly this. As we will see in the following, we must see the film image not as a transparent representation of a referent, but as the manifestation of a relation to the world.[3]

Stressing the importance of conceiving dignity as a *relational human worth*, as much connected to a *social milieu* as to our own individual autonomy, the authors points out how dignity is connected to how we relate to each other, to social organization and to exploitation:

> to take just two examples: the operation of slavery in the 18th and 19th centuries (and still today) depended on destroying the ordinary relationships that

---

[3] You will find this idea formulated and developed in, for example, Aumont (1997).

make for meaningful human life and turning a human being into a mere commodity, a body to be used, traded, disposed of; the use of torture, whether through pyshical or psychological violence, whether in Guantanamo Bay or elsewhere, involves a similar denial of the dignity of the individual, operating through the destruction of the ordinary relations that form the human life, reforming those relations according to the desires of the interrogator, dissolving the world and the world along with it. (Malpas & Lickass, 2007: 24)

Dignity, we are here reminded, is not only some value existing in the individual, but a social concept guiding us to preserve a respectful interaction with each other, and promising, more generally, a livable world for people across cultural borders. Malpas & Lickass adds an explicit consideration of the social to Kant's maxim – a consideration we bring with us in the following discussion of dignified images.

## Abounaddara's Concept of Dignified Images

How to preserve this dignity when presenting people in images? How to retain a person's dignity in representations? Moreover, can images *give* dignity to people? Can images be considered as a dignifying gesture of some sort? Can images offer people a dignity that is taken away from them in other contexts; that is, represent them in a way that reinscribe dignity in their image (or in our image of them)? Furthermore: How to *perceive* and *react* to images that work against, reduce or destroys the dignity of people, and how to critique and counter these images? How, that is, are we to give a *dignified response* to images of actual people? Summarily, How to retain dignity in one's gaze, both as image-makers and as image-viewers, so as to preserve the dignity of the represented?

These are some of the critical questions evoked by the work of Abounaddara. Their work is rooted in their principle of dignified images, and this principle, stating "that people's dignity should be preserved within their images," Mayyasi (2015) takes on a particular urgency in the context of the complex situation in today's Syria. However, the idea of dignified images addresses a broader, more general and international concern in our image-saturated world, where many of us daily experience distant realities in mediated forms. Explaining the importance of this principle, Abounaddara explicitly links it to Human Rights and the Kantian conception of dignity: "Consecrated by the Universal Declaration

of Human Rights, the principle [of dignity] presumes that a human must not be treated as a means, but rather as an end in herself or himself" (Abounaddara, 2016). This begs the question: How to follow this principle in the actual construction and viewing of images?

An image representing a human being should treat this human being as an end, and not merely as a means – so much is established, or at least so much can be a working hypothesis guiding our idea of dignified images. According to this idea, it seems reasonable to say, an image should (by way of example) not merely represent a human being as an *example* of the victims of one side of a conflict; it should take care to portray a person as a singular human being integrated in a shared, common humanity – as a "singular plural."[4] This first principle of dignified images implicates, moreover, a call for a dignified viewer, a dignified response; their concept of dignified images, as I read Abounaddara, is not only a question of images' treatment of a referent, but a matter of addressing the viewer as an empathic world citizen, as part of a "human family," and not merely as an individual consumer. Regarded in this twofold sense – as a dignified representation and as a dignified response – the concept of dignified images invokes the Kantian notion of our *duty* to respect another person's autonomy and freedom. Abounaddara invoke this sense of a moral duty in the sphere of images; we are not to reduce a person into a rigid, schematic image (for instance, a stereotype or cliché), not to quench his or her freedom in our representational treatment (as image-makers) or perceptual grasp (as image-viewers). This seems to demand both a certain open-endedness in the images' representation and figuration of the real, and a certain open-mindedness in the viewer's engagement with representational images.

But how to conceive this in more specific terms? What does it require from an image or an image-work, such as a film, to allow for such a dignified image to be created, empathically encountered, and critically reflected? This essay will not pretend to give satisfying answers to these questions; it wants, however, to raise them in different forms and try to give some possible answers by pointing to some of Abounaddara's particular films.

---

4 I borrow this term from Marcia Sá Cavalcante Schuback (2017), who again borrows it from the French philosopher Jean-Luc Nancy.

Moreover, it is my hope *to show some of the ways in which Abounaddara's work on dignified images communicates the risk of representational and perceptual dehumanization.* When images representing actual conflicts do not preserve the dignity of the people therein represented, reducing them to schematic *types* in a discourse or narrative, they potentially put people in risk of a dehumanized perception – potentially making it easier to accept inhuman, undignified acts against these people. As the Syrian filmmakers declare in "A Right to the Image for all: a concept paper for a coming revolution" (2015): "We live in a world filled with images that are captured, edited, and published at hyper speeds. […] Our political, ethical, and intimate lives are constructed around images, through images, and in images." They continue: "In situations of war and mass violations of human rights, our hyper-mediatized world creates the typical images of victims." Considering the fact that representational images constitutes an extensive part of many peoples' life world and their information, knowledge and perception of other human beings, this risk should be addressed and acknowledged as a crucial aspect of the social well-being of the individual in today's globalized world. Before we go further into Abounaddara's specific films, however, it should be helpful with a brief contextualization of their work.

## Contextualizing Abounaddara

In the Syrian conflict, starting with the civil uprising in 2011 and continuing to this day with the Civil War, people on different sides have participated in what researcher Stefan Tarnowski has called a "struggle for representation" (Tarnowski, 2017). Iconoclasm during the uprising, mobile witnessing of the state's violent repressions, and ISIS' sensationalistic propaganda videos, are only some prominent examples of participants in this struggle. It has been noted that the destruction and the creation of images was one of the first important moves in the start of the Syrian uprising (Elias, 2017; Tarnowski, 2017). Yet the proliferation of images (not least moving images) from the conflict zones was not only an initial event, but has been enormous throughout the last years of struggle.

In this context, Abounaddara has been recognized for their *critical* work on filmic representation, "merging," as film scholar Nicole

Brenez succinctly suggests, "civil emergency" and a "deep formalism" (Desistfilm, 2014). Regarding their own work as an "emergency cinema" (Cooke, 2016), Abounaddara work on the social and moral responsibility of aesthetic forms, narrative strategies and representational conventions in a historical time of emergency, and not in the eternal sublime; theirs is what we could call a *moral formalism* that in their very representations ask questions of representation. This has involved not only a work *with* images, or a *use* of images, but a work *on, in* and *against* images; a critical and inventive, questioning and self-reflective work with images as complex material constructions and symbolic configurations intervening in a reality, initiating points of view and raising questions. The image is to be treated as a questioning, problematizing and problematic construction and perspective, and not as a collection of views, a container of information, a narrative to easily comprehend, or a spectacle for consumption. That is, Abounaddara has stressed the image as a *problematic treatment* of actuality, and not as a transparent transmission of it. And as I hope to make clear further on, this is a crucial part of their work on "dignified images."

Abounaddara was established already in 2010, before the uprising, as an initiative outside of the established system of cinema production in Syria. The collective consists of anonymous, self-taught filmmakers (Boëx, 2012). Abounaddara's self-proclaimed goal was to offer the Syrian people *images of themselves* untainted by censorship from the state and what they termed "the culture industry" – evoking Adorno and Horkheimer's damning critique of a media industry of mass distraction.[5] As such, Abounaddara can be conceived as a film collective of *resistance* already from before the uprising, working, according to their spokesperson, to "break the monopoly held by the Assad regime and the culture industry over the way our society is represented" (Mayyasi, 2015). "It was out of desperation," their spokesperson Charif Kiwan said, that they launched the collective in 2010: "We absolutely had to change the

---

5   I borrow the term "mass distraction" from the American Philosopher Cornel West. See, for example, West, Cornel & Ehrenberg, John (2011): "Left Matters: An Interview with Cornel West", New Political Science, Vol. 33, N. 3, p. 359.

way our society was represented – a representation monopolized by a tyrannical government and a blind culture industry" (Ibid.). From this, it is clear that Abounaddara already engaged in a "struggle for representation" even before the revolution and the coming Civil War, offering a critical questioning of the ways in which its society and its citizens were represented, and a project of social (re)description guided by an ideal of human plurality.

To grasp the interconnection of a social project of "civil emergency," and a historically informed "formalism," in the work of Abounaddara, it is worth reflecting on the group's name. The name "Abounaddara" can be translated to "Man with Glasses," referring to ordinary people living in Syria (in Arabian cities, people in general are identified by their professions or by the professions' associated words). However, the name has several significations, one of them being the reference to the Soviet montage filmmaker and theorist Dziga Vertov, his film *Man with a Movie Camera* from 1929, and his concept of *Kino-Glaz* (Kino-Eye). The first reference signals the collective's commitment to represent the human being as a *citizen*, and not reduced to the role of victim, persecutor or hero in the conflict, and to a *common humanity* across ideological differences; theirs is an "emergency cinema" wanting to preserve or restore the dignity of the citizen, and to communicate the risk of dehumanization in the process of a heated, multisided "struggle for representation."

With the second reference, Abounaddara explicitly inscribe themselves into a history of cinema, more specifically into a tradition of experimental documentary intent on redescribing and exploring the world through cinema's capacity of perceptual reconfigurations. Dziga Vertovs concept of *Kino-Glaz* (and the movement aligned with it) articulated, polemically against a conception of cinema as a dramatic-narrative spectacle, a conception of cinema as an exploration and treatment of the actual world in ways that differs from earlier art forms, mediums of communication, and ordinary human perception.[6] Situated in such a conception of cinema, Abounaddara's work seems dedicated to rework and question our perception of the world through the constructive operations of cinematic images,

---

6   See Vertov, Dziga (1984): *Kino-Eye: The Writings of Dziga Vertov*. University of California Press.

sounds, titles and *montage*. In this approach to cinema, montage is not only to be regarded as a tool for creatively juxtaposing images into an organized, coherent whole – "the art of telling stories through a series of disconnected yet linked points of view" (Aumont, 2015:5) – or a tool for creating meaningful relations between images of phenomena; it becomes a work on what Vertov called the *interval*, the dynamic temporal space or *gap* between images. A film is not just an audiovisual presentation of images based on the principle of clarity and continuity; it offers a *temporal disjunction* of the real as we ordinarily perceive it. Abounaddara work on this disjunction, recurrently putting emphasis on the gap between images, working to destabilize and question images and relations between images as much as to produce them. Several of their films play with the gap (or interval) between images to destabilize a sense of control and mastery in our perception of the events and people represented. In the conclusion of the chapter, I will point to one such film, *The Walk to School*.

After the uprising started, Abounaddara has posted a short film on their Vimeo channel (and other social media, such as Facebook) almost every Friday (Ryzik, 2015; Bayoumi, 2015; Abounaddara, 2016) – at least until 2017.[7] Known as a day of anti-regime demonstrations or protest in Arabian cities, this choice indicates that the collective supports the revolution (if not necessarily its violent means) and opposes the Assad regime (if not in violent ways), and this has been confirmed by their spokesperson in several interviews.[8] If the term "protest" is fruitful in describing their output, however, I would like to bring to attention (in the context of our topic) that this involves a *metacinematic* protest, and not an easily identifiable political slogan; theirs is a concern with countering "undignified images,", representational images not respecting the dignity of human beings, and thereby risking a dehumanization of our "image" of the people represented – and, importantly, this applies to people on

---

7  In addition to this work, the collective has (among other things) made the long film *During Revolution* (*Fi al-thawra*, Maya Khoury, 2018) and published the book *The Question of the Right to the Image* (2019), edited by The Abounaddara Collective and Katarina Nitsch. I have not read this book written in Arabic.
8  See, for instance, Mejcher-Atassi, S. (2014).

different sides of the conflict. Abounaddara continually stress the importance of not reducing people to *representatives* of different sides of the conflict; their "protest" takes the form of "counter-images" to the many "sensational" images of dead bodies and violent fighting, to the many standardized news reports, to the many conventional frames of victimization and heroism. "Theirs is the demand," writes philosopher Marcia Sa Cavalcante Schuback (2017), "not to be fixed in what renders existence indecent."

## Aesthetic Strategies

Abounaddara's cinema works to un-limit the fixity of stereotypical images, clichés and closed narratives, and this, I would argue, is a crucial part of their communication of the risk of dehumanization. In this work, I would like to point out two central aesthetic strategies (among various): first, that of *détournement*,[9] or rhetorical appropriation, and what we more generally could call rhetorical play (and irony) with established conventions and clichés; secondly, an *open-ended, questioning description* of events or portrait of people, where the *gap* between images is important, and conventional narrative structures either dispensed with or challenged.

In *The Butcher of Aleppo* (2016), for example, the title evokes, for many of us, images of a murderer in this Civil War, a "butcher" in a metaphorical sense. Red-colored letters in the opening image presenting the title of the film reinforce the title's violent metaphoricity. The first shot, however, is a close-up of the concentrated, peaceful face of a boy doing some work. The next shot reveals that he is cutting meat from the bones of an animal. The next few images suggest he is helping out what seems to be his father or boss, a butcher. The film, it turns out, is a quiet, peaceful portrait of an actual butcher selling meat to his customers; the blood-dripping title was a joke, a play with our expectations. The film ends with the text: "To the Butcher of Aleppo, crushed by the Doctor of Damascus."

---

9   A term developed by the Lettrists. See, for instance, Debord, Guy & Wolman, Gil J. (1956): «A User's Guide to Détournement», Les Lèvres Nues, No. 8: https://www.cddc.vt.edu/sionline/presitu/usersguide.html (30.08.2019).

No further commentary is given, no contextualization, just these evocative and ambiguous verbal formulations accompanying and framing the images. The film is an open-ended description of a place and an event of selling and buying meat, and a brief, fragmentary portrait of two persons. *The Butcher of Alleppo* is a peaceful film, a peaceful portrait, but one marked by a violent rhetorical play that questions our expectations (the title that signals a murderer) and the powers and responsibility of metaphors.

*The Butcher of Aleppo* is just one of many films by Abounaddara that operates with rhetorical play, brutal irony, and a questioning of the viewer's gaze, the conventions of narrative forms and textual framing. Sometimes, this takes very confrontational forms vis-à-vis the viewer. In *Two minutes for Syria* (2013), we are shown close-ups of human skulls in a museum, and tourists taking photographs of these skulls, with the sound of camera-clicking intruding our view. The film ends with the declaration: "STOP the spectacle!," followed by: "There is another way you can help the Syrian people." Or take *Syria Today* (2012), in where a frontal shot of a train moving toward the front of the image, or toward us, recalls Lumière's famous *Arrival of a Train at La Ciotat* (1896) (but also alludes, one could argue, to the trains bringing the Jews to the concentration camps). The train, moving directly toward us, do not stop, do not arrive at a quiet station, as in Lumiere's film, but figuratively *hits us*, before a red text fills a black screen, erasing our: "Stop watching! We are dying!" The "view aesthetic" of early cinema are used and then countered to question a tradition of pleasurable looking: we are not given a contemplative view but a troubling wound.

## An Anti-View Aesthetic

Dignity, Abounaddara remind us in an essay, "is one of the pillars on which our shared world was constructed in the wake of the crimes against humanity committed by the Nazis" (Abounaddara, 2017). While their work concerns the Syrian situation of today, their concept of dignified images proposes and frames the whole history of (representational) cinema and medial image-production as a history of dignity and lack of dignity, as a history of humanization and dehumanization. They remind

us of what Nicole Brenez, in a different context, refers to as "the stakes involved in every representation of a face" (Brenez, 2014: 64). The concept of dignified images, I would argue, allow us to rethink various images, and the "image" in general (that is, as a phenomenon), in terms of its social and moral responsibility as a representation and figuration of the real – and the risks of (intentional and unintentional) dehumanization when losing sight of this responsibility.

In making and in viewing images of actual persons, there is always a risk of reducing or not respecting their irreducible humanity, including their dignity, their autonomy, their freedom as moral beings. An image, just by virtue of its very material and formal properties, reduces the represented to a limited point of view, *figures* it in a certain way: "an image," film scholar Jacques Aumont points out, "cannot visualize a physical and psychological phenomenon, unless it simplifies and/or symbolizes it" (Aumont, 2017:31). There is always a risk of reducing the complexity of who or what is represented in an image; and it follows from this that one do not need to be involved in a conflict, or a victim or persecutor of racist ideologies, to be entangled in or work with images that reduces the fullness of the human to a symbolic configuration. One can depict a person or a group of human beings in an "undignified" manner without having an intent to do so – the creation of a *stereotypical* image, for example, might reduce the complexity and freedom of a human being belonging to a group, and this stereotypical reduction can happen without intent of harm.

Either intentionally or non-intentionally, from the inception of cinema to today's global media networks, various people have been framed in stereotypical ways, "colonized" by an aesthetics formed by a stranger's gaze. In their article "Colonialism, Racism and Representation" (1999 [1983]), Stam & Spence notes that the "beginnings of the cinema coincided with the height of European imperialism" (239). Cinema was used as a tool and technology in figuring the "Other," by framing people in a certain light, giving or attaching certain values to certain people. They note, for example, that Arabs from early on was represented as "shifty" (Ibid). Abounaddara's spokesperson gives us a concrete example when making critical comments on The Lumière brothers'1897 portrayal of a Syrian as "fanatic" (Bayoumi, 2015). In what is arguably the first

cinematic depiction of a Syrian, *Assassinat de Kléber*, a fictional staging of the killing of the French general Jean-Baptiste Kléber, the scene shows a Syrian man violently stabbing the general. In the film, the bearded man looks mad. But could this person, who's name was Suleiman al-Halabi, have had rational, political reasons for the killing, and did he actually have a beard? Abounaddara's spokesperson asks these questions (and state that he did, in fact, not have a beard), but Lumière's film does not invite us to ask them. The calm distance of the framing, the controlled and scenic *mise-en-scène*, assure us of our secure position as onlookers to a spectacle, as an audience to an attraction.

If it is true, as film scholar Tom Gunning (2006) argued, that the "cinema of attraction" of early cinema addresses an "acknowledged spectator," that its relation to the viewer is one of "exhibitionist confrontation," this is one that is "inciting visual curiosity, and supplying pleasure through an exciting spectacle – a unique event, whether fictional or documentary, that is of interest in itself" (2006:384). Cinema, in this tradition, offers us spectacular *views*. The "anti-view" aesthetic of Abounaddara's films – epitomized by the clear message in *Two minutes for Syria*: "It is other ways in which you can help!" – problematize this tradition of cinema as pleasurable attraction, as an event interesting in itself. This critique addresses several present risks regarding representational images more generally.

## Addressing Present Risks

Abounaddara's initiative involves, as should be clear, not only a critique of images of the past, but also of the present. In today's global photojournalism, for example, there are risks of framing others in undignified ways. Commenting on how photojournalism transmits images of suffering, Sohrad Mohebbi (2016) reminds us of the risk of stripping people of dignity in terms of representation: "Starving children or encamped asylum seekers are not only deprived of many basic human needs such as food, clean water, and shelter; they are further deprived of the possibility to decide how they are to be represented" (284). As these observations remind us, and as Abounaddara stresses, a crucial aspect of dignified images relates to the question of *who* controls the image. It is from the

perceived lack of the Syrian people's *self-determination* (important in the Kantian conception of dignity), a lack of control of "their own image," that Abounaddara seems to intervene in the global image economy.

Blaagaard et al. (2017) argues that today's extensive dissemination of images through technological networks connects local conflicts to a global reality in new ways. This implicates new stakes involved in what they term "the politics of visibility" (1113). Referring to how Western media portray realities of conflicts in other areas of the world, the authors point to "the difficult cause of communicating the specific needs of their [Humanitarian organizations] causes while protecting the dignity of those who have suffered from conflict" (1114). Here it is stressed that protection of dignity means, among other things, avoiding stereotypes: "the continued (re)production of images that fall neatly into stereotypes of female victims and masculine perpetrators risks essentializing victims of war and conflict as emotionally charged and geopolitically dependent on Western help and pity" (1115). Images, of course, play into our idea and "image" of conflicts and of suffering. So, perceiving and grasping the complexity of a specific reality demand us not be content with stereotypes and "grand narratives," but to allow a reality to be seen from different perspectives. This is what Abounaddara's stated goal is to present perspectives that questions the viewer's perspective or perception of the reality addressed.

Now, as Blaagard et al. argues, images taken and disseminated by people actually living in conflict zones have the potential of giving us new insight, but it also potentially create a distance "due to their lack of accessibility to outsiders to whom they often come across as selective, fragmentary, and difficult to decipher" (1116). Abounaddara seems, from my perspective (being distant to the events, not living in Syria), to *embrace*, develop and use the fragmentary as an aesthetic tool to remind us of our own distance to the events. Standardized news reports, such as those offered by the Norwegian TV channels NRK and TV2 or international ones like CNN, have a tendency to familiarize us with the events, or at least to familiarize ourselves with the *distance* to the events. Partly, they establish an atmosphere of familiarity by staging a sense of authority, standardized forms of composition, editing, voice-over commentary, and various narrative conventions. Abounaddara often work in an aesthetics of the fragmentary, evoking a sense of lack, a hole in the depiction. This

is part of their *emergency* cinema; not striving to give us a "complete" image of the reality represented and evoked.

## "Bullet Films"

Commenting on their guiding principle of dignified images, the principle "that people's dignity should be preserved within their images," Abounaddara states:

> Our position is based on arguments that are aesthetic (death in close-up offers no more information about a crime than pornography does about love), political (Syrians are not victims of a natural disaster, but men and women who are fighting for an ideal of freedom and dignity), legal (individuals' rights to their images must be respected in all circumstances), and ethical (pity is dangerous, especially when it is preached by a media with a vested interest in disseminating sensationalist images). (Mayyasi, 2015)

Here, it becomes obvious that the concept of dignified images is a complex one, communicating several risks involved in image-production. Two of these (political and legal) refer explicitly to the actual persons portrayed, while the other two (aesthetic and ethical) relates more directly to the act of looking and regarding, to what we have termed "the problem of the viewer." We are reminded that our encounter with images bears an ethical responsibility; to look at images entails, in this context, to engage in the perception of other's reality (including their potential suffering and happiness), and this entails, as I read Abounaddara, an empathic and *questioning perception*, not merely a pitiful gaze. We are reminded that, in the act of voyeuristically watching images, we risk being complicit in a dehumanizing perception of people not controlling their own image.

In this regard, it could be fruitful to consider one of the models for Abounaddara's notion of dignified images: The American director Samuel Fuller. The group has referred to Fuller as an inspiration, notably his way of filming the Falkenau Concentration Camp (in Czechoslovakia) in the aftermath of its liberation in May, 1945: Fuller did not "exhibit" the dead bodies (Feinstein, 2015; Dork, 2016), but rather showed a funeral ritual in a carefully composed way, giving shape to the moral implications of the event and respecting the individuality of the dead. By way of his compositions and editing, the film joins forces with the detailed ritual in dignifying the dead (Orgeron, 2006). This was a "huge artistic lesson"

for Abounaddara: "How to evoke the horrors, how to let people imagine the worst thing possible, without actually exhibiting it" (Feinstein, 2015). Fuller, having experience both as a journalist and as a soldier, also figures as an inspiration for the collective in more general terms, as a filmmaker working with small budgets and who balanced "dryness" and "lyricism" in his approach to subjects, treating social concerns with dignity (Ibid.). Taking this into account, I want to suggest that a scene from Fuller's fiction film *The Big Red One* (1981) might also guide us to see an ethics of dignified images. This film is an autobiographical World War II film portraying some weeks in the life of a platoon. Creating a scene where the soldiers stumble onto a concentration camp, Fuller felt a responsibility of not giving us a *voyeuristic* view of suffering. Film critic Jonathan Rosenbaum, affected by the haunting viewer-confrontation Fuller constructs, describes the scene in the following way:

> [The American soldier] Griff (Mark Hamill), who has heretofore been portrayed as a coward afraid to shoot, finds human bones inside a crematorium, then a live German solider inside the next one — and proceeds to fire at the latter again and again, coldly and maniacally, at a funeral-march tempo. The refusal of Fuller to cut away from Griff to a second shot of his target is very disquieting: "That's for *you* to feel what's happening to that body on the skeleton. I don't want the audience to see it — I want them to *feel* it." (Rosenbaum, 1980)

This scene, by not showing us the Nazi soldier dying, by not giving us this vengeful view (a conventional reverse shot), turns the viewer into view. Fuller, by many regarded as a director of spectacle (and a poet of the close-up of human faces), refuses us *this* spectacle. Rather than giving us a close-up of the Nazi soldiers' bullet-ridden body, we are given, so to speak, a close-up of our own ignorance. By this unconventional formal move, we are reminded of our inability to be there or to grasp this reality, while simultaneously being offered an opportunity to imaginatively place ourselves in the German soldier's place. Part of the "dignity" of this specific cinematic moment, this specific image combination, I would argue, stems from its perspectival ambiguity, the troubling openness and gap of such an "anti-view" aesthetic; it does not give us a closed view of the event depicted, but challenges us; these images challenges our perception of the represented event. There is a dignity in these kind of image-challenges to perception, whereby *we are in view* as much as the represented reality. In

an interview with Rosenbaum, Fuller explains his decision: "I was not interested so much in the violence on the screen [...] as in the violent emotional reaction of an audience" (Rosenbaum, 1980). This sentiment is repeated in the film's press book: "To make a real war movie [...] would be to fire at the audience from behind a screen" (Ibid). In the scene just described, Fuller comes close to enacting this sentiment.

Abounaddara's spokesperson has explicitly referred to Samuel Fuller and this ethics of cinematic representation. According to him, the collective has sometimes felt an urge to show the dead bodies of their massacred compatriots, but, remembering how Fuller filmed the Falkenau Concentration Camp, they have resisted (Mayyasi, 2015). Adding to this, I would suggest seeing this moment from *The Big Red One* as one model for Abounaddara's conception of dignified images. This example and model points to the inseparable interconnection between aesthetics and ethics – in fiction as well as in documentary cinema – so crucial to the Syrian collective's particular form of risk communication.[10] There are stakes involved in showing a close-up or not, and there is, in certain circumstances, an ethics in not giving us a "full" view of a represented reality; turning the image toward ourselves as viewers. In this regard, and with the shooting scene in *The Big Red One* in mind, Abounaddara's description of their own work as "bullet films" (Mejcher-Atassi, 2014) makes perfect sense.

---

10 Abounaddara's *resistance* to the inclinations of showing their dead friends brings to mind Friedrich Schiller's notion, in *On Grace and Dignity*, that when it comes to emotion (where, in his account, nature speaks), moral freedom express itself in resistance; "mastery of instinct by moral force is *freedom of mind*, and *dignity* is the name of its epiphany" (Schiller, 1988: 374). Concerned not with the dead bodies but with the humanity of the dead, Abounaddara, in their refusal to give in to the desire to show the dead bodies of their friends, let their films represent a *moral force* in Schiller's sense. I wish to add that Schiller's text could, more generally, enrich our understanding of Abounaddara's concept of dignified images, not least the interconnection between aesthetics and morality.

## The Walk to School

In her essay "Being without a People" (2017), the philosopher Marcia Sa Cavalcante Schuback suggests, in the vein of Susan Sontag's famous critique in *Regarding the Pain of Others* (2003), that the piles of dead bodies we see in images and on screens can turn us into indifferent viewers. In the essay, Schuback refers to nameless graves of dead Syrian children, and relates this to the importance of having a *name* so as to belong to a community. The name, she argues, singles out the singularity of a person in a community – a community being always a community of singular existences. A name is not only a matter of identification, she argues, but "the sign of a voice, a voice that calls and can be called." After this evocative image, she continues: "As what calls and can be called, the name renders vibrant the taking place of existence as unique and common." Alluding to how Abounaddara's notion of dignified images can be seen as a practice of naming in a similar sense, Schuback opposes this work to the construction of a more abstract "people." The more abstract designation of a group of people has tended to, in a historical perspective, to establish and reinforce notions of the "other," thereby overlooking a common humanity and creating a sense of us and them. Abounaddara avoids the representation of an abstract people, rather giving voices to singular human beings belonging to a common humanity:

> Some Syrian artists gathered under the name Abounaddara, which means anonymous, are working today for the right to a decent image [...]. Through their images, they scream that they are not refugees, they are not the suffers, but that they are fleeing, they are suffering. Theirs is the demand not to be fixed in what renders existence indecent. They ask to let their voices be heard. These artists film scenes of everyday life in the middle of a monstrous war, followed by the world with an indifference that grows the more one becomes used to seeing dead pieces of bodies on the screen. (Ibid.)

A demand not to be "fixed" – for example in a stereotype – is essential to preserve a person's dignity, a person's self-determination. In the conclusion of this chapter, I would like to point to a film by Abounaddara exemplifying the tendencies we have looked at.

*The Walk to School* lasts for 1 minute. The film shows us children running, scared, in the streets. The camera moves in the opposite direction of where the children are running. An ambulance enters the scene. An

abrupt cut (an ellipsis creating a small, uneasy gap), and we are taken to the ambulance's arrival at what seems to be a schoolyard, emptied of children. The camera turns around, and we gradually see traces of violence: a shoe barely visible under a car, and then, right on the inside of a building, blood. The film then fades to black, accompanied by harrowing siren sounds.

It was not before one of my students suggested it that I thought of the possibility that the title could be referring to the person walking with the camera. To me, the title had been very troubling, almost unbearable (after having watched the film several times), as it evoked peaceful memories of my own walks to school, before giving me this violent fragment of a reality that I know nothing about. The film robs us of a conventional opening and a conventional ending; it throws us into a chaotic scene and leaves us in a state of confusion, ending with a violent trace. I experienced an *affective gap* between the title and the cinematographic description of the event, a gap that disrupted my comfortable viewer position – and that demanded, I felt, a dignified response.

The title can be interpreted as part of an overall aesthetic of the gap. Other than the title, one can mention elements such as the *confusion* in the street, stressed by the lack of a compositional center in the images, and by letting the sound of an alarm introduce the first images of fleeing children; the choice of showing *fragments* of an event without its cause or background; the abruptness of the continuity editing, giving room for a sense of discontinuity, something fragmentary, an interval, something missing; the ending, leaving us in a "gap," so to speak, refusing to show more than the blood, a discomforting trace punctuated by a disquieting fade-out and the lack of any contextual text, either spoken or written.

One could very well imagine this film as part of a conventional news story or reportage, with a voice of authority comforting us with information, letting the images illustrate a rapport; in Abounaddara's film we are left on our own. We are left with our reaction to a fragmentary and incomplete description of a reality most of us know nothing about, but which speaks to us with a name: *The Walk to School*.

Where is the dignity in such a film?

The film's length, and its representation of a daily scene, recalls the early films of the Lumiere brothers. And as film critic Gilberto Perez (1998) has argued, Lumière's views tend to be enclosed, not encouraging

us to look beyond the frame, not inspiring us to wonder what else could have been shown, what came before and what came after. In *Workers Leaving the Lumière Factory* (1895), Lumiére, starting his film with the opening of the gates of his factory and ending with the closing of the gates, sought to give the film "as far as possible the completeness of a painting" (Perez, 1998:53).

Abounaddara's film, in its incomplete form, refuses us a painterly view. It is indeed what they call a "bullet film." This notion follows Walter Benjamin's dictum in "The Author as Producer" (Benjamin, 1982), an essay Abounaddara is very much aware of, that the work of art must not turn reality into "an object of pleasure," but should compel us to reflect on and take action in the world. Here, the title, *The Walk to School*, by indexing the scene with a strangely normalizing caption, is crucial in the way it demands us to see, precisely, the "normality" of such a scene as completely undignified. In this refusal to be a mere "view," I propose that the film manifests two forms of dignity. Firstly, the dignity of the people in the images is preserved by not reducing them to elements of a view, of something clearly visible, or a controlled narrative. Not figuring the people in the images as victims in a political narrative, as instrumental illustrations of a cause, the form calls attention – exactly in its fragmentary and unfinished description – to a vulnerable existence. I will here remind the reader of Schuback's statement that Abounaddara's images "scream that they are not refugees, they are not sufferers, but that they are fleeing, they are suffering."

Secondly, by stressing what is not shown, by not constructing a clear view or a comprehensive narrative and by letting us get a sense of the gaps in its mediation, it urges us not to be tourists in suffering, not to look with voyeurism, but to reflect on our own gaze and perception, and to *respond with dignity*. We are reminded, moreover, of the risk of a dehumanized perception if losing sight of what we don't see in a representation – if we fix a person to an image or two, trapping them in images instead of letting them call out of them.

## Conclusion

I have argued in this chapter that Abounaddara's concept of dignified images communicates the potentially dehumanizing effects undignified

images can have for the people represented in these images. Abounaddara reminds us of the (often unintentional) role and responsibility images have in processes of dehumanization. Having stressed how Abounaddara's films tend to challenge and problematize the *viewer's perception* – through rhetorical play with established conventions (exemplified in the *Butcher of Alleppo*), detournement (*Syria Today*), explicit messages (*Two Minutes for Syria*) and open-ended, questioning description of events or portrait of people (*The Walk to School*) – I have tried to show how the question of dignity and indignity in the sphere of images is a matter of the perception of viewers of images as well as the representation of actual people. The concept of dignified images, and the work made in its ethos, thereby points to a twofold risk in our "hyper-mediatized world."

This Syrian film collective initiates many important questions that I have not tackled. For instance, the *legal* question of "the right to one's self-image" is an important aspect of Abounaddara's risk communication that I have not discussed. I have, however, studied the work of Abounaddara mainly from an aesthetic point of view, and regarded the question of dignified images as an aesthetico-ethical problem. From this perspective, their work reminds us of the risks of losing sight of our common humanity and dignity – our "human family" – when images reduce people to victims, oppressors or heroes.

## References

Aumont, J. (1997). *The Image*. London: BFI Publishing.

Aumont, J. (2014). *Montage*. 2th edition. Montreal: Caboose.

Aumont, J. (2017). The Veiled Image: The Luminous Formless. In Beugnet, M., Cameron A., Fetveit A. (Eds.), *Indefinite Visions: Cinema and the Attractions of Uncertainty*. Edinburgh Studies in Film and Intermediality.

Benjamin, W. (1982). The Author as Producer. In Burgin, V. (Ed.), *Thinking Photography: Communications and Culture*. London: Palgrave.

Blaagaard, B., Mortensen, M., Neumayer, C. (2017). Digital Images and Globalized Conflict. *Media, Culture & Society*, 39(8), 1111–1121. doi: 10.1177/0163443717725573.

Brenez, N. (2014). Contemporary Experimental Documentary and the Premises of Anthropology: The Work of Robert Fenz. In Schneider, A. & Pasqualino, C. (Eds.), *Experimental Film and Anthroplogy*. London: Bloomsbury Academic.

Cahn, S. M. (2012). *Classics in Political and Moral Philosophy*. 2th edition. New York: Oxford University Press.

Cooke, M. (2016). *Dancing in Damascus: Creativity, Resilience, and the Syrian Revolution*. London: Routledge.

Debes, Remy (2017): *Dignity: A History*. New York: Oxford University Press.

Elias, C. (2017). Emergency Cinema and the Dignified Image: Cell Phone Activism and Filmmaking in Syria. *Film Quarterly*, 71(1), 18–31. doi: 10.1525/fq.2017.71.1.18.

Frost, T. (2013). Et aktualiserende etterord om menneskets iboende verdighet internasjonalt og nasjonalt i vår samtid. In Pico della Mirandola, G., *Lovprisning av menneskets verdighet: Om det værende og det éne*. Oslo: Vidarforlaget.

Gunning, T. (2006). Cinema of Attraction[s]: Early Film, Its Spectator and the Avant-Garde. In Strauven W. (Ed.), *The Cinema of Attractions Reloaded*. Amsterdam: Amsterdam University Press.

Hennette-Vauchez, S. (2011). A Human *Dignitas*? Remnants of the Ancient Legal Concept in Contemporary Dignity Jurisprudence. *International Journal of Constitutional Law*, 9(1), 32–57. doi: 10.1093/icon/mor031.

Kant, I. (2012). Groundwork of the Metaphysics of Morals. In Cahn, S. M. (Ed.), *Classics in Political and Moral Philosophy* (p. 765–805). 2th edition. New York: Oxford University Press.

Malpas, J. & Lickiss, N. (2007). *Perspectives on Human Dignity: A Conversation*. Amsterdam: Springer.

Mohebbi, S. (2016). The Right to One's Self-Image. In Balsom, E. & Peleg, H. (Eds.), *Documentary Across Diciplines*. Boston: The MIT Press.

Oliver, S. (2010). Dehumanization: Perceiving the Body as (In) Human. In Kaufmann et al. (Eds.), *Humiliation, Degradation, Dehumanization: Human Dignity Violated* (p. 85–97). Amsterdam: Springer.

Orgeron, M. (2006). Liberating Images? Samuel Fuller's Film of Falkenau Concentration Camp. *Film Quarterly*, 60(2), 38–47. doi: FQ.2006.60.2.38.

Perez, G. (1998). *The Material Ghost: Films and Their Medium*. London: The Anthony Hopkins University Press.

Riley, S. (2010). Dignity as the Abscense of the Bestial: A Genealogy. *Journal for Cultural Research*, 14 (2), 143–159. doi: 10.1080/14797580903481298.

Rosen, M. (2012). *Dignity: Its History and Meaning*. Cambridge: Harvard University Press.

Schiller, F. (1988). *Friedrich Schiller: Poet of Freedom vol II*. Washington D.C.: Schiller Institute.

Sontag, S. (2003). *Regarding the Pain of Others*. England: Penguin Books.

Stam, R. & Spence, L. (1999 [1983]). Colonialism, Racism and Representation. In Braudy, L. & Cohen, M. (Eds.), *Film Theory and Criticism: Introductory Readings*. 5th Edition. New York: Oxford University Press.

Tarling, N. (2007). Dignity and Indignity. In Maplas, J. & Lickiss, N. (Eds.), *Perspectives on Human Dignity: A Conversation* (p. 141–149). Amsterdam: Springer.

Vertov, D. (1984). *Kino-Eye: The Writings of Dziga Vertov*. CA: University of California Press.

West, C. & Ehrenberg, J. (2011). Left Matters: An Interview with Cornel West. *New Political Science*, 33(3), 357–369. doi: 10.1080/07393148.2011.592023.

## Web

Abounaddara (2015). A Right to the Image for All. Retrieved from https://post.at.moma.org/content_items/719-a-right-to-the-image-for-all-concept-paper-for-a-coming-revolution (01.09.2019).

Abounaddara (2016). Regarding the Spectacle. Retrieved from https://www.thenation.com/article/regarding-the-spectacle/ (30.08.2019).

Abounaddara (2017). Dignity Has Never been Photographed. Retrieved from https://www.documenta14.de/en/notes-and-works/15348/dignity-has-never-been-photographed (30.08.2019).

Bayoumi, M. (2015). The Civil War in Syria Is Invisible – but This Anonymous Film Collective Is Changing That. Retrieved from https://www.thenation.com/article/the-civil-war-in-syria-is-invisible-but-this-anonymous-film-collective-is-changing-that/ (30.08.2019).

Boëx, C. (2012). Emergency Cinema: An Interview with Syrian Film Collective Abounaddara. Retrieved from http://www.booksandideas.net/Emergency-Cinema.html (30.08.2019).

Debord, G. & Wolman, Gil J. (1956). «A User's Guide to Détournement», Les Lèvres Nues, No. 8: https://www.cddc.vt.edu/sionline/presitu/usersguide.html (30.08.2019).

Desistfilm (2014). Desistfilm 2014 Film Round-Up: The List. Retrieved from http://blog.desistfilm.com/2014/12/29/desistfilm-2014-round-up-the-list/ (30.08.2019).

Dork, Z. (2016). Le droit à l'image est-il égalitaire? Retrieved from https://www.artpress.com/2016/05/18/le-droit-a-limage-est-il-egalitaire%E2%80%89/ (16.05.2020).

Feinstein, L. (2015). This Syrian Film Collective Shows the Banality of Life in War. Retrived from https://www.vice.com/en_us/article/mvxgap/this-syrian-art-collective-shines-an-intimate-light-on-life-in-their-war-torn-country-456 (16.05.2020).

Mayyasi, A. (2015). A New Kind of Weapon in Syria: Film. Retrived from http://brooklynquarterly.org/a-new-kind-of-weapon-in-syria-film/ (15.01.2018).

Mejcher-Atassi, S. (2014). Abounaddara's Take on Images in the Syrian Revolution: A Conversation between Charif Kiwan and Akram Zaatari (Part II). Retrieved from https://www.jadaliyya.com/Details/31172 (01.09.2019).

Riley, S. & Bos, G. (2019). "Human Dignity", Internet Encyclopedia of Philosophy. Retrived from https://www.iep.utm.edu/hum-dign/ (30.08.2019).

Rosenbaum, J. (1980). Sam Fuller Spills His Guts. Retrieved from http://www.jonathanrosenbaum.net/1980/07/sam-fuller-spills-his-guts/ (01.09.2019).

Ryzik, M. (2015). Syrian Film Collective Offers View of Life Behind a Conflict. Retrived from https://www.nytimes.com/2015/10/19/movies/syrian-film-collective-offers-view-of-life-behind-a-conflict.html (30.08.2019).

Sá Cavalcante Schuback, M. (2017). Being Without a People. Retrieved from https://thephilosophicalsalon.com/being-without-a-people/ (30.08.2019).

Tarnowski, S. (2017). What Have We Been Watching? What Have We Been Watching?. Retrieved from https://bidayyat.org/opinions_article.php?id=167#.XWj-7igza71 (30.08.2019).

## Films

*Arrival of a Train at La Ciotat* (Auguste & Louis Lumière, 1896).

*Assassinat de Kléber* (Auguste & Louis Lumière, 1987).

*Big Red One, the* (Samuel Fuller, 1981).

*Butcher of Aleppo, the* (Abounaddara, 2016).

*Ewige Jude, der* (Fritz Hippler, 1940).

*Man With a Movie Camera* (Dziga Vertov, 1929).

*Syria Today* (Abounaddara, 2012).

*Two Minutes for Syria* (Abounaddara, 2013).

*Winter Soldier* (The Winterfilm Collective, 1972).

*Workers Leaving the Lumière Factory* (Auguste & Louis Lumière, 1895).